Portrait of the Art World

William F. Stapp

Portrait of the Art World

A Century of *ARTnews* Photographs

With essays by
Pete Hamill
and Milton Esterow

and contributions by
Tracey L. Avant
Frank H. Goodyear III
Sarah A. Loffman
Tess Mann
Ann Shumard
Kristin Smith

National Portrait Gallery
Smithsonian Institution
Washington, D.C.

in association with
Yale University Press
New Haven and London

This exhibition has been organized by the National Portrait Gallery, Smithsonian Institution, and is sponsored nationally by AXA Art Insurance Corporation.

Exhibition Itinerary

New-York Historical Society
New York City
September 27, 2002–January 5, 2003

International Gallery, S. Dillon Ripley Center, Smithsonian Institution
Washington, D.C.
February 7–April 6, 2003

Elmhurst Art Museum
Elmhurst, Illinois
May 2–July 27, 2003

Museum of New Mexico, Museum of Fine Arts
Santa Fe
September 12, 2003–January 4, 2004

Jacket illustration: Photograph of Louise Nevelson by Hans Namuth *(detail),* 1977. National Portrait Gallery, Smithsonian Institution, Washington, D. C.; gift of the James Smithson Society © Hans Namuth Ltd.

Designed by Daphne Geismar
Set in Caecila type by Amy Storm
Printed in Singapore by C S Graphics

Library of Congress Cataloging-in-Publication Data
Stapp, William F., 1945–
Portrait of the art world: a century of Artnews photographs/William F. Stapp, with essays by Pete Hamill and Milton Esterow; and contributions by Tracey L. Avant . . . [et al.].
 p. cm.
ISBN 0-300-09752-2 (cloth: alk. paper)
1. Artists—Portraits—Exhibitions. 2. Portrait photography—Exhibitions. 3. ARTnews annual (New York, N.Y.: 1964)—History—Exhibitions. I. Hamill, Pete, 1935– II. Esterow, Milton. III. Avant, Tracey L. IV. National Portrait Gallery (Smithsonian Institution) V. Title.
TR681.A7 S73 2002
779'.9709'22—dc21
2002005815

Contents

Foreword

At its core, portraiture has always been about remembrance. In describing the origins of this artistic genre, the Roman author Pliny relates a tale about a potter's daughter who outlines the shadow of her departing lover on a wall as a means of remembering him. Fearing the loss of one who means so much, she turns to portraiture in an effort to save his image for all time.

When editors at the *American Art News*—the forerunner of today's *ARTnews*—introduced into their pages photographic portraits of prominent artists for the first time in 1904, one wonders whether a similar desire guided their thinking. Certainly from a business perspective, the inclusion of photographs gave the young magazine a forward-thinking identity and a competitive advantage over other journals. Indeed, few publications at this time had taken advantage of photography as an illustrative medium. Although marketing played an important role in the decision to incorporate photography into the magazine, I am more inclined to believe that the editors' intimate connection to the contemporary art world proved vital in their decision. Given the close relationship that developed between the magazine and many of the artists who were featured in it, it should not be surprising that the editors embraced photography as a means to celebrate and to remember the lives of working artists. Because of its supposed transparency and its ability to mark one's presence at a particular moment, photography was ideally suited to represent these individuals.

"Portrait of the Art World: A Century of *ARTnews* Photographs" is, therefore, both a celebration of the one-hundredth anniversary of America's

oldest art journal and a remembrance of the many relationships that have been forged between the magazine and the artistic community during that time. The exhibition features photographic portraits of one hundred individuals who shaped the twentieth-century art world. In retrospect, the broad diversity of artists who appeared in the magazine is striking. Though critics have favored certain artistic traditions at different times during the past hundred years, this roster makes clear that no single orthodoxy ruled the day at *ARTnews*. At the height of the Abstract Expressionist movement, for example, readers were as likely to encounter feature articles on a realist painter like Edward Hopper or the Russian Surrealist Pavel Tchelitchew as to read about such stars as Jackson Pollock or Willem de Kooning. The breadth of its artistic scope remains a hallmark of the magazine to this day.

It is clear, too, that the editors at *ARTnews* welcomed the opportunity to present the work of young artists whose reputations were not already well established. In securing portraits of these individuals, they often recruited little-known photographers. And although the list of photographers whose images were published in *ARTnews* now reads like a who's who of twentieth-century photography, many achieved recognition for the first time in its pages. Photographers such as Zaida Ben-Yusuf, Jessie Tarbox Beals, and Cindy Sherman were all under thirty-five when *ARTnews* first published their work. This commitment to the present and the future has been a defining charac-

teristic of the magazine and is an important reason for its unparalleled longevity.

The National Portrait Gallery is proud to join with *ARTnews* in celebrating its centenary. By looking back, we hope not simply to extol the achievements of the magazine and the artists whose lives were chronicled in it, but also to understand the important place of art in the twentieth century. I wish to extend heartfelt thanks to all who helped make this exhibition possible. Of particular note, let me acknowledge the support that the AXA Art Insurance Corporation has provided. To Dr. Dietrich von Frank and Christiane Fischer, chief operating officer of AXA, thank you. Last, this exhibition would not have been possible without the generous cooperation of Milton Esterow, the longtime editor and publisher of *ARTnews*. To him—as well as to Judy Esterow, Grace Scalera, Virginia Wadsworth, Robin Cembalest, and Sylvia Hochfield at *ARTnews*—we bid our deepest gratitude.

Our thanks also goes to many people in various departments of the National Portrait Gallery who helped make this book and exhibition possible, including Carolyn Carr, Beverly Cox, Dru Dowdy, Ann Shumard, Frank Goodyear, Tracey Avant, Kristin Smith, Jennifer Lee, Sarah Loffman, and Tess Mann. To all of you, our appreciation.

Marc Pachter
Director
National Portrait Gallery

A Letter from AXA Art

As a specialist insurer—unique in the global industry—the AXA Art Insurance Corporation has dedicated its insurance products to the preservation and protection of art. The company covers private and institutional collections and art exhibitions, as well as a sizable portion of the art trade. As such, we play an integral part in the art world, offering our art historical services and all risks coverages to private and commercial collectors alike.

It seemed a natural fit, therefore, for us to become the sole sponsor of an exhibition celebrating the one-hundredth anniversary of the magazine *ARTnews,* this indispensable monthly source of excellent information about art, which over a hundred years grew to become an integral part of international journalism under its six distinguished publishers.

When Milton Esterow approached me in the summer of 2000 with the quest for financial underwriting of an exhibition featuring photography of artists and their oeuvre who had appeared in *ARTnews* since 1902, I was fascinated with the concept of his intent to personalize and individualize this centennial celebration through a medium whose coming of age so perfectly parallels the lifespan of *ARTnews.*

The collaboration between *ARTnews* and the AXA Art Insurance Corporation would have been unthinkable, however, without the participation of the National Portrait Gallery, which took it upon itself to put together this unique show.

At a time when images more and more replace the written word, *ARTnews* is and will be uniquely positioned to continue to bring us the kind of journalism that we need to form our own opinions about art—as it has done for the past one hundred years.

Dr. Dietrich von Frank
President and CEO
AXA Art Insurance Corporation

ARTnews

Chronicling a Century

The first issue of *Hyde's Weekly Art News* appeared on November 29, 1902. It was the only art periodical published in the United States, a one-sided, one-sheet affair, laid out, the writer Richard F. Shepard noted, "in five columns of print that would make a legal journal seem lively by comparison."

James Clarence Hyde had been an art historian and art critic for the *New York World* and *Tribune.* His creation, which measured about seventeen by thirteen inches, had no illustrations, no criticism, and no advertising, but it was a national journal, even if one that devoted much space to art in Europe, which was where Americans still looked for cultural uplift. Claude Monet, Paul Cézanne, and Edgar Degas were still at work. But few Americans were aware that Thomas Eakins, Winslow Homer, and Albert Pinkham Ryder were alive, much less making works of beauty.

Hyde wrote, "The endeavor will be to make the news interesting, up to date, and absolutely reliable. Appreciating that the value of this paper will be its bonafide news of art matters, the publisher will print only that which he believes to be trustworthy."

Both art and the magazine have grown. Art, one of my distinguished predecessors, the late Alfred M. Frankfurter, wrote a half-century ago, "has developed from a social diversion to a national expression." *Hyde's Weekly*, which became a monthly in 1946, is now read in 120 countries by nearly 250,000 people, the largest monthly art audience in the world.

There have been galvanic changes in art in the past one hundred years—changes in taste and fashion, as well as in aesthetics. Soon after *ARTnews* and the twentieth century began, Pablo Picasso and Georges Braque invented Cubism, but they had trouble selling a painting even when they were close to fifty. At almost the same time, in Paris, Henri Matisse, André Derain, and their friends showed some of their colorful paintings and were denounced as *fauves*—wild beasts.

ARTnews has documented the artists and the art world through photographs as well as words. We featured portrait photographs of artists as early as 1904. Some of the photographers—Man Ray, Henri Cartier-Bresson, Robert Capa, Berenice Abbott, George Platt Lynes, Arnold Newman, Hans Namuth, and Duane Michals, among others— rank with their artist subjects. Some lesser-known photographers have also made pictures that epitomize an art movement or period. The early photographs, as this exhibition indicates, were elegantly formal, showing painters dressed as soberly as their banker clients. Today, the style is usually T-shirt and jeans.

A long-lived publication, it has been said, is a perpetually self-renewing work in progress directed by a succession of creative people who, if one is fortunate, materialize at the proper moment.

I could mention some of our more celebrated contributors— Bernard Berenson, Duncan Phillips, Harold Rosenberg, Aldous Huxley, Kenneth Clark, Meyer Schapiro, Alfred Barr, André Malraux, Marcel

Duchamp, Barnett Newman, Robert Motherwell, Philip Johnson, Robert Rosenblum, Arthur Danto, Robert Rauschenberg.

I could list some of our exclusive stories—the scandal over Nazi art loot in Austria; the secret art depositories in the Soviet Union, which the George Polk Awards Committee called "a remarkable East-West journalistic achievement." Or the six awards for excellence from the Society of the Silurians, the organization of veteran editors and reporters.

None of the kudos would have come without the less celebrated editors, reporters, art historians, critics, and artists who have appeared on *ARTnews*'s masthead and changed the course of art journalism. To all of them—my respect, admiration, and affection.

What of the future? What will art become? I don't know. What our pages will contain depends on what will be happening in the world we cover—and on the larger forces that shape that world.

I have no hesitation, however, in predicting that *ARTnews* will be there, reporting and analyzing what is going on, with a receptiveness to new ideas and the values embodied by James Clarence Hyde in 1902. We will use whatever technology is needed to do all this while at the same time resisting tendencies for technology to become the master rather than the tool of the magazine.

Meyer Schapiro once said, "To perceive the aims of the art of one's own time and to judge them rightly is so unusual as to constitute an act of genius." *ARTnews* has not always perceived the art of its own time rightly.

Back in 1911, our critic in Paris was upset over the "diabolical influence" of the so-called Cubists and hoped that American artists "will not become affected by this germ that makes for decay in the beauty of line, form and thought."

Years later, the germ affected one of our critics, who was absolutely certain that Duchamp's *Nude Descending a Staircase* was the work of a "carpenter."

Perhaps that's one of the reasons why, on our sixtieth birthday, Josef Albers summed us up this way:

> Sometimes I love you,
>
> Sometimes I hate you,
>
> But when I hate you,
>
> It's cause I love you.

Milton Esterow

Editor and Publisher

ARTnews

Pete Hamill

The First Hundred Years of *ARTnews*

That year, exactly a century ago, few people paid much attention to the birth in New York of a small trade paper about the art business. Theodore Roosevelt was the muscular new president, taking charge a year earlier after the assassination of William McKinley. "Teddy," as everyone called him, was presiding over a vicious jungle war in the Philippines, that Asian trophy of McKinley's war with Spain. He was forcing Colombia at gunpoint to surrender Panama as the site of a grand canal that would connect the Atlantic to the Pacific. At the same time, he was using the Oval Office as a passionate bully pulpit for many progressive ideas.

In New York, while that trade paper about the art business was being born, American society was being transformed. On a social level, the immense fortunes of the post–Civil War millionaires were absorbing the older self-proclaimed New York aristocracy from the Brownstone Republic of Gramercy Park. Teddy Roosevelt had come from that downtown world of Knickerbocker money and remains the only native of New York City to become president of the United States. The older downtown fortunes were derived from the business of the port, from shipbuilding and warehousing and rents derived from such squalid New York slums as the Five Points. The children of this fortunate class were educated to do nothing. They lived in a world of muted manners, of "good taste," of prolonged journeys to Europe. Discretion was all. They bought art, discreetly. They displayed art, discreetly. They married, or had love affairs, discreetly. And they looked on the arriviste millionaires with an icy contempt.

But then the downtown aristocracy began to understand that the world had changed. They had the manners and style of an aristocracy based on the British model. But they had less and less money, precisely because their children and grandchildren had been trained to be useless. An exchange began. The downtown people surrendered their manners, breeding, and good names to the uptown vulgarians, who in turn provided access to their fortunes. Edith Wharton knew that world intimately and would make it the subject of her greatest fictions. Indeed, she published her first novel in 1902, when she was forty. The mergers saved the downtown children from the ignominy of work. And the combination of discreet restraint, good "breeding," and much cash turned out to be good for art. All artists, dead or alive, need great collectors. A great collector can revive a faded artistic reputation or preserve the most valuable art of the past. A great collector can give sustenance to living artists, helping morale, warding off hunger, saving artists from descending into audience-driven hackery. The merger of downtown taste with fresh bushels of money was the unstated subject of that small journal about the art business.

To be sure, the great Gilded Age social merger was not, at the beginning, good for American artists. Those who bought art still believed that great work came exclusively from Europe. Some bought art by the crate load, like the fictional publisher in *Citizen Kane*. Others, among them J. P. Morgan, purchased grand mansions in England and the Continent, where they could display their treasures and avoid paying high American import taxes (a subject covered in that new weekly newspaper about the art business). And American artists were themselves in thrall to the myth of Europe. Three of the finest American painters—James Abbott McNeill Whistler, Mary Cassatt, and John Singer Sargent—were essentially Europeans, living in London or Paris. Thomas Eakins was working in relative obscurity in Philadelphia. Winslow Homer had retreated to craggy isolation in Maine.

Many younger (and less talented) Americans believed that they would be incomplete as artists if they lacked a European artistic education. They crowded into the Académie Julian in Paris. They studied with painters and sculptors in Rome and Florence. Their teachers at the Art Students League (est. 1875) and the Pennsylvania Academy of the Fine Arts (est. 1805) encouraged them to leave for places where they'd be free of

deep-rooted American puritanism and the crassness of robber baron commercialism. Romanticism was vividly alive: it was thought better to be hungry in a Paris garret than to grow prosperous and plump making portraits of the wives of grasping merchants.

Those who stayed in America (along with many who came home from their European immersion) scrambled to make a living. They produced banal landscapes for the carriage trade. They painted insipid family portraits. Some furtively made copies of European masters (at one point, three thousand fake Corots were said to be in circulation, some in the mansions of wealthy collectors). The best artists used their skill and craft to make illustrations for the exuberant periodical press (more on this later). Others worked as teachers, transmitting the fable of Europe to their young charges.

All of this played out against another great social current: the immense wave of immigrants, especially from Ireland, Italy, Germany, and eastern Europe. The earlier immigration of the famine Irish seemed small in comparison. Between 1880 and 1919, some twenty-three million newcomers would arrive in the port of New York. In 1902 alone, nearly half a million passed through Ellis Island and about a quarter stayed in New York, which had become Greater New York in 1898. That city of 3.5 million human beings was transformed; 1.3 million of its residents were foreign-born. In Manhattan, the old Protestant ascendancy often felt engulfed, even threatened. Certainly their political power waned, as the immigrants became Americans and turned out to vote. When one of old New York's most glorious children, Henry James, returned from more than twenty years of European exile in 1904, he said he felt dispossessed.

Yet this unprecedented surge of Catholics and Jews, the mixture of southern Europe with the descendants of England, was creating a vibrant new popular culture. Newspapers flourished, presenting among many riches the first splendid generation of comic strips. A foreign-language press emerged with astonishing vigor, freed from the censorship and suppression of the countries left behind; between 1885 and 1914 more than 150 Yiddish-language dailies, weeklies, and monthly magazines were published in New York City alone, and Yiddish words and expressions added vitamins to the English language. The descendants of African slaves

and Irish indentured servants helped create popular music and dancing, rising from vicious slums to the theater stages, from the Bowery to Broadway. Along came ragtime, and dime novels, and the rowdy pleasures of music halls. (Far away in Dublin, twenty-year-old James Joyce wrote: "The music hall, not poetry, is the criticism of life.") None of it seemed connected to Europe. This was something new, something very American: anti-Establishment, mocking, communal, a celebration of the man and woman in the street.

Technology was forcing other changes. Electric light had opened up the New York night in the 1880s. By 1902, great gashes severed the city's streets as its first subway line pushed north through Manhattan (dug and built by thousands of those immigrants); it would be completed two years later. In 1902, Enrico Caruso made his first phonograph recordings, and opera soon became available to people who could not pay their way into opera houses. That same year, Henry Ford began work on his first assembly line in Dearborn, Michigan. And in New York, Macy's opened its great store on Thirty-fourth Street.

Architecture was one of the most obvious expressions of the new New York. The first passenger elevator was installed in a cast-iron building in 1857, and in a series of swift conceptual steps, the door opened to skyscrapers. James made the point that the skyscraper was also uniquely American, built only for business, although he had deep reservations about the tall new buildings: "They never begin to speak to you, in the manner of the builded majesties of the world as we have heretofore known such—towers or temples or fortresses or palaces—with the authority of things of permanence or even of things of long duration. One story is good only till another is told."

In 1902, the twenty-story Flatiron Building was completed on its triangular plot at the intersection of Fifth Avenue, Broadway, and Twenty-third Street, and was a popular and artistic sensation. At night, it resembled a gigantic ocean liner, plowing through cement on a voyage to the north, and would be photographed by both Alfred Stieglitz and Edward Steichen, two early masters of the new medium.

The city's greatest living architect in 1902 was probably Stanford White, whose mark was placed on so many buildings that still survive

among the city's ornaments. White was a dominant figure in New York's social life, friend of painters and sculptors, a great collector of antiquities, a lavish spender, a true celebrity (yes, the word was in use in his day). In 1902, he was forty-nine. Four years later, he would be murdered by a man named Harry K. Thaw in the rooftop café of an earlier version of Madison Square Garden, a building that "Stannie" had designed. Thaw was driven mad by jealousy over White's earlier affair with Thaw's wife, a beauty named Evelyn Nesbit. She in turn had been portrayed in 1902 in an elegant drawing by Charles Dana Gibson, the most famous illustrator of the era. With Queen Victoria safely dead, and the value system that bore her name beginning to fray, the twentieth century was off to an extraordinary start, a time when all values—social, aesthetic, political—would be tested.

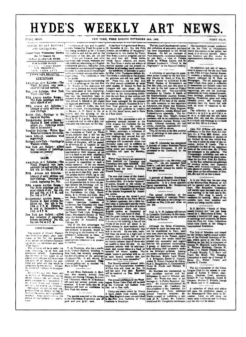

Fig. 1
Hyde's Weekly Art News,
November 29, 1902.
ARTnews Collection

A man named James Clarence Hyde modestly announced himself in this world in the summer of 1902. He was an experienced newspaperman and something of an art historian. He had worked for the *Tribune* and the *World*, journals captained respectively by Horace Greeley, who was long dead, and Joseph Pulitzer, who was very much alive. Pulitzer that year was in fact one of those free-spending collectors, off in Europe buying art for a new house designed by Stanford White (a Millet for $1,250, a Titian for $13,000). In his ambitions, Hyde surely did not intend to hurl a challenge at the existing press barons, but like many newspapermen before and since, he wanted to run his own paper.

He prepared all that summer and on November 29, 1902, issued the first copy of *Hyde's Weekly Art News* (fig. 1). The weekly consisted of a single sheet, its dense type printed on one side. Just by showing up, it became for a while the only American journal devoted exclusively to art. Hyde issued a blunt mission statement: "The purpose of HYDE'S WEEKLY ART NEWS is to supply plain statements of fact for the guidance of art editors and collectors concerning artists, art exhibitions and sales of art objects. The endeavor will be to make the news interesting, up to date

and absolutely reliable. Appreciating that the value of this paper will be its bona fide news of art matters, the publisher will print only that which he believes to be trustworthy. All matter submitted is subject to his approval."

In its way, the subject of the paper wasn't art at all. There were no critical reviews, no interviews with artists, definitely no manifestos. The subject was the art business. That first issue listed ten exhibitions, all in New York. An editorial disguised as a news story attacked "the absurd tax on art." There were notes about artists who had won commissions from patrons, brief reports on sales, and not much else. In this newspaper about the art business, there were no illustrations. Its business was business.

But the paper had been launched. And week after week, it survived.

Then in 1904, Hyde stepped aside as publisher (remaining briefly as editor) and was replaced by James Bliss Townsend. The record is now a blur, but almost certainly Hyde sold the paper to Townsend, who was another first-class newspaperman. He had served Joseph Pulitzer for ten years after 1883, when the Hungarian immigrant purchased the *New York World* from the crooked financier Jay Gould. He did everything at the *World*, from editing other people's copy to covering national conventions as a political reporter. Like many newspapermen, Townsend was also restless. In 1897, he became art editor of the *New York Times* and, in 1902, moved on to serve as art critic of the *New York Herald*. He was a sophisticated man who traveled widely, spoke several languages, and had visited many of the museums, galleries, and private collections of Europe. As soon as Townsend took over the stuffy little weekly, he made changes.

The most obvious was the eviction of Hyde's name from the paper's title. In November 1904, now aged two, it became *American Art News* (fig. 2). But more important was the expansion to what an editorial described as "four excellently printed pages adorned with photogravure cuts." These were the first steps toward transforming the trade paper into an art magazine. Townsend began using coated stock to show off those excellently printed illustrations, and he added advertising. The journal was soon finding an audience far from New York; at one point, ads for foreign dealers outnumbered the Americans.

The subject of the journal's scrutiny, too, was changing. A fresh generation of American painters was emerging in New York, many of them rising from the pressure cooker of journalism. Six artists were central to the change: Robert Henri, John Sloan, George Bellows, Everett Shinn, William Glackens, and George Luks. Five of them came to New York from Philadelphia (Bellows was from Columbus, Ohio) and all but Henri had worked as illus- trators or cartoonists. The leader of the group was Henri, a fine painter, a brilliant talker, an even greater teacher. He galvanized the others, urging them into art. All shared a belief that the teeming life they witnessed as journalist-illustrators could be trans- formed into art, in the way that newspapermen like Walt Whitman and Stephen Crane had made literature from their journalistic bases.

The young painters caused a revolution in American painting. To be sure, their revolution was not one of form. In Paris in 1908, twenty-seven- year-old Pablo Picasso had already painted *Les Demoiselles d'Avignon* (after absorbing lessons from African sculp- ture and Paul Cézanne), had forged an artistic alliance with Georges Braque, and was creating his first Cubist masterpieces. Henri Matisse had already shown his Fauvist paintings. The New York–based American painters knew little of all this, although Stieglitz was showing some of the new work at his gallery at 291 Fifth Avenue (opened in 1905). They did know the work of the Impressionists, of course, including the paintings of American followers of the French vision, William Merritt Chase and Childe Hassam (among many) and had clear ideas, derived from tradition, about the shape of a well-made picture.

Their revolution was one of content. They painted the slums, with their immigrants and children at play, their tenements and dray horses,

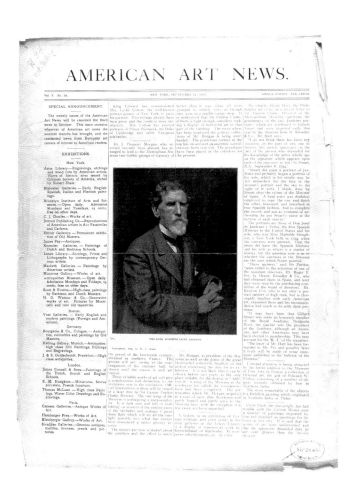

Fig. 2
American Art News,
September 14, 1907.
Smithsonian
Institution Libraries

wash lines and rooftops and fire escapes. The downtown burgher's muted drawing room was replaced by the workingman's saloon. They entered theaters and workplaces and prowled the beaches of Coney Island. They were not the first painters to look for beauty in cities; in France, such artists as Edgar Degas, Gustave Caillebotte, and Edouard Manet had painted aspects of urban life, as had Whistler and Walter Sickert in London. But they were the first Americans to seek vital beauty in the meanest streets of the teeming American city. If that was not a startling revolution, it certainly redefined the subject of the artist's hand. In the shorthand of journalism they became known as the Ashcan School.

A symbolic measure of their emergence came in the November 1905 issue of *American Art News*: the publication of a halftone reproduction of *Chez Mouquin,* by Glackens. This was the first American painting to be seen in its pages. More would come. In 1908, again pushed by Henri, the brash young men staged an exhibition of their work at the Macbeth Gallery. Only Bellows was missing, and the five migrants from Philadelphia were joined by Impressionists Ernest Lawson and Maurice Prendergast and the Symbolist Arthur B. Davies. Their work of "The Eight" was promoted in the press (primarily by Henri) as a challenge to the stuffy academics of the National Academy of Design.

Townsend went to the show and wrote a mixed review. He approved the "unquestionably virile" Henri. He slammed Prendergast: "Blotches of paint on canvas without harmony of color or tune—these are all that can be made of these curious performances." Luks, he wrote, "at least knows how to paint." But he did say of The Eight that "they make for amusement, for gayety and for education with their remarkable show." And then added, "It never does to predict what may be the fashion in art, especially in these United States, a few years hence."

A few years hence, a single event broke open the American art world for the rest of the century and drastically shifted the focus of Townsend's art paper. The fresh, daring winds that were blowing from Paris combined in a sudden storm. Some works of the new European painters had been shown before in New York, notably at Stieglitz's 291 gallery (which had featured two shows by Matisse). Scattered reports from Europe spoke of

daring experiments and baffling visions, but *American Art News* paid them little attention. And if most American artists and critics were ignorant of the new visions, the new work was virtually unknown to the public.

Then on February 17, 1913, the doors to the Sixty-ninth Regiment Armory on Lexington Avenue opened to the most extraordinary art exhibit in American history. Its formal title was the *International Exhibition of Modern Art*. It was instantly dubbed the Armory Show.

The show was organized by artists, including Arthur B. Davies and Walt Kuhn, who combined to create news in the press while raising funds to mount the show (the story of the maneuverings, quarrels, and ambitions of all those involved has been vividly told by such art historians as Martin Green and Annie Cohen-Solal). The scope was immense: about 1,250 works by more than three hundred artists, living and dead. In eighteen galleries, the visitor could see works by the great masters of the past—Jean-Auguste-Dominique Ingres, Francisco José de Goya, Eugène Delacroix—and the daring young artists of Montmartre and its branch offices.

There was no artistic coherence, in spite of much chatter about various "isms"—from Impressionism to Post-Impressionism, Fauvism, Pointillism, and Futurism. Taken together, the works were a celebration of diversity and pluralism that in their collective way reflected the city itself. A visitor could look at Picasso and Matisse, Cézanne or Manet, Degas or Jean Renoir, Wassily Kandinsky, Edvard Munch, or Ernst Kirchner. Or stand close to Paul Gauguin and Vincent van Gogh. Or gaze, in no particular order, at Monet, Degas, Georges Seurat, or Henri de Toulouse-Lautrec. There was the great Auguste Rodin, and Pierre Puvis de Chavannes, and dozens of mystical works by Odilon Redon.

In the first of what must have been many visits to the Armory Show, Townsend saw much work by Americans. The familiar names were there: Bellows, Sloan, Glackens, Hassam, Julian Alden Weir, John Twachtman. Conspicuous by their absence were Sargent and Chase, apparently subjected to a generational veto. There were a number of works by established women artists (Cassatt was hung, perhaps fittingly, with French artists). But Townsend also saw works by a number of new American artists. Young Edward Hopper had one lonesome painting on the walls, and it was purchased for $250, the first sale of Hopper's career. There were two still-lifes

by Marsden Hartley, along with his smaller color studies exploring the new cubist idiom. John Marin's brilliant expressionist visions of the New York skyscraper (in particular, the Woolworth Building) attracted much attention. Townsend surely saw the works by Joseph Stella and Abraham Walkowitz, Albert Ryder and Alfred Maurer. He must have been consoled by the presence of Robert Henri, whose marvelous life-size nude painting of a female dancer—called *Figure in Motion*—stood as a counterpoint to the most controversial work in the show: Marcel Duchamp's *Nude Descending a Staircase, No. 2.*

The Duchamp masterwork hung in Gallery I, which was labeled in the catalogue "French Painting and Sculpture" but swiftly became known in the daily press as the "Chamber of Horrors." In addition to the Duchamp, the room housed Matisse's *Blue Nude*. The room was packed each day and created the most public controversy. With notable exceptions, critics expressed various degrees of outrage, contempt, or mockery. Cartoonists did brilliant parodies of the Duchamp. Puritans expressed revulsion at the Matisse. The Armory Show, in short, was a flat-out sensation, selling thousands of dollars' worth of tickets, profoundly shaking critics, artists, dealers, and collectors.

In *American Art News*, Townsend wavered between embrace and rejection. He wrote a thoughtful piece in a throat-clearing Jamesian style for the February 22 issue.

"Taken as a whole," he wrote, "the exhibition is a clean, strong, and a varied one and of vast artistic, educational interest, and, if I mistake not, will have as a result, and despite the unquestionably skeptical and even hostile attitude towards the merits of the new foreign movements, or an indisposition to accept them as being worthy of the title of art movements in general—the most marked effect upon the cause of art in America, and upon the coming production of American painters and sculptors, than anything that has occurred since the first exhibition of the so-called Munich band of young American painters in the old American art galleries in 1878, and of the work of Monet and his contemporaries and followers held here in 1883."

So Townsend knew that the art world had shifted drastically. At the same time, he couldn't resist joining in the baffled philistine reaction, or

at least acknowledging it. In the March 1 issue, he announced a ten-dollar prize for the best solution by a reader to what many saw as the mystery of Duchamp's painting. Confronted with a new visual language, some observers had failed to see the nude or searched in vain for the staircase. Townsend's tongue-in-cheek contest brought many replies, most of them humorous, and the prize was duly awarded, although the name of the winner is now also lost to history.

Still, in the wake of the Armory Show, Townsend cut a template for his publication that would survive his death in 1921 and remains essential to the magazine now called simply *ARTnews*. The magazine would carry hard news of the world of art, in addition to interviews, reviews, and more sustained criticism. Its correspondents would recognize that art has few frontiers, that developments in Paris or Vienna or Madrid must be made known in the United States. Seeing art that was new didn't mean that the art of the past should be consigned to the rubbish bin; they could—even must—coexist. In a way, "modern" art forced a deeper examination of older art, embracing the notion, as the poet Ezra Pound later stated, that literature was "news that stays news."

The editors and writers didn't need to embrace new art to recognize that it was news. They might think some of it was worthless or would not survive the whims of fad and fashion. But they had to look at it. They needed to make informed judgments about it. They had to help make its existence known to the audience of other artists, art students, gallery owners, and collectors.

A much more apocalyptic change would follow the Armory Show. In June 1914 a Serbian nationalist assassinated Archduke Franz Ferdinand in Sarajevo, and by August the terrible slaughter of the Great War was under way. Millions died. Empires crumbled. All certainties were demolished.

During the Great War, travel to Europe was, of course, dangerous. The submarine had been added to the marvels of human ingenuity, and on land, the machine gun was adding to the numbers of human corpses. News of the art world was sketchy and seemed trivial when measured against the enormous European calamity. A number of French artists and writers were wounded in combat, including Braque, the poet-critic Guillaume Apolli-

naire, the young Fernand Léger. The American Henry James took British citizenship in 1915 as a gesture of support for the war against Germany and died the following year. Edith Wharton worked for the wounded from her base in Paris.

At home, there were a variety of reactions to the war, which had, of course, cut the artistic umbilical cord to Mother Europe. Some older American painters starting moving West. John Sloan, who resigned from the Socialist Party with the outbreak of the war, Robert Henri, and dozens of others made pilgrimages to the Southwest to gaze at the austere landscapes around Santa Fe. Their reactions to the Cubist revolution in form was to seek other subject matter. Young Stuart Davis, a pupil of Henri and friend of Sloan, stayed home, struggling with his reactions to the Armory Show, determined to find his place in the modernist enterprise. He started with cityscapes that owed much to Marin but worked very hard at welding his intellect, taste, and skill into canvases of great originality.

American Art News struggled as hard as the artists did. The important development of a homegrown Bohemia in New York eluded Townsend. In its way, the Greenwich Village phenomenon was a means of substitution; if artists and poets could not make pilgrimages to the Left Bank in the age of the submarine, they could create a Left Bank at home. Bars and cafés drew various groups of artists and poets, mixed in with labor activists and political radicals. Salons were created, usually by rich women (Mabel Dodge was the most famous). American ideas of rebellion were in the air, played against the ongoing disintegration of European civilization. Rebellion took many forms. Women rallied around the banners of what was later called feminism. Poets discarded the stale forms of English poetry and hailed their own Walt Whitman. The growing democracy of art often merged with the democracy of the bed.

Much of this tale was missed by *American Art News* and the general interest newspapers. It would be told in retrospect by social and cultural historians, memoirists, the writers of art history. But Townsend did provide news that is of great value to historians today. The opening of new American museums, the failure of modernist masters to sell their works, the storage of the Elgin Marbles in a safe London basement: all were part of the paper's texture during the war years. There were gossipy items about Picasso,

Matisse, Francis Picabia. Townsend ran a solid piece about the death of
J. P. Morgan and the emergence of Henry C. Frick as a great collector.

When the war ended in 1919, the European economy lay in ruins,
and New York had emerged as the most important art market in the
world. This was not proclaimed by Townsend, but it was a fact. So were other
developments in the world. The Bolsheviks had seized power in Russia.
Irish rebels were fighting for independence from England. Mexico was in the final
throes of the revolution and civil war that had begun in 1910. In the United States, women
at last had the right to vote, and one consequence was the advent of the great social folly
called Prohibition.

Townsend did not live to chronicle the extraordinary decade of the twenties.
He died on March 10, 1921. Within a month, his son sold *American Art News* to the team
of Samuel W. Frankel and Peyton Boswell. At first, advertising man Frankel handled the
business side, while Boswell, art critic of William Randolph Hearst's *New York American*,
served as editor. The magazine sharpened its layout, modernized its tone. Advertising
increased. In February 1923, the name was changed to *The Art News*,
with a subtitle: "An International Newspaper of Art" (fig. 3). Then in 1924,
Frankel bought out Boswell.

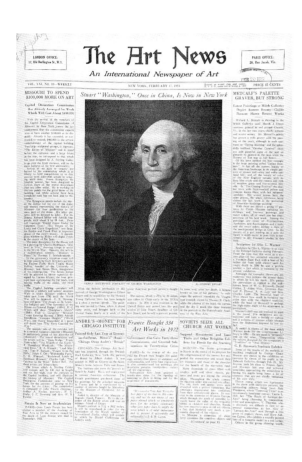

Throughout the 1920s, as bootleggers created the modern Mob, and
rowdy tabloid newspapers created a new American pantheon of ball-
players, prizefighters, movie stars, and aviators, *The Art News* reported dili-
gently on the world of art, adding to what André Malraux later called
"the museum without walls." The editors created special editions of the
newspaper-magazine and a lavishly illustrated annual. There were
reports on the creation of new museums, including the Museum of Mod-
ern Art in New York, and the expansion of American collections at the
Metropolitan Museum of Art, along with information about sales, bequests,

and gifts. The deaths of Sargent, Renoir, and Monet were solemnly noted. The emergence of the Bauhaus in Germany and the mural movement in Mexico also found space in the journal. The audience was a mixture that has endured: collectors, artists, curators, historians, dealers, and art students in search of the new. Even during the 1920s, which columnist Westbrook Pegler would dub "The Era of Wonderful Nonsense," the magazine made clear that there could be no great art without great patrons. It was so in the Florence of the Medici; it was true in the era of Babe Ruth, Jack Dempsey, Charles Lindbergh, and Charlie Chaplin.

There were dissenters from that version of America, of course, and some of them, as before, found their way to Paris. Some were in flight from the right-wing politics of the era, the Palmer Raids, and the Red Scare. Others despised the rise of the Ku Klux Klan and the dicta of political blowhards. Americans Gertrude Stein and her brother Leo were major players in the rarefied Paris where Picasso and Matisse lived and worked. They influenced writers more than visual artists, but those young writers included Sherwood Anderson, Ernest Hemingway, Hart Crane, Ezra Pound, and F. Scott Fitzgerald. Many young expatriates had been disillusioned by the horrors of the Great War; they had forsaken all belief in political abstractions, organized religion, the certainties of patriotism. Many were in flight from what H. L. Mencken called "the booboisie." They wanted to be young in a place where they could drink wine or beer or absinthe and not be arrested by Prohibition agents. Some wanted to escape the blue-nosed puritans who still defined obscenity in art and literature. And they could afford Paris. Dollars were hard, the franc was soft, and if you had American money you could get a three-course meal for twenty cents.

Unlike their predecessors, most of the young postwar expatriates didn't go to school in Paris; they went there to write and paint in the best of company. To some of them, even Picasso and Matisse seemed old hat. Dada had announced itself early in the decade, then broke down in schism, with Surrealism emerging from the ruins. Everybody seemed to be writing manifestos, with the printed word often preceding the making of art. There were quarrels, alliances, fistfights. Orgies were organized. Anathemas were cast. A few noses were broken. Booze took some of them and drugs took others, but some excellent art was made along the way.

Man Ray (once a student of Henri) emerged as a major artist with a camera. Alexander Calder was painting circus subjects. Artists as varied as Joseph Stella, Thomas Hart Benton, and Jo Davidson moved through Paris as if it were an aesthetic graduate school and then went home.

In *The Art News* some of this ferment was recognized; most was not. In Germany, George Grosz, John Heartfield, Otto Dix, and Käthe Kollwitz were creating art of great power, even savagery, visually predicting the horrors that were sure to come, but they made little immediate impact on the American audience. By the end of the decade, a much larger story was to affect the entire world. The roaring postwar spree ended on October 24, 1929, when Wall Street laid its famous egg. The Great Depression soon spread around the globe. Nobody was immune. Not the very rich. Not working people. Certainly not artists.

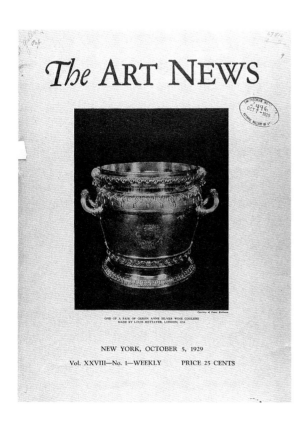

THE ART NEWS

ONE OF A PAIR OF QUEEN ANNE SILVER WINE COOLERS
MADE BY LOUIS METTAYER, LONDON, 1714

NEW YORK, OCTOBER 5, 1929

Vol. XXVIII—No. 1—WEEKLY PRICE 25 CENTS

In the same month that the stock market crashed, *The Art News* completed its transition from newspaper to magazine, with a cover on heavier stock (fig. 4). It remained a weekly, covering art-related stories, foreign and domestic: the sale of many works of art by stricken American millionaires; the creation, under Franklin Roosevelt, of the Works Progess Administration, which would give work to many artists; reports of the war on artistic freedom as Josef Stalin consolidated his power in the Soviet Union and Adolf Hitler took over in Germany. The Bauhaus was closed. Grosz immigrated to America. While such modernists as Piet Mondrian and Kasimir Malevich worked on their spare aesthetic visions, the Nazis assembled an exhibition of "degenerate" art.

American politics became more radical, of course, and so did art, with many Paris-influenced formalists dismissed as practitioners of "art-for-art's-sake" in a time when people were on bread lines in American cities and farms were turning to dust. Many younger American artists

were influenced directly or indirectly by the Mexicans—Diego Rivera, José Clemente Orozco, and David Alfaro Siqueiros. All three were at the height of their powers. All three did work in the United States: Rivera in San Francisco, Detroit, and most famously Rockefeller Center, Orozco in Pomona, at Dartmouth, and at the New School for Social Research, Siqueiros in California. Rivera was a Trotskyite, Siqueiros a militant Stalinist, and they cordially detested each other. *The Art News* wasn't much interested in the intracommunist ideological debate, but the left-wing press was noisy with vehement polemics. The destruction of Rivera's Rockefeller Center mural (for containing a heroic portrait of Lenin) was page-one news around the world, and a number of artists—including John Sloan—tried valiantly to save the painting. It was, after all, an era of lost causes.

Meanwhile, conservative enthusiasts were finding artistic heroes. Thomas Hart Benton, home after four years in Paris (which he claimed to loathe) was often paired in public notices with John Steuart Curry. They painted visual odes to American farmers, the work ethic, the glories of the land, in a kind of Capitalist Realism. Grant Wood celebrated in a somber way the lives of farmers. But the revival of realism wasn't always an embrace of conservative politics. A tough urban version of realism emerged in the work of Reginald Marsh (who had been an illustrator for the tabloid *New York Daily News* in the 1920s) and in the evolution of Edward Hopper's scrutiny of loneliness and isolation in the American city.

In coffee shops, cafeterias, art schools, and galleries, Americans heatedly debated the differences between Socialist Realism (a diktat of the Stalinists) and Social Realism. There was great artistic variety among the realists. Among the best was Ben Shahn, an immigrant as a child from Lithuania, shaped by his youth in Brooklyn, his parents' adherence to socialism, the free city universities, and Paris. He worked as an assistant to Rivera at Rockefeller Center and in 1931 began his series of twenty-three paintings about the case of Sacco and Vanzetti. He would remain committed to the ideals of the left until his death in 1969.

Others avoided direct social commentary. And all displayed individual approaches to the era. Ivan Albright's studies in decay and private horror had little to do with the mysterious work of George Tooker, with his scary subway stations and walled-off figures in isolated bureaucratic

purgatories. Isabel Bishop was capable of luminous celebration, particularly of the humanity of working women, and in a very general way, her work felt connected to the equally humane visions of Moses and Raphael Soyer. At the same time, Philip Evergood and William Gropper tried to elevate the subject matter of left-wing cartoons into more enduring art. Many others looked in astonished embrace at Picasso's *Guernica*—painted in response to the fascist bombing of a town in the Spanish Civil War—as a guide to resolving the problem of merging formal modernism with content.

In October 1935, amid this social, political, and artistic ferment, Samuel W. Frankel died and was succeeded as publisher by his wife, Elfreda. The following January she named Alfred M. Frankfurter as consulting editor, charging him with developing a plan for the future of the magazine (fig. 5). Chicago-born, a student of Bernard Berenson in Italy in the 1920s, Frankfurter had freelanced as an art critic after 1927. When he became editor in 1936, circulation had dropped to twelve hundred an issue and advertising revenue was paltry. Frankfurter brought his passion for art to the task of saving *The Art News*. He established high standards of writing and thinking. He looked for good young writers. He first cut the weekly to a periodical published every other week and then made it a monthly. In 1941, he also dropped "the" from the magazine's name, making it simply *Art News* (fig. 6). And he made clear that he was looking for a wider audience.

Fig. 5
Alfred Frankfurter
(1906–1965) by Rudolph
Burckhardt (1914–1999),
photograph, not dated.
ARTnews Collection.
Courtesy the Estate of
Rudolph Burckhardt and
Tibor de Nagy Gallery,
New York City

Fig. 6
Art News, February 1941.
Smithsonian
Institution Libraries

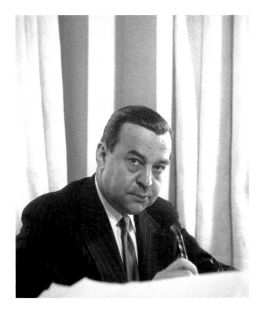

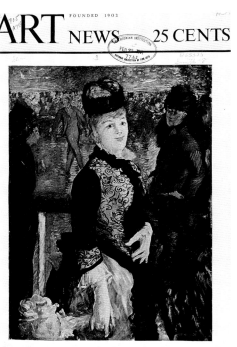

"The basic purpose," Frankfurter wrote later, "was to make over a traditionally professional and trade art journal into one intended to serve the wider public, wider interests and wider needs of the American civilization wherein art was gradually developing from an esoteric and social diversion."

Frankfurter himself wrote occasional pieces for the magazine, including a major examination of Picasso. He was surely responsible for the 1945 obituary of Franklin Roosevelt, calling him "the best friend of art this country ever had in a President." The long unsigned assessment of FDR and art that appeared in the following month also sounds like Frankfurter (it correctly predicts, by the way, that the G.I. Bill of Rights would have an enormous impact on the arts). But it was the postwar era that gave Frankfurter the chance to make a new magazine of enormous vitality. Paper rationing was over. Europe was free. A marvelous sense of possibility filled people's senses in New York and other American cities. *Art News* reached out to the best writers it could find. Some were familiar names: Henry McBride had been writing his reactions to art and artists since the time of the Armory Show, and Meyer Schapiro was building his reputation as a critic and historian of wide knowledge and culture.

Others were about to become famous or had already built reputations in Europe. Jean-Paul Sartre delivered pieces on Alexander Calder and Alberto Giacometti. André Malraux wrote on Goya. Stephen Spender examined van Gogh. Amateur painter Winston Churchill published a charming essay on painting as a pastime. This established a pattern that has endured to the present day. Across the postwar years, critics and scholars such as Alfred H. Barr, Sir Kenneth Clark, William Rubin, Robert Rosenblum, and Arthur Danto would appear in the magazine's pages, along with contributions from writers as varied as Aldous Huxley, Francine Prose, and Carlos Fuentes. In the choice of contributors, the editors consistently shunned orthodoxy.

Sartre, Malraux, and Churchill appeared in a magazine where a new generation of critics was announcing a postwar cultural phenomenon: the emergence of a group of American artists who were totally free of the School of Paris. The painters were Jackson Pollock, Arshile Gorky, and Willem de Kooning, along with others (Franz Kline would arrive in 1950). The critics were Harold Rosenberg (fig. 7), Clement Greenberg, and Thomas B.

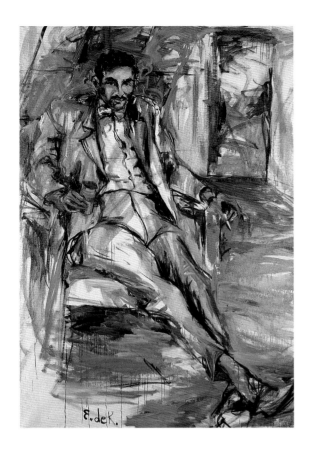

Hess (who had joined the *Art News* staff in 1946 and helped persuade Frankfurter about the value of the new painting). If New York had emerged after the Great War as the major art market of the world, by the end of World War II it had become the world's capital for the making of art. The exhausted School of Paris had become part of art history. Now the Americans were showing the Europeans the way.

In May 1951, *Art News* published an article about Jackson Pollock painting a picture, with a superb text by Robert Goodnough and photographs by Hans Namuth. The article crystallized the era. But it was only one of many that made clear that something new had arrived among us. Elaine de Kooning (herself a fine painter) wrote an article about the sculptor David Smith. Hess did another on Willem de Kooning. All attempted to describe both the process and intention in the making of these new works. But the naming of the new art fell to critic Harold Rosenberg. In December 1952, he published in *Art News* a brilliant critical essay called "The American Action Painters." He wrote: "At a certain moment the canvas began to appear to one American painter after another as an arena in which to act—rather than as a space in which to reproduce, re-design, analyze or 'express' an object, actual or imagined. What was to go on the canvas was not a picture but an event."

Rosenberg didn't mention a single painter among the Action Painters, but when his article appeared, his readers surely knew their names. The magazine itself had helped make them known, and the mass media were now paying attention, making Pollock the star of the movement. Some critics used the phrase Abstract Expressionists to describe them, and others spoke of the New York School. But by whatever name, Rosenberg— in tandem, or contrast, with Clement Greenberg—helped us all understand the new art.

In the wake of this great shift, there were casualties among artists. The Mexican muralists fell completely out of fashion, and the most

blatant of the 1930s social propagandists now seemed embarrassing. Some excellent American painters—Shahn, for example, and young Jack Levine—received little serious attention. Many continued to paint, and most to mount exhibits. But few received sustained scrutiny or the benefits of publicity. The pages of *Art News* were limited, after all, and if in the past the newspaper-magazine had lagged behind in its coverage of the new—or even

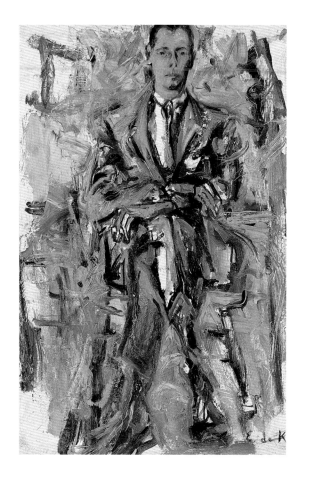

Fig. 8
Thomas B. Hess
(1920–1978)
by Elaine de Kooning
(1918–1989),
oil on board, 1956.
National Portrait
Gallery, Smithsonian
Institution
© Elaine de
Kooning Trust

actively opposed it—this time the editors seemed determined to get it right. Frankfurter encouraged the coverage while simultaneously opposing the tides of McCarthyism in the arts.

During this period, Frankfurter also worked to secure the future of the magazine. *Art News* was owned by the Art Foundation Press, and in 1962, all the stock was sold to the Washington Post Company, specifically to *Newsweek*. The deal included editorial independence for *Art News*, and the new owners were true to the bargain. The circulation had risen to thirty thousand a month from its Depression-era low, and with the enormous help of Hess, Frankfurter had made his magazine essential to understanding the world of art. Then in May 1965, after almost thirty years in command, Frankfurter died. The staff was shaken, but the transition was smooth. After almost twenty years with *Art News*, Hess became the new editor (fig. 8).

Hess continued to champion the Action Painters, although Pollock had died in 1956 and Kline in 1962. The magazine looked with respect on the second generation of New York painters—Helen Frankenthaler, Morris Louis, Kenneth Noland—but also noted the emergence of another major development. The work of Jasper Johns and Robert Rauschenberg suddenly appeared on the scene and, without planning it that way, formed a bridge from the Action Painters to what became known as Pop Art. This drew on comic strips, advertisements, commercial products, transformed by irony, humor, and personal vision into a new kind of art. A fresh

set of proper nouns entered the pages of *Art News*: Andy Warhol, Claes Oldenburg, Roy Lichtenstein, and Jim Dine, among others. Hess clarified the differences among these artists and used his pages to help readers understand what they were doing.

Then in 1972, *ARTnews* (the name had undergone a typographical refinement in 1969) experienced another major change (fig. 9).

That year, as the war raged in Vietnam and the crimes that led to the Watergate scandal were under way, a veteran *New York Times* reporter named Milton Esterow bought *ARTnews* from *Newsweek* (fig. 10). Hess moved on to become art critic for *New York* magazine and consultative chairman of the department of twentieth-century art at the Metropolitan Museum of Art. He died in 1978.

In 1972, the magazine was seventy. Esterow was forty-four. He was another son of Brooklyn, born there to immigrants. His mother was from Poland, his father from Russia; they met and married in America. Esterow had an American childhood, playing ball in the streets, wandering to Coney Island in summers. But he also grew up reading Yiddish (including stories by Sholom Aleichem and Tolstoy's *Kreutzer Sonata*), making many visits to the Brooklyn Museum of Art, and then entering Brooklyn College. While a student, he found a job as a copy boy at the *New York Times*, and three years he later became a general assignment reporter. He

Fig. 9
ARTnews, May 1969. Smithsonian Institution Libraries

Fig. 10
Milton Esterow (born 1928) by Timothy Greenfield-Sanders (born 1952). ARTnews Collection. Photo courtesy Timothy Greenfield-Sanders

covered fires and homicides and other calamities but always made clear that his heart belonged to the arts.

By the late 1950s, Esterow had moved to the drama department to write feature stories along with reviews of Off-Broadway plays and movies. And he reported and wrote occasional pieces on the world of art. When the *Times* broadened its cultural coverage in 1962, Esterow became its chief reporter and then assistant to the cultural news editor. He was once asked why he bought *ARTnews*. He explained that he felt there was a void among art magazines, then added: "I always wanted to run my own show, and I knew I couldn't buy the *Times*."

To his new role as publisher-editor Esterow brought a passion for art and the healthy skepticism of the newspaper reporter. He thought that much writing about art had become dense with jargon or was buried under layers of obscure poetical musings. His first task was to establish lucidity. He insisted that writing about art could be clear and stylish. He imposed on the magazine a combination of handsome design, hard news, solid features, and concise reviews.

On the evidence of the magazine's contents, Esterow had clearly chosen not to be the mouthpiece for any artistic creed. This reflected the situation in the art world. Starting in the 1970s, an aesthetic free-for-all was under way, with no "school" dominating the scene. For a while, art seemed less and less about art and more and more about publicity and merchandising. Some observers brooded about the consequences of the amazing amount of money entering the world of art and its effect on museums, collectors, and artists themselves. In 1975, to follow the marketplace, Esterow created the *ARTnewsletter*, a modern, well-reported, livelier version of *Hyde's Weekly Art News* of 1902.

Esterow's *ARTnews* wasn't content just to cover this complicated, occasionally ludicrous beat and subject it to reportorial common sense. He also wanted the magazine to break stories. Increasingly, he applied the tools of investigative journalism to the world of art. The magazine gave extensive coverage to problems of authenticity and provenance, asking whether certain works were what they claimed to be, and if so, where did they come from? And he sought out some buried secrets of recent history. Esterow's reporters discovered, for example, that many cultural

treasures seized by the victorious Red Army at the end of World War II were still hidden away in the crumbling Soviet Union. They verified the existence of this concealed booty and broke the story to a worldwide audience. Another *ARTnews* investigation revealed that the Austrian government still held treasures seized from Jewish victims of the Holocaust. The magazine hammered away at this story and finally forced the Austrian government to turn these art works over to the Jewish community in Vienna.

The results were rewarded. From 1978 to the end of the century, *ARTnews* won more than twenty journalism awards for excellence in reporting, design, and criticism. Organizations outside journalism added to the awards. In addition, excellent journalism once more had proven to be good business. Circulation rose steadily to its present eighty-two thousand, the highest in the journal's history and the largest of all art magazines. In 1995, *ARTnews* expanded into new media with the creation of an excellent website.

A century after Mr. Hyde started his little trade paper, almost everything has changed. If he could spend a few weeks among us now, he might recognize some of the charlatans who are drawn to the peddling of art, and the passions of young artists to make something new, and the resentments of older artists who have seen their own stars fall to earth. But I suspect he would feel a certain joy, too. He would probably be astonished at the triumph of American art, the great mixtures in New York of artists from all over the planet, the continued vitality of those who still insist on putting art before theory.

But I suspect that if he picked up a copy of *ARTnews*, and riffled through its pages, and sat at a table in a café and started to read, he would be delighted. He was, after all, present at the creation. And those who came after him have elaborated, expanded, and honored that original vision. I'd love to see them all share a table: Hyde, Townsend, Frankel, Frankfurter, Hess, and Esterow. A hundred years. Six editors. The talk would surely be brilliant.

William F. Stapp

Portrait of the Art World

During the first century of its history ARTnews evolved from a one-page broadside for the trade published on newsprint to an internationally influential publication that is the most widely read art magazine in the world. Although it has undergone changes in owners, editors, title, format, and editorial policy and style since its founding in 1902, the magazine we know today as ARTnews (for ease of reading, ARTnews is used throughout this essay) has been distinguished since early on by its commitment to the personalities of the contemporary art world—not just artists but dealers, collectors, museum directors, and curators—in its coverage of the visual arts. Portrait illustrations have always been integral to this coverage, used not only to make the subjects of articles tangible as individuals but also to show how they work. Indeed, numerous artists featured in ARTnews over the years have achieved recognition and then celebrity status at least in part because of what has appeared about them—including the photographs—in ARTnews. The exhibition Portrait of the Art World: A Century of ARTnews Photographs, which provides the context for this publication, celebrates the centenary of America's oldest art journal with a selection of one hundred of these portraits, some of the most memorable published in ARTnews during its first one hundred years.

Portrait photographs have been used as illustrations in ARTnews since 1904, and they have come from a variety of sources. Many have been commissioned by the magazine, but others have been supplied by art galleries, muse-

ums and other institutions, private collectors, the artists' dealers, the subjects of the articles themselves (or their families or friends or estates) as well as by picture services. All in all, thousands of likenesses have been reproduced in *ARTnews* over the past one hundred years, comprising a rich and compelling visual archive of the figures of the art world of the past century and beyond—and not only of the successful and famous but also of the once popular but now obscure. The historical and artistic significance of this material is as varied as the images are themselves: it may reside solely in the picture's subject, but sometimes the photographer is equally (or even more) important. Indeed portraits taken by some of the most illustrious names in the history of photography have appeared in *ARTnews*, including, for example, David Octavius Hill and Robert Adamson, Albert Sands Southworth and Josiah Johnson Hawes, Julia Margaret Cameron, Nadar, and other nineteenth-century masters, as well as Alfred Stieglitz, Edward Steichen, Paul Strand, Man Ray, Berenice Abbott, Aaron Siskind, Henri Cartier-Bresson, Arnold Newman, Nan Goldin, Duane Michals, Robert Mapplethorpe, Cindy Sherman, and Timothy Greenfield-Sanders, to name some of the more famous. Two photographers whose careers were closely identified with *ARTnews* for many years, Rudolph ("Rudy") Burckhardt and Hans Namuth, should be included in this panoply, for both were noted for the intimate, often highly spontaneous photographs they made of artists in their studios and at work. Their cameras photographed virtually every major figure of postwar American art, and their pictures were a regular feature—and one of the most enduring contributions—of *ARTnews* in the 1950s, 1960s, and later. Today, a century after its founding, *ARTnews* is still building and expanding on this remarkable legacy by continuing to illustrate each new issue with portraits taken by some of the most gifted talents in the field.

Portrait of the Art World: A Century of ARTnews Photographs is a collection of one hundred portrait photographs chosen from the thousands that have been published in *ARTnews*. However, a collection of one hundred images cannot pretend to represent adequately the contributions this magazine has made in the course of its century. At best, such a selection can merely suggest the appeal, variety, and import of the works that the magazine has published. Even so, in choosing the works to be included in

Portrait of the Art World, several criteria had to be applied: the significance of the subject; the significance of the photographer; the significance of that particular image within the overall history of *ARTnews*; the aesthetic effect of the picture; and, perhaps less obviously, the availability, quality, and condition of the original print—these were most important among the factors taken into account. (Original prints for a number of fine images that appeared in the magazine simply could not be obtained.) In the end, regardless of the reason for their inclusion, what all these pictures have in common is their relevance and importance as images in the context of *ARTnews*. Furthermore, while most of the photographs included here are more or less contemporary with the issue of the magazine in which they appeared, several are not, for although *ARTnews* has always emphasized current issues and practice, it has also reported on the past— from the recent moment back through the nineteenth century and on into antiquity. For the sake of visual coherence, however, the works in *Portrait of the Art World* have been deliberately confined to the twentieth century. For similar reasons, images from book reviews or supplied by the publishers were also excluded. Last, it is important to note that our goal has been to include primarily original works in *Portrait of the Art World*: either vintage prints made around the time the image was taken or prints newly made on appropriate materials directly from the original negative or transparency. Although many prints in this exhibition are from the *ARTnews* archive, some come from other sources. As this selection of work demonstrates, the aesthetic impact of a portrait is not dependent solely on the fidelity of the likeness or the artfulness of the pose. Those visual qualities of the image combine with the sensual qualities that are inherent in the partic- ular photographic medium—the physical materials of the print or transparency, its tonalities, its color, its warmth or coldness, its surface— to determine our immediate, intuitive reaction to the photograph. The closer the reproduction is to the photographer's intention, the more pro- found the viewer's response will be.

The important role that portraits assumed in *ARTnews* originated in an editorial decision to illustrate articles about figures in the art world with photographs. This was a highly innovative as well as an aggressively ambitious decision in 1904, when the technology of photomechanical repro-

duction was still new, imperfect, and expensive, so that photographic images were still a novelty even in prestigious magazines, much less modest newsletters. Once begun, however, the use of portraits in *ARTnews* grew steadily if intermittently over the next forty years. A change in owner-ship and editors in 1936 promised a new format for the magazine, with content directed less to the trade and more to the public, more emphasis on American art, and more photographs, but the restrictions and priorities resulting from World War II delayed much of what the new editor, Alfred Frankfurter, had hoped to implement when he took over the magazine. With the war's end, however, came a revitalized, modernized economy and a dynamic flowering of the visual arts in America, both of which contributed to the success of the expanded, reoriented, invigorated *ARTnews* that emerged after the war. For the next twenty-seven years, under the vital lead-ership of Frankfurter (1936–65) and his associate and eventual successor Thomas Hess (1965–72), *ARTnews* played a central role in bringing recognition and validation to a new generation of American artists, particularly the Abstract Expressionists as well as the Pop artists, promoting them and their work to international prominence. The photographic content of *ARTnews* increased dramatically beginning in 1945–46. Photographers were relying more on compact, high-quality, handheld cameras that used rolls of film rather than sheets and could be worked rapidly and unobtrusively. The result was a new approach to photographing artists. By the end of the 1940s *ARTnews* was publishing a regular series of articles on artists at work—"So and So Paints a Picture," ". . . Makes a Sculpture"—that incorporated sequences of action photographs of the artist creating the work described in the article. Hans Namuth's famous action shots of Jackson Pollock mak-ing one of his drip paintings (cat. 35) are the best known of these sequences, to the point of being *ARTnews*'s (as well as Namuth's) signature images. The importance of these sequences in popularizing and legitimiz-ing the art of what came to be known as the New York School from the late 1940s into the 1960s should not be underestimated.

The editorial policies of Milton Esterow, who became publisher and editor of *ARTnews* in 1972, have modernized the magazine, expanded its scope, addressed new audiences, and extended its purview to embrace art forms as diverse as architecture, performance art, film, video, new media,

and even photography, as well as investigative reporting. Now printed on high-quality glossy stock that maximizes the capabilities of modern printing technology, the magazine features brilliant color photographs in every issue in addition to the occasional crisply printed black-and-white image. *ARTnews* now profiles international artists and exhibitions in as much depth and as regularly as it does American artists and exhibitions, and it has made a consistent effort to acknowledge the contribution that women and minorities have made and are making, not only as artists but as collectors, scholars, dealers, curators, and arts administrators. Under Esterow, *ARTnews* has focused international attention on issues as troubling as looted art works and the repatriation of stolen art works and has influenced legislation in the United States and abroad regulating international traffic in such works. With all this, portrait photographs of leading artists, including the occasional photographer, routinely grace *ARTnews* covers, and they embellish any article that deals with a figure from the art world, whether from the past or present.

After one hundred years, *ARTnews* remains a vital force in the art world. It has undergone several transformations in its lifespan, each of which has enlarged as well as enriched its importance to the field. From the beginning, its editors have recognized the value of photographs as a way of making artists and their work accessible, therefore more meaningful to its readership, which has grown over the years from the small group that constituted the art trade in America in 1902 to an audience that includes both the interested public and arts professionals and spans continents. The use of portraits—whether specifically commissioned or otherwise acquired—has been a constant in the magazine's history since 1904, and it continues to bring relevance, immediacy, and human interest to a magazine now entering its second century.

Among the one hundred images in this selection several are especially noteworthy: Zaida Ben-Yusuf and Jessie Tarbox Beals received the first portrait commissions from *ARTnews* (then titled *American Art News*), in 1904. Whatever his motives, editor James Townsend's choice of two women to take the portraits illustrating a series of short biographical profiles of contemporary American artists was extraordinary as well as daring, for pro-

fessional photography at the turn of the century was a field still over-whelmingly dominated by men. Ben-Yusuf was considered at the time to be one of the best portrait artists in America by progressive male colleagues such as photographer and gallery owner Alfred Stieglitz and critic Sadikichi Hartmann, but she is obscure today. So little of her work survives that the eight portraits she made for *American Art News* (only three of which still exist as original prints) constitute the largest known group of her images. Ben-Yusuf's original platinum print portrait of Everett Shinn (cat. 5) epitomizes her skills as a photographer and printmaker: dramatically lit, evocatively posed, the image is perfectly expressed by the dark, velvety tones of the platinum paper. The aesthetic qualities of such a print, however, would have been difficult to reproduce or communicate using the relatively crude halftone printing technology of the period, which may well be why this image was never used. In contrast, her gelatin silver print of Daniel Chester French (cat. 2), though it undoubtedly compromised her aesthetic

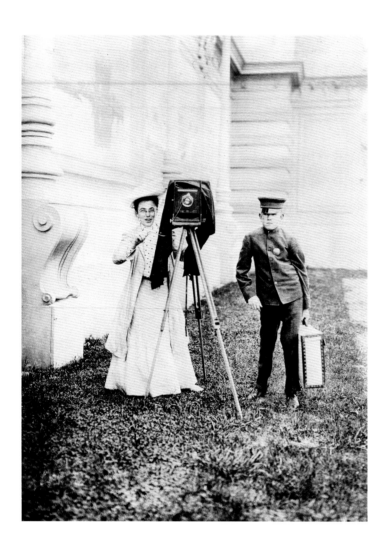

Fig. 11
Jessie Tarbox Beals
(1871–1942), self-portrait,
gelatin silver print, 1904.
National Portrait Gallery,
Smithsonian Institution;
gift of Joanna Sturm

standards, reproduced reasonably well. Jessie Tarbox Beals (fig. 11) worked primarily as a successful photojournalist throughout her career, and she had acquired a national reputation in that young but already difficult and competitive field—the first woman to do so—when Townsend hired her. Parenthetically, one of Beals's sitters for this commission was the only woman to be profiled by Townsend, Rhonda Holmes Nicholls, who thus became one of the few women artists to be recognized in *ARTnews* before the late 1940s. Like most of her male colleagues, Nicholls dressed formally for her portrait, choosing to be photographed in a fine fashionable

gown, bedecked in her jewelry. Until the late 1940s, the typical artist's portrait published in *ARTnews* portrayed him (the overwhelming majority were men) in business attire, wearing a suit and tie and often smoking a cigarette. In the American context, at least, depicting an artist in his or her working clothes became common only after World War II.

In spite of this promising start, however, the quality of the portraiture that appeared in the publication in the years immediately following was disappointing. Alice Boughton's portrait of the painter Albert Pinkham Ryder (cat. 4) that was used to illustrate his obituary in 1917 is one of the few exceptional portraits used in the teens. Actually taken in 1905, this tightly composed, dramatically lit, confrontationally posed head shot is a compelling likeness that stands out markedly from the unimaginative, conventionalized studio portraits that then predominated in *ARTnews*.

The powerful image of John Singer Sargent standing and glaring directly at the camera (cat. 8) is one of the most effective portraits to appear in *ARTnews* in the 1920s. Taken the summer before the artist's death by Henry Havelock Pierce, a noted New York society photographer of the period, this imposing, full standing figure was published with Sargent's front-page obituary in 1925. An equally fine but more tranquil likeness of the painter George Bellows, taken in 1924 by Alfred Cohn and now preserved in the *ARTnews* archives (cat. 9), may have been acquired to illustrate Bellows's obituary but possibly arrived too late to be used. Cohn had been a student at the Clarence White School of Photography, and this photograph of Bellows reveals the influence of the soft-focus, romantic Pictorialist aesthetic that was taught there. This image was never published, provoking speculation as to why a different and somewhat less interesting likeness by an unidentified photographer was used to illustrate Bellows's obituary in 1925 and why the original Cohn print survived while the other did not.

Like every other American periodical of 1929, *ARTnews* was seriously affected by the collapse of the stock market and the Great Depression, although—unlike many—it survived. A substantial drop in advertising and circulation led to a reduction in staff and a leaner paper, as well as a noticeable reduction in the number of illustrations—not just portraits— that appeared in each issue over the next decade. Even during this austere period, however, an interesting portrait occasionally graced the pages

The Art News, April 7, 1934

AS THEY ARE
"THE INTERPRETER"

"HENRY McBRIDE"
Photograph by Carl Van Vechten

Fig. 12

Henry McBride featured
in "As They Are," *The
Art News*, April 7, 1934.
Smithsonian
Institution Libraries

of *ARTnews*, usually in connection with the extended series of profiles of notable contemporary art world figures called "As They Are" that first appeared in 1934. Among these is the likeness of Henry McBride, one of the leading art critics of the time, by Carl Van Vechten (fig. 12), which appeared with McBride's "As They Are" profile subtitled "The Interpreter." Van Vechten was a popular novelist, critic, and social gadfly, as well as an ardent amateur photographer who used his miniature camera to collect the head of every celebrity of any kind that he met. He is best remembered for his documentation of the personalities of the Harlem Renaissance, but his social contacts included a wide variety of people, and he probably knew McBride. Van Vechten's technique was not especially refined and his work often seems harsh, but this likeness shows the photographer at his best: working up-close, with natural light, Van Vechten appears to have caught McBride unaware in a moment of introspection. The resulting portrait is a still (but not static), seemingly unforced, evocative portrait of a man of intellect who was one of the most important and prescient advocates of contemporary American art of his generation. It was a most appropriate image to illustrate an article extolling McBride's contributions to American art.

Alfred Frankfurter, a trained art historian with a preference for Renaissance art, who took over the magazine in 1936, committed himself from the beginning to rebuilding it, expanding its readership, and increasing its interest and relevance to a wider audience. In looking through issues of *ARTnews* from this period, it is apparent that part of Frankfurter's strategy to revitalize *ARTnews*, the circulation of which had shrunk to twelve hundred readers when he took over the publication, was to elevate and promote a high standard of photographic portraiture. Even though only six portraits appeared in the magazine between 1936 and 1940, they included a Gertrude Käsebier of Arthur B. Davies from the turn of the century, a

Man Ray of Pablo Picasso from 1922, and a very fine but unusual snapshot portrait of Picasso in a business suit taken in 1934 by the noted American art collector Albert E. Gallatin, who collected Picassos (cat. 11). The most contemporary portrait in this group, California photographer Max Yavno's circa 1938 portrait of the Japanese-American painter Yasuo Kuniyoshi (cat. 15), is an example of a more dynamic approach to portrait illustrations. Captioned "The artist in his studio: modern photographic version of a traditional, timely and symbolic theme, showing Yasuo Kuniyoshi before his easel," the photograph shows Kuniyoshi leaning against the wall at the left side of the image frame. Rather than standing at his canvas, as the title suggests, he is separated from it by the breadth of a wide glass window through which the facade of the building opposite—articulated by a regular pattern of Italianate windows and arches—serves as a backdrop. The image is neatly bisected by a bunched drape that hangs down the middle of the window, precisely balancing the artist against his creation. Yavno's photograph is thus a carefully constructed tableau, a still-life in which narrative content is completely subordinated to form and composition, and which therefore appeals to the eye even more than it describes the artist or his relation to his work. A similar aesthetic informs the group portrait of the Hanging Committee for the 113th Annual Exhibition at the National Academy of Design from 1938, published in 1942 (cat. 14). The photograph, taken by the Gray Photo Studio in New York, depicts nine nattily dressed, serious gentlemen artfully arrayed across a corner of the National Academy of Design's exhibition space and therefore across the image frame. It is a visually incongruous group: six of the men wear hats, all have on ties, and all but one are wearing their suit jackets. Four of the men also have on overcoats, including one of fur that reaches almost to the floor. On the left, two men are sitting in chairs and one is perched on a ladder in the background, forming a group that serves as a fulcrum upon which the remaining men, who are all standing, each carefully positioned in relation to the others, are grouped to achieve a rhythmically balanced but off-center composition. Not only are the men not looking at each other, but all except two are also looking away from the works of art on the wall (including one who seems to be pointing out a detail in one of the paintings), and no one seems to be looking at the same thing, much less in the

same direction. It is an extremely curious group, yet it is completely engaging, precisely because it is so obviously, self-consciously artificial and inherently nonnarrative.

The outbreak of World War II interrupted the progress of planned change for the magazine. For the duration, much of the editorial content was concerned with the role of the visual arts in the war effort, but even so, a gradually but steadily increasing number of quality portraits appeared in the magazine's pages. A 1943 article on Frank Crowninshield's collection of paintings by the French artist André Dunoyer de Segonzac featured a small reproduction of a portrait of Segonzac by Edward Steichen, at the time the most influential photographer in America because of the fashion and portrait work he did as the chief photographer for Condé Nast, publisher of *Vogue* and *Vanity Fair*. This Segonzac portrait was the only contemporary Steichen photograph ever published in *ARTnews*, and it was doubtless made available for the article only because Crowninshield was Condé Nast's art editor. (As a matter of interest, the photograph was published without a credit line to Steichen.) Cropped down to a bust, the likeness of Segonzac is a paradigm of a Steichen portrait of the late 1930s and early 1940s, when he used bright, almost harsh, stage lights to illuminate the figure from either side and from below to cast strong, dramatic shadows on the face. An equally fine, but less theatrical, portrait of Ralston Crawford by the Peter A. Juley & Son Studio (cat. 22) was also cropped to a tight head when it was used to illustrate Crawford's biographical profile in the "Art News Who's Who" series, a column Frankfurter initiated in 1944. Illuminated evenly with diffused studio light, the full composition is a three-quarter pose that shows Crawford, dressed in white trousers and a white neckless pullover, sitting in a simple chair, his hands crossed over his knees, which are also crossed. His body is turned slightly to one side, his head to the other. It is a simple yet compelling image. When it is cropped to the head (as the image was used), what strikes the viewer is the artist's handsomeness. Sadly, the suggestiveness of the slight slump of Crawford's shoulders and of his torso, the casual dash of his impeccable clothes, and above all the conventionalized manly gesture of the partially smoked cigarette he holds in one hand—all vital elements of the original composition—were lost to the magazine's readers. The origi-

nal photograph is an outstanding example of mid-twentieth-century American studio portraiture, and typical of the fine work produced by the Juleys, whose main business was making record photographs of artists' works for galleries, museums, and catalogues and other publications.

During this time Frankfurter also found exceptional new photographic talent. A portrait of the art dealer Dikran Kelekian published in 1944 (cat. 23) was one of the first photographs by Arnold Newman to appear in print. Now renowned as one of the great portrait photographers of the second half of the twentieth century, Newman is noted for his portraits of important artists. Although he was never a regular contributor to *ARTnews*, his photographs have occasionally appeared in later issues of the magazine, including an outstanding 1948 portrait of the young Nelson Rockefeller, then president of the Museum of Modern Art (cat. 32), and a poignant color portrait of the aged Bill Brandt, perhaps the greatest British photographer of the twentieth century (cat. 67), from Newman's series "The Great British," a project commissioned by the *London Sunday Times Magazine*.

In 1946, Frankfurter recruited Thomas B. Hess for the *ARTnews* editorial staff. With Frankfurter's support, Hess, a young, progressive, articulate critic, steered the magazine's shift in emphasis to the promotion of contemporary art, particularly in America. At the same time, *ARTnews* benefited from the improved, cheaper printing technologies that became available in the postwar years, along with the growing acceptance by picture editors of photographs made with the small-format cameras that were becoming popular with working photographers. In keeping with the magazine's drive to expand its audience and influence, portraits—along with other illustrations of all kinds—became vital components in its issues. Moreover, the portraits the magazine published became more varied at this time, both in terms of formal style and in approach to the genre—a reflection, perhaps, of the influence of the innovative images being produced by the new, postwar generation of photographers. The group portrait of eleven young Boston artists whom the 1947 reader was urged to "keep your eye on" (cat. 29) was posed by photographer John Brook in the galleries of Boston's Institute of Modern Art to create what the picture's caption described as "a

living abstraction." Although Brook's image recalls the photograph of the Hanging Committee of the 113th Annual Exhibition of the National Academy of Design, its composition was more probably inspired by the meticulously organized, balanced structure of the photographs by the young fashion photographer Irving Penn being featured in contemporary issues of *Vogue* magazine. In contrast to the self-conscious formality of Brook's photograph, the Collier & McCann portrait of John Marin (cat. 24) that was used in a review of his retrospective exhibition in Boston is an unposed likeness of the artist concentrating, not on his easel, but on his piano. In publication this image was tightly cropped, reducing it to a bust while eliminating any reference to the activity it actually documents in order to suggest the intensity of Marin's absorption in the process of painting. In yet another contrasting example, the likeness of László Moholy-Nagy, published just a few issues later (cat. 27), was almost certainly a publicity portrait supplied by the Institute of Design, the revival of the Bauhaus that Moholy-Nagy founded in Chicago in 1938. The unidentified cameraman who took the photograph neatly encapsulated Moholy-Nagy's influence on American art in a single, formally posed image: sitting in a chrome-and-leather Bauhaus chair, Moholy-Nagy faces the camera wearing a dark, tailored suit, holding a copy of *Look* magazine in his hands, while an abstract sculpture and two poster designs—both described as students' work—hang on the wall behind him. One of the founders of the Bauhaus in Germany and one of its major figures, Moholy-Nagy made seminal contributions to the modernist movement as an artist, writer, and teacher both in Germany in the 1920s and subsequently in the United States. Obviously a set piece, this photograph nonetheless describes and evokes both the man and the artist very effectively, from the prim propriety of his dress and personal appearance to the disciplined order of his aesthetics.

By the early 1950s, *ARTnews* had become an internationally influential advocate for contemporary American art, particularly for the school of New York painters known as the Abstract Expressionists. This was due in large part to the writers Hess recruited: influential critics such as Harold Rosenberg and Clement Greenberg, and articulate artists such as Larry Rivers, Ad Reinhardt, Alexander Liberman, and Elaine de Kooning. De Kooning,

in particular, was a regular contributor to *ARTnews* for a number of years, often reporting on studio visits with up-and-coming young artists as well as established ones. Photography, however, played an equally crucial role in this aggressive coverage, particularly through the ". . . Paints a Picture" series that was a regular feature of the magazine throughout the 1950s and into the mid 1960s. By making palpable the deliberation and process that went into the creation of nonfigurative works such as a drip painting by Jackson Pollock (fig. 13), the photographs played a crucial role in legitimizing abstract art and promoting the work of American artists. Undoubtedly the best-known photographs ever published in *ARTnews*—Hans Namuth's sequence showing Pollock working on the drip painting *Number Four, 1950* (cat. 35)—were in this series. These photographs, the first by Namuth used by the magazine (and subsequently published in *Life* magazine), established a popular image of Pollock at work that has come to acquire stereotypical force.

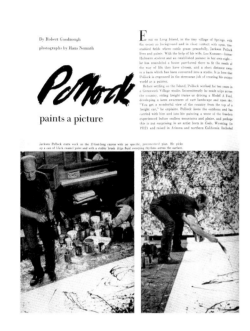

They became Namuth's signature work and initiated a long and creative relationship between *ARTnews* and the photographer that endured into the 1980s. Primarily because of the Pollock photographs, Namuth's reputation has overshadowed that of Rudolph Burckhardt, whose association with *ARTnews* coincides almost exactly with Namuth's. Indeed, Burckhardt was just as important in terms of both the number of his images that were published in the magazine and the contemporary (or eventual) reputations of his subjects. Namuth and Burckhardt had much in common. Both were Europeans whose first language was German— Namuth was German, Burckhardt Swiss. They both immigrated to the United States before World War II and became naturalized citizens. Both had a background in documentary photography and were familiar with the practices of European photojournalists. Both were filmmakers. In addition—and most important—both were comfortable with artists (Burckhardt was himself a talented painter) and counted artists—including many of those they photographed—among their friends. Burckhardt was Willem de Kooning's neighbor and a close friend of the Dutch-born

painter and his wife—and photographed both of them for the ". . . Paints a Picture" series. The rapport that Namuth and Burckhardt shared with their subjects enabled them to photograph spontaneously and unobtrusively, so that in the best of their work, the artist is either oblivious to the camera and fully engaged with his or her work or else responding not to the camera but to the familiar personality behind it. With some exceptions, this is true even for the formal portraits that Namuth and Burckhardt took for the magazine. But while Namuth and Burckhardt were responsible for most of the ". . . Paints a Picture" assignments, other photographers also contributed to the series, notably (and surprisingly) Robert Frank, whose photographs of the Abstract Expressionist painter Lester Johnson at work appeared in "Lester Johnson Paints a Picture" in 1961 (cat. 47). Johnson was only one of a number of the Abstract Expressionist painters Frank photographed during this period—as with Burckhardt, they were his neighbors and friends in New York City—but his pictures were the only photographs by Frank used by *ARTnews*. Portraiture is not a genre usually associated with Frank, but the arbitrarily framed, flat-toned, and grainy pictures of Johnson attacking his canvas are at least entirely consistent in style with the radical, antitraditional approach to documentary photography that characterized Frank's seminal photo-essay *The Americans*, the first American edition of which had been published just two years earlier, in 1959.

Other photographers whose work appeared in *ARTnews* in the 1950s and 1960s include Aaron Siskind, Cecil Beaton (see cat. 25), George Platt Lynes (see cat. 34), Robert Doisneau, Berenice Abbott (see cat. 31), Inge Morath, André Villers (see cat. 45), and Walter Rosenblum (see cat. 40), *Life* magazine photographers Nina Leen (see cat. 36) and Dean Loomis, and a host of others, many of whom—like Walter Silver, who took candid portraits of the New York School artists—are not well known today. The Siskinds are disappointingly conventional portraits, notable primarily because it is difficult to reconcile them with the bold, Abstract Expressionist–inspired abstract images for which Siskind was then becoming known. Siskind's photographs of the writer Clifford Odets, a major collector of the work of Paul Klee; Henry McBride, the important critic who been a longtime contributor to *ARTnews* (fig. 14); and a group portrait of painters Mark Rothko, Robert Motherwell, and Bradley Walker Tomlin, are not Siskind at his best.

Indeed, they are so atypical that one suspects the *ARTnews* editors of attempting to exploit Siskind's growing reputation as an artist. By contrast, Beaton's photograph of Gertrude Stein (cat. 25) is an unusual, poignant likeness of the poet and great art collector in old age, surrounded by pieces from her collection—and very unlike the flamboyant society portraits and fashion work for which Beaton was best known.

There seems to be a difference in tone between the portraiture published in *ARTnews* in the 1950s and in the 1960s, but if so, that difference is subtle, difficult to identify, and equally hard to articulate. It may have to do with the quality of revolutionary self-confidence and optimism that characterized American culture in the 1950s, an outgrowth of victory in World War II, America's economic recovery, and an overweening sense of superiority that went unchallenged until the Soviets' launch of Sputnik I in 1957. In the 1960s, the portraits seem to have assumed a more somber tone. In Robert Frank's 1959 photographs of Lester Johnson (cat. 47), the artist is shown working stripped to the waist, in most of the images seen only in part because the edges of Frank's aggressive image frames chop off or truncate Johnson's body. The disjunctive effect of Frank's technique psychologically mirrors the painter's aggressive assault on the canvas—it is disturbing but still invigorating. In contrast, Douglass Glass's portrait of the British painter Francis Bacon (cat. 54), while completely formal in its

conception and execution, is also disturbing—and somber and sober-ing. Glass posed Bacon, who is dressed casually but nattily in jeans with the cuffs rolled up and a clean, light-colored sweater with the sleeves pushed up to his elbows, in a corner of the painter's studio. The floor and every other horizontal surface is heaped with papers, books, empty cigarette packs, and other trash, and the walls are smeared with strokes of dark paint and decorated with two framed but indecipherable artworks. The contrast between the apparent serenity of the artist—haloed in pristine natural light, apparently lost in his thoughts, an Everyman of the present age—and the disorder of his surroundings is striking, suggesting that the dark vision of Bacon's art is, in fact, a detached response to the chaos that surrounds us in modern life.

Milton Esterow, who became editor and publisher of *ARTnews* in 1972 and has shepherded the magazine through the past three decades into the beginning of its second century in publication, has embraced a larger, more politically proactive vision of the magazine than his predecessors—and one that more closely reflects the complex, global nature of the present-day art world, our expanding acceptance of what constitutes art, and the belief that ethical issues as well as aesthetics are relevant to coverage of the arts. Under Esterow, *ARTnews* has become a graphically bolder magazine, visually more appealing and exciting, printed on better paper, incorporating

Fig. 15
Cover of June 1998
ARTnews featuring Kiki
Smith with *Garden
of Eden*, photographed by
Jason Schmidt, 1998.
ARTnews collection

Fig. 16
Cover of 1994 *ARTnews*
featuring a 1993
self-portrait of Richard
Avedon. Smithsonian
Institution Libraries

more photography and more and better color reproductions. *ARTnews* regularly features articles and reviews on the arts abroad—not just on the art scene in Europe but also on the non-European world. In the early twenty-first century, *ARTnews* is a more truly international and cosmopolitan magazine than ever before.

Under Esterow, *ARTnews* has continued to use photographs, particularly portraiture, as an integral component of its coverage. ". . . Paints a Picture" appears occasionally. Its scope has broadened to include installations, video, and even photography itself. Individual and sometimes group portrait photographs illustrate most of the magazine's articles. These are now largely in color, taken by photographers as varied in style and technique as Abe Frajndlich (see cats. 64, 84, and 88), Dirk Reinartz (see cats. 83 and 92), Jen Fong (cat. 100), Jason Schmidt (fig. 15), and even Thomas Ruff and Nan Goldin (see cat. 68)—to name but a few. Moreover, portrait photographs, which had been confined to the inside pages of the magazine until the November 1968 issue, are now used as the magazine's covers. One of the most striking examples of these cover portraits is Philippe Halsman's photograph of Salvador Dalí from 1944 (cat. 21): shot up-close in filter-distorted light, the image both personifies and caricatures Surrealism's last great—and probably most self-consciously notorious—practitioner. Among other especially noteworthy portrait covers are the straight self-portraits by the Japanese artist-photographer Yasumasa Morimura and the American artist-photographer Cindy Sherman (cat. 79) (both of whom have earned major international reputations by adopting other personae and modeling for their own art works), as well as a striking, overpainted black-and-white self-portrait by William Klein (cat. 91) and a self-portrait by Richard Avedon (fig. 16 and cat. 93), one of the most influential photographers of the post–World War II era. These portraits reflect a crucial shift that has occurred in the art world: the complete acceptance of photography as a fine art, and therefore the recognition of the photographer as a creative artist in his or her own right. As opposed to just thirty years ago, the covers and pages of today's *ARTnews* are as likely to feature a photographer or a video artist or even a filmmaker as they are to highlight a painter or sculptor.

Over the past three decades *ARTnews* has impartially publicized, and

therefore supported and promoted, the roles and contributions to the contemporary art scene of men and women of all ethnic origins and ages, whether as artists, art administrators, experts, or patrons. This has been accomplished in part through the photographic portraits that illustrate today's articles. As they have from the beginning, the portrait photographs gracing the pages of today's *ARTnews* make tangible in a direct, intuitive way what would otherwise be literary abstractions: they connect us one to one, not only to all those individuals who create the art that so powerfully expresses our contemporary culture, but also to all those who are mediators—in whatever way—between the artist and the public. They remind us that all art is human expression and, above all, that the world of the visual arts—now more than ever—is inclusive rather than exclusive.

ARTnews is now a century old, yet it is more vigorous than ever. Photography and photographic portraiture have vitalized the publication and ensured its continued relevance over the decades. Even as the publication has evolved and matured, so has photography, as a technology as well as a medium of visual expression. In the past, the magazine has certainly exploited and benefited from the expanded capabilities of photography. Now, photography is undergoing a technological revolution as profound as the invention of photography itself. What the eventual impact of this revolution will be is unknown, but whatever it is, there is no doubt that whoever is editor of *ARTnews* will adapt it to the fulfillment of the magazine's mission —to bring news about the visual arts to contemporary practitioners, other professionals in the field, and the interested public. That *ARTnews* has survived its first century thriving is a testament to its validity as a concept, the relevance of its content, and—yes—the effectiveness of portraiture as a means of nonverbal communication.

Authors

TA Tracey L. Avant

FG Frank H. Goodyear III

SL Sarah A. Loffman

TM Tess Mann

AS Ann Shumard

KS Kristin Smith

WS William Stapp

A Century of ARTnews Photographs

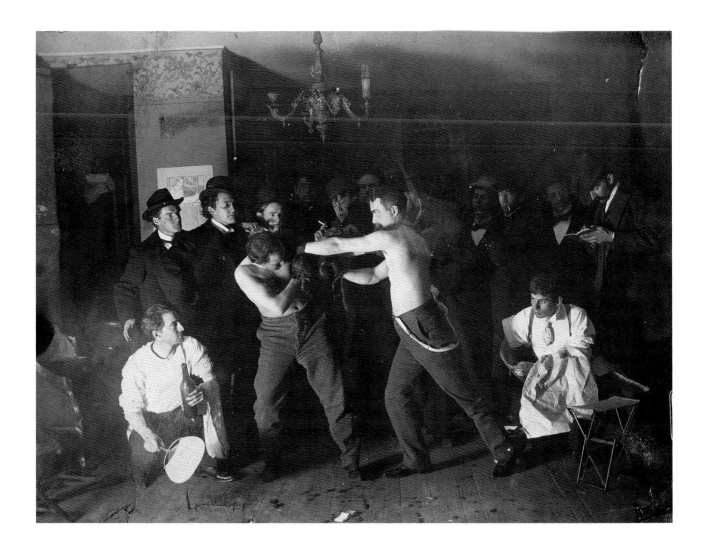

1

Unidentified artist
Gelatin silver print, c. 1895
Published November 1954
John Sloan Archives,
Delaware Art Museum

A Boxing Scene: John Sloan's Studio

Before they achieved national prominence as part of the Ashcan School, John
Sloan, George Luks, William Glackens, and Everett Shinn worked as newspaper
illustrators in Philadelphia. There they became good friends, often working
in the same office and spending evenings together. This photograph features a
mock boxing match that took place one evening at Sloan's studio. Luks is
the boxer on the left, Shinn is directly behind him, and Sloan stands beside Shinn
in derby and pince-nez. Each artist became well known for work that rejected
the tradition of aestheticism—or art for art's sake—that prevailed in turn-of-the-
century America. By incorporating this photograph in a later tribute to the
Ashcan School, *ARTnews* was deliberately evoking the movement's reputation
for irreverence and masculine rebellion. —FG

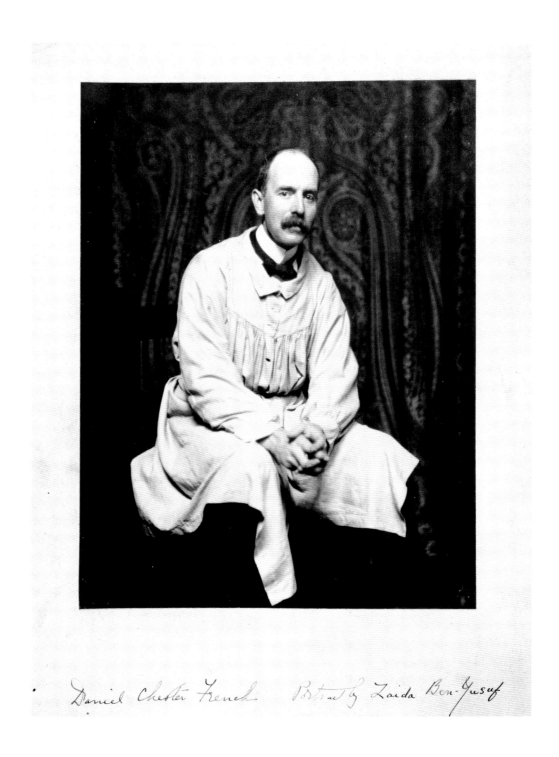

Daniel Chester French *Portrait by Zaida Ben-Yusuf*

2

Zaida Ben-Yusuf (active 1896–1915)
Gelatin silver print, 1905
Published October 21, 1905
ARTnews Collection

Daniel Chester French (1850–1931)

By 1905, when this picture appeared, Daniel Chester French, who was largely self-taught, had established himself as the leading American sculptor of his generation. His first major commissions included the *Minute Man* monument in Concord, Massachusetts (1871–75), and the statue of John Harvard in Harvard Yard, Cambridge (1883–84). Much of French's work incorporates allegorical figures and themes, but he remains best known for his humanistic portrayal of Abraham Lincoln for the Lincoln Memorial in Washington, D.C. —TM

3

Jessie Tarbox Beals (1870–1942)
Gelatin silver print, 1905
Published December 16, 1905
ARTnews Collection

George W. Maynard (1843–1923)

George W. Maynard was a respected American painter whose work, according to *American Art News*, "was characterized by originality of conception, strong and correct drawing, and good color." Having assisted John La Farge on the decorative murals in Boston's Trinity Church as a young man, Maynard went on to make a reputation for himself in this artistic genre. His award-winning mural program on the exterior of the Agricultural Building at the Chicago World's Fair in 1893 was considered one of his most important achievements. Jessie Tarbox Beals, a young newspaper photographer who had recently arrived in New York City, created Maynard's portrait. This image was the first in what became a significant series of artist portraits by Beals that *American Art News* published in 1905–6. Because of this and other projects, Beals had become one of the first female photographers in America to gain a national reputation. —FG

Alice Boughton (1865–1943)
Gelatin silver print, 1905
Published March 31, 1917
National Portrait Gallery,
Smithsonian Institution

Albert Pinkham Ryder (1847–1917)

When Albert Pinkham Ryder died at the age of seventy, *ARTnews* noted his passing
with the observation that "Ryder was considered by the cognoscenti as one of
the ablest and strongest of modern American painters." While to some degree the
pastoral scenes of his early career reflected the traditions of both European and
American painting, Ryder's art became increasingly original in both style and con-
tent as he matured. His subject matter grew to embrace literary, religious, and
imaginative themes that he distilled in evocative paintings informed by a deeply per-
sonal vision. Ryder's radical simplification of form and space resonated with a
younger generation of avant-garde artists, who acknowledged him as a prophet of
modernism by including ten of his paintings in the Armory Show of 1913. Alice
Boughton photographed Ryder at the suggestion of artist Arthur B. Davies, who was
later one of the Armory Show's organizers. —AS

5

Zaida Ben-Yusuf (active 1896–1915)
Platinum print, c. 1905
Not published
ARTnews Collection

Everett Shinn (1876–1953)

Everett Shinn became widely known as one of "The Eight"—that group of American artists who first exhibited together at New York's Macbeth Gallery in 1908. United by a common interest in urban realism and a disdain for the conservative policies of the National Academy of Design, these painters challenged the art establishment. Shinn began as a newspaper illustrator for the *Philadelphia Press*. Drawing noteworthy events in the life of a city shaped his later artistic direction. He became especially fascinated by popular theater and represented this subject in a variety of artistic mediums. Here Shinn poses before the camera of Zaida Ben-Yusuf, a respected portraitist whose Fifth Avenue studio in New York attracted much attention. Beginning in the fall of 1905, *American Art News* published a number of her photographic portraits of prominent artists. —FG

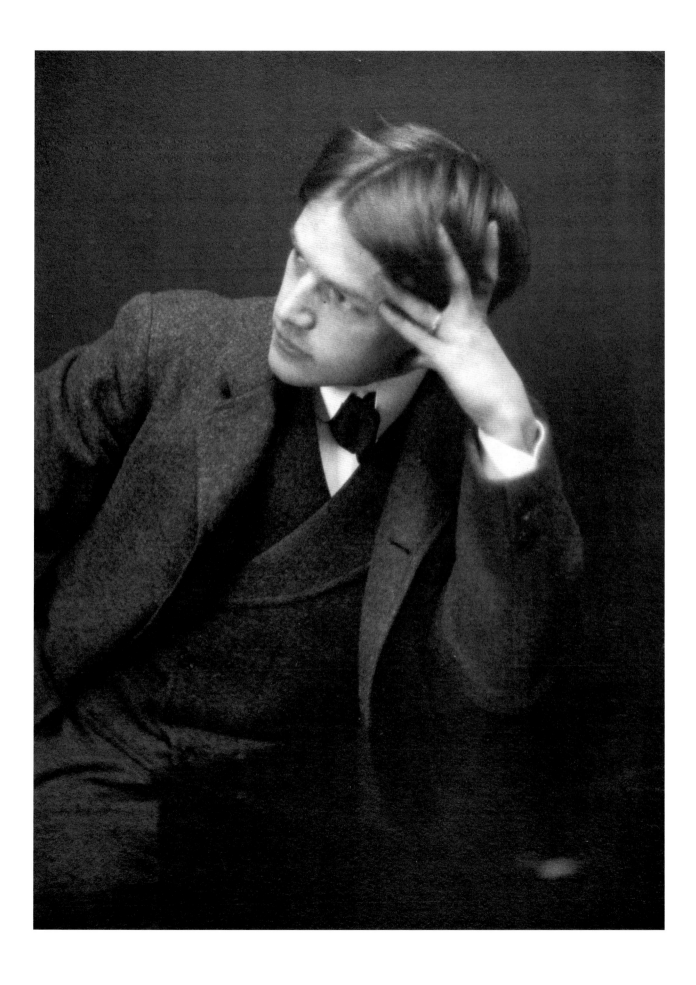

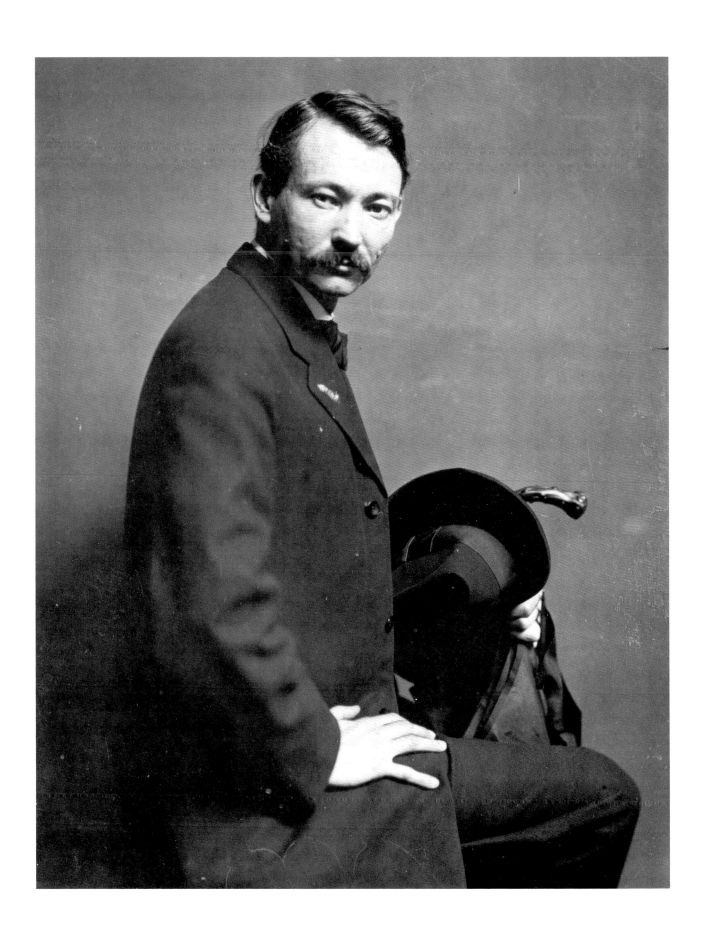

6

Gertrude Käsebier (1852–1934)
Platinum print, 1907
Published December 1982
Delaware Art Museum; gift of
Helen Farr Sloan, 1978

Robert Henri (1865–1929)

By 1907, the year of this portrait by Gertrude Käsebier, Robert Henri was recognized as one of the most forceful personalities on the American art scene. His much-heralded classes at the New York School of Art attracted many promising young artists, including Edward Hopper, George Bellows, and Rockwell Kent. As *ARTnews* proclaimed in a later tribute, Henri "led his pupils away from idyllic landscapes, mid-Victorian interiors and still life in order to open their eyes—and minds—to the life about them. He insisted that no spot on God's green or soot-stained earth was forbidden subject matter." His emphasis on painting from real life in a loose, gestural style won him praise initially from the period's leading American art institutions. His progressive vision, however, was not uniformly embraced. In evaluating entries for the prestigious annual exhibition at the National Academy of Design in 1907, a conservative contingent of jurors balked at the work of Henri's peers. In response, Henri withdrew his own paintings from the exhibition and organized a group show at New York's Macbeth Gallery. Entitled *The Eight*, after the number of participants, this exhibition represented the first public collaboration among a group of artists who later became known as the Ashcan School. —FG

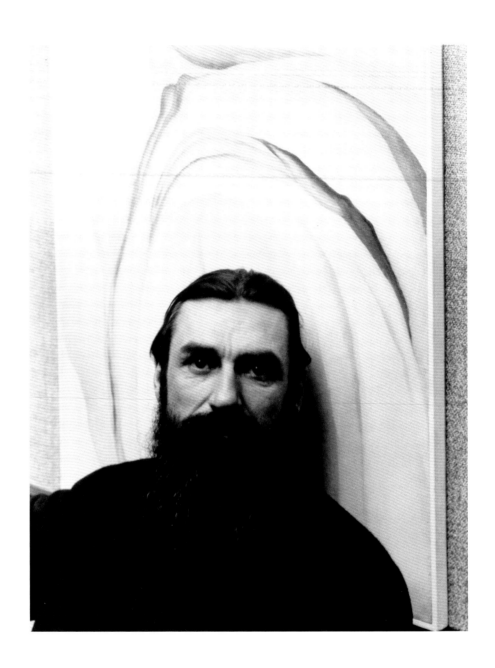

Alfred Stieglitz (1864–1946)
Platinum print, 1921
Published April 1953
Philadelphia Museum of Art;
the Alfred Stieglitz Collection, 1949

Arthur B. Carles (1882–1952)

Described in *ARTnews* on his death as "undoubtedly one of the great colorists of the
American School," Arthur B. Carles poses here for photographer Alfred Stieglitz
on the occasion of a 1921 exhibition at the Pennsylvania Academy of the Fine Arts.
The two men were close friends, Stieglitz's famous 291 gallery having been the
first to present Carles's Fauvist-inspired abstract paintings after he returned in 1910
from study in Europe. At the time of this photograph Carles held a teaching post
at the Pennsylvania Academy and a reputation for his bohemian temperament and
appearance. A painting by fellow modernist Georgia O'Keeffe serves as a backdrop
for this evocative portrait. —FG

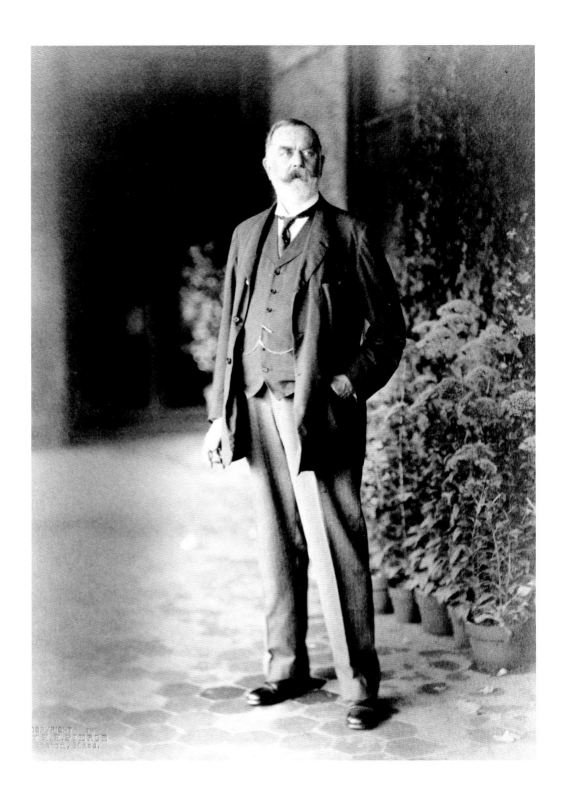

Henry Havelock Pierce (1875–?)
Gelatin silver print, 1924
Published April 18, 1925
Private collection

John Singer Sargent (1856–1925)

"The Art News is able to present to its readers this last photograph," read the caption for this portrait of the American painter John Singer Sargent, which appeared with Sargent's obituary in April 1925. Sargent, the article explained, was not fond of having his photograph taken but had agreed to a formal session with Henry Havelock Pierce the summer before his death. Celebrated for his scandalous portrait of Madame Pierre Gautreau, better known as *Madame X*, Sargent perfected a style that was characteristically sensuous as well as stately. Pierce's photograph emulates the more aristocratic qualities of Sargent's subjects, borrowing a pose familiar from many of Sargent's portraits. —TM

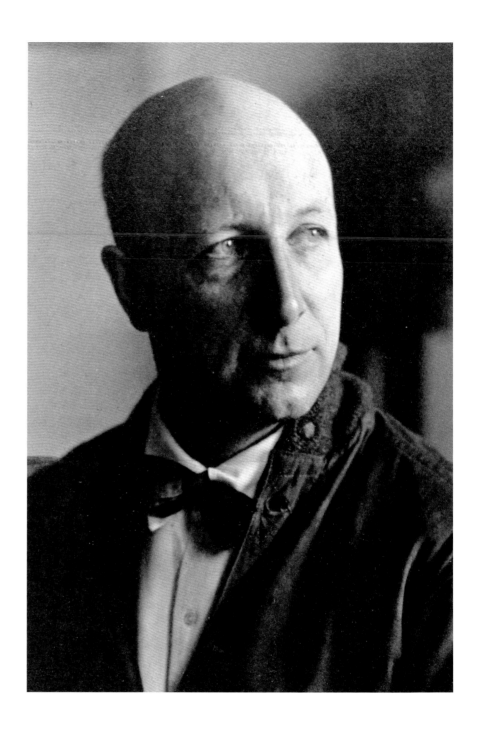

9

Alfred Cohn (1897–1972)
Gelatin silver print, 1924
Not published
ARTnews Collection

George W. Bellows (1882–1925)

In its memorial tribute to George W. Bellows in 1925, *ARTnews* proclaimed, "America has lost perhaps her most vigorous and forthright painter, . . . [a man] in whose work the stalk, roots, and fibre of America found a sincere and inspired expression." Born in Ohio, Bellows moved to New York City in 1904, seeking work as a commercial illustrator. Inspired by the teaching of painter Robert Henri, however, he redirected his focus and devoted himself to painting and lithography. Like Henri, Bellows was enthralled by the bustling city. His depictions of crowded neighborhoods, giant construction projects, and, most famously, fierce boxing matches at Sharkey's club-saloon reflect his interest in the tremendous sense of movement and change that characterized the metropolis. This portrait of Bellows by New York photographer Alfred Cohn was taken in 1924, only a year before Bellows's death at age forty-two from appendicitis. —FG

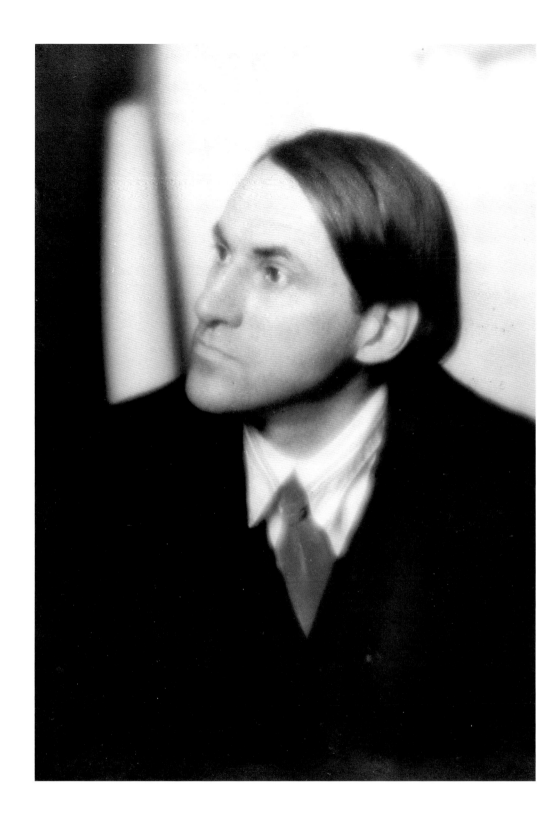

Serge Charchoune (1888–1975)

Although he was a friend and contemporary of Man Ray and Marcel Duchamp, Serge
Charchoune's reluctance to associate too closely with any one group contributed
to his prolonged relative obscurity. *ARTnews* "introduced" Charchoune to a general
public in 1960, the year of his first solo exhibition in the United States. Man Ray
took this portrait in 1925 shortly after Charchoune's break with Dadaism. Put off by
the political elements of the Dadaist movement, Charchoune pursued an unapolo-
getically ornamental style of abstract painting influenced by Spanish-Moorish art
and the icons of his native Russia. —TM

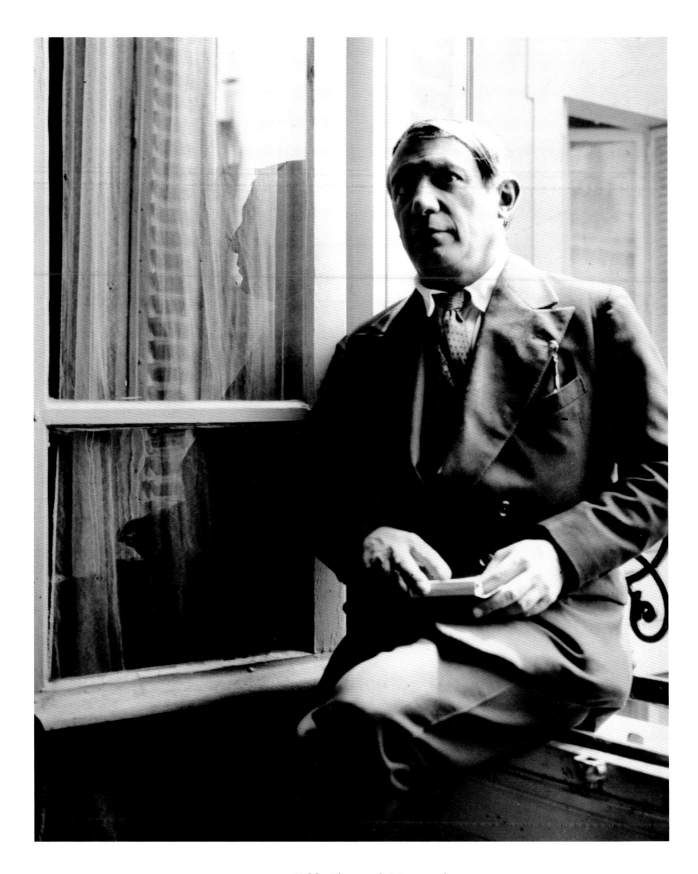

Albert E. Gallatin (1881/82?–1952)
Gelatin silver print, 1934
Published November 18, 1939
ARTnews Collection

Pablo Picasso (1881–1973)

Perhaps best described by *ARTnews* as "creativity personified," Spanish-born Pablo Picasso was arguably the most influential artist of the twentieth century and the central figure in the development of Cubism. Although his work *Les Demoiselles d'Avignon* (1907) was not publicly seen until 1937, it is considered the most revolutionary painting of his career and the true beginning of Cubism. Surrealist artist and champion of modern art Roland Penrose once declared that chiefly because of Picasso, "the conception of art as a powerful emotional medium, rather than a speech for the perfection of ideal forms of beauty, has become accepted among the artists of our time." —TA

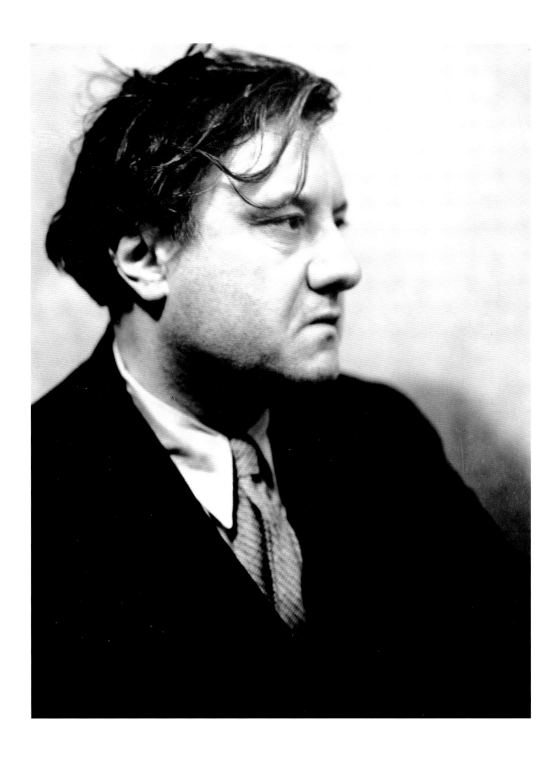

Soichi Sunami (1885–1971)
Gelatin silver print, c. 1934
Published January 1947
ARTnews Collection

Gaston Lachaise (1882–1935)

Born in Paris, artistic prodigy Gaston Lachaise was using his father's woodworking tools to make carvings before he was old enough to attend school. He excelled in his studies and was headed for an accomplished career in France when he met and fell in love with Isabel Dutaud Nagle, who was visiting from America. Lachaise soon gave up his place at the Académie Nationale des Beaux-Arts to earn money and in 1906 moved to Boston to be with Nagle. Called by *ARTnews* the "greatest American sculptor of his time," Lachaise split his time between creating incomparable portrait sculpture and creating sculpture that reflected his vision of the archetypal form of women. Using Isabel as inspiration and model, Lachaise created pieces whose sexuality and erotic presence pushed the boundaries of nude figuration. —TA

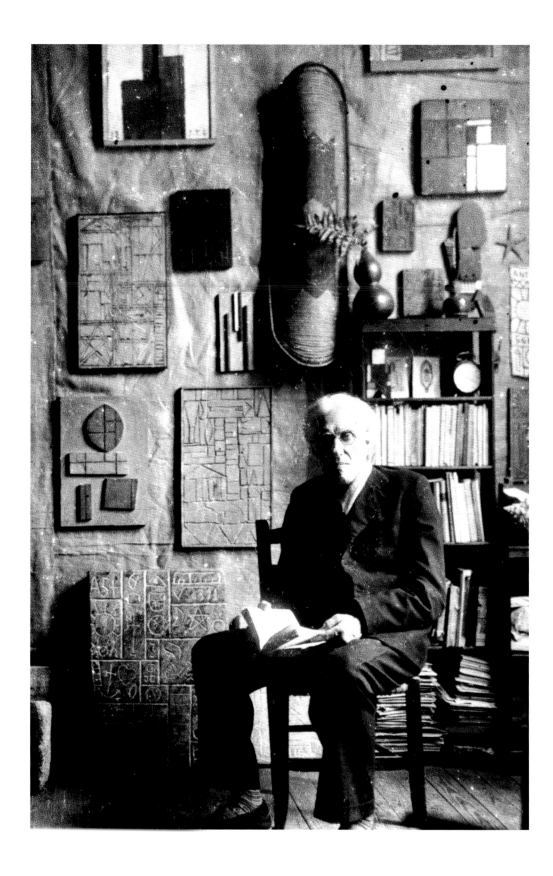

Unidentified photographer
Gelatin silver print, 1937
Published March 1960
ARTnews Collection

Joaquín Torres-García (1874–1949)

"Structure means recognition that unity is at the foundation of everything. To say
structure is also to say *Abstraction*: geometry, rhythm, proportion, lines, planes, idea
of object. These are elements of work—they act, they form, they construct and gain
significance through the law of unity." These are words Joaquín Torres-García used
to explain Humanistic Constructivism, the abstract geometrical style he is credited
with developing. Torres-García, born in Montevideo, Uruguay, and raised in Spain,
returned to his birthplace after an absence of forty-three years and became the
leading modernist in South America. His style of art helped lay the groundwork for
the Arte Concreto-Invención—an avant-garde movement that emerged in
Argentina in the mid-1940s. —TA

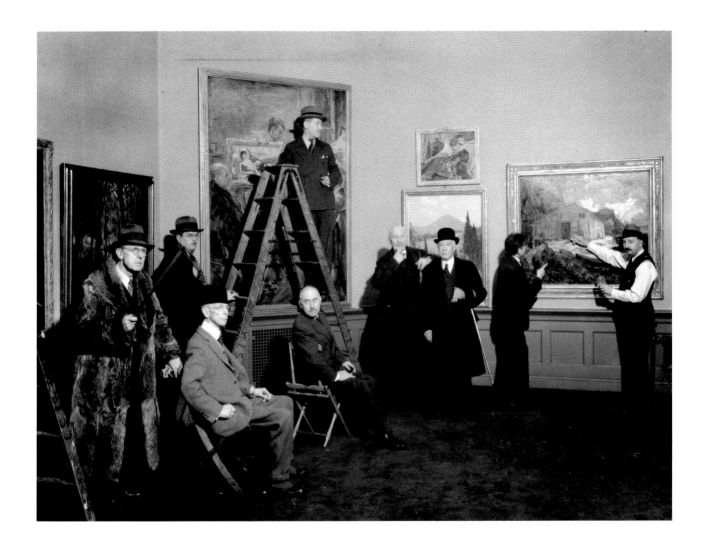

Gray Photo Studio (active 1938)
Gelatin silver print, 1938
Published January 1942
ARTnews Collection

Hanging Committee for the 113th Annual Exhibition, 1938, National Academy of Design

This photograph features representatives of the National Academy of Design's Hanging Committee—the group responsible for selecting and hanging works for its annual juried exhibition. Founded in New York City in 1825 as both an art school and an exhibition space for contemporary artists, the National Academy of Design earned over time a reputation for its conservative taste. Though a 1942 tribute in *ARTnews* proclaimed the institution "an essential vertebra in America's artistic backbone," the academy's annual exhibition was renowned for "taking in the new only after it has been thoroughly tested." This philosophy often alienated young artists and led many to criticize in particular the Hanging Committee. —FG

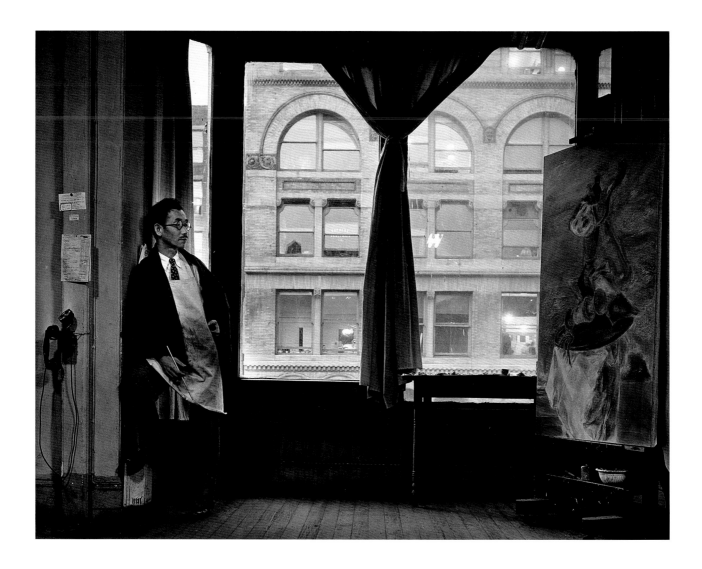

15

Max Yavno (1911–1985)
Gelatin silver print, c. 1938
Published November 23, 1940
Center for Creative Photography,
The University of Arizona, Tucson
© 1998 Center for Creative Photography,
The University of Arizona Foundation

Yasuo Kuniyoshi (1893–1953)

Yasuo Kuniyoshi's early work often combined styles and themes—Eastern and Western, fantasy and humor—in a unique and personal iconography of children, cows, and insects. Kuniyoshi is better known for his later work, principally paintings of women. This photograph appeared in conjunction with an editorial on Art Week, a festival started by President Franklin Roosevelt in 1940. These cross-country art shows featuring reasonably priced works of art were aimed at increasing the visibility of American artists and the affordability of fine art for the masses. Kuniyoshi supported the program and often sold his work on an installment plan that allowed people of average means to purchase it. Equally interested in promoting the rights of artists, Kuniyoshi founded and became the first president of the Artists Equity Association in 1947. —TA

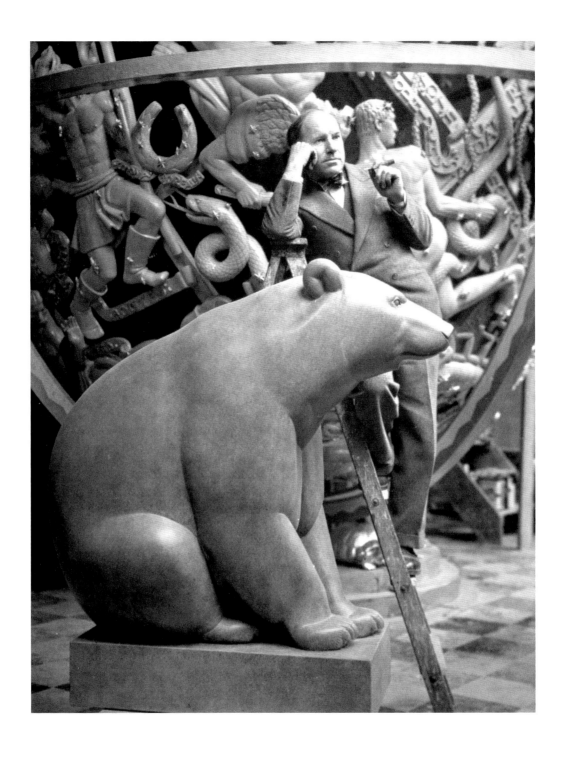

Walter J. Russell (lifedates unknown)
Gelatin silver print, c. 1939
Not published
ARTnews Collection

Paul Manship (1885–1966)

For more than fifty years, Paul Manship enjoyed an international reputation as one of the finest American sculptors. Awarded the prestigious Prix de Rome in 1909 at age twenty-four, Manship completed a number of highly visible public commissions in his long career. His *Prometheus Fountain* at New York's Rockefeller Center and his work for the 1939 New York World's Fair are among his best-known projects. In this photograph Manship poses in his studio behind a marble bear and in front of another his famous commissions, the *Celestial Sphere* in honor of Woodrow Wilson. Ultimately destined for a location in front of the European offices of the United Nations in Geneva, this monumental sphere combines Manship's interest in Greek classicism with his dedication to the high modernist aesthetic. —FG

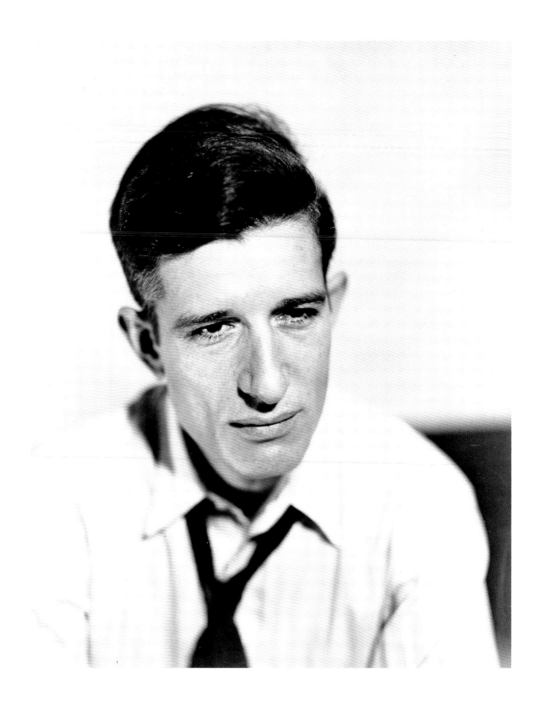

17

Unidentified photographer
Gelatin silver print, c. 1940
Published October 1963
National Portrait Gallery, Smithsonian Institution;
gift of Marcella Brenner

Morris Louis (1912–1962)

Morris Louis created abstract paintings that *ARTnews* characterized as "rivers of color." Combining the control of color-field painter Helen Frankenthaler and the spontaneity of action painter Jackson Pollock, Louis often poured paint in directed streams onto his canvases. As *ARTnews* reported, "To him, it did not matter if the color ran down for a mile or a foot but it *did* matter that the color (not the paint) impregnated the canvas, that the two were physically unified." His stated goal was to "convert physical paint into stabbing light." Though he worked outside Washington, D.C., in relative obscurity during much of his career, Louis began to gain wider acclaim toward the end of his life. This undated photograph came from the collection of Louis's widow, Marcella Louis Brenner. —FG

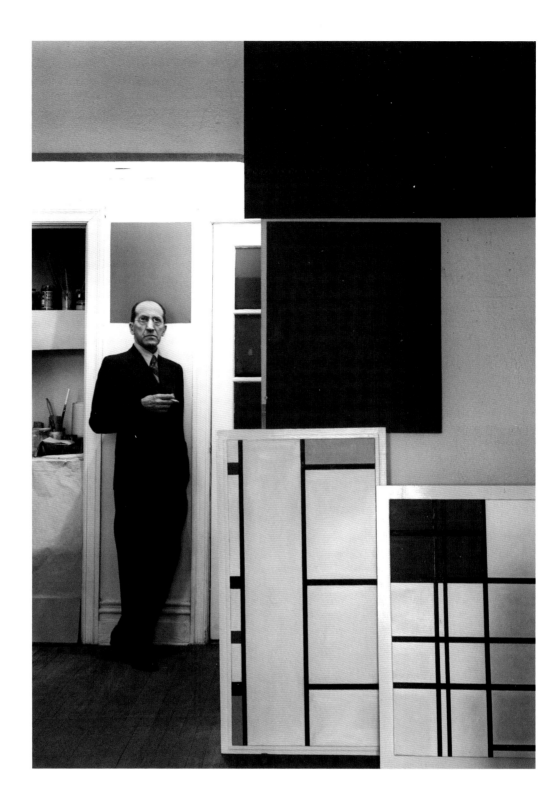

18

Arnold Newman (born 1918)
Gelatin silver print, 1941/42
Published October 1963
Arnold Newman
©Arnold Newman/Getty Images

Piet Mondrian (1872–1944)

Dutch painter Piet Mondrian, influenced by the theories of Dutch philosopher
M. J. H. Schoenmaekers—who believed that the orthogonal opposition of horizon-
tal and vertical lines and the three primary colors of red, yellow, and blue held
cosmic significance—created the geometrical abstract style known as Neoplasticism
in 1921. First published in 1963, the photograph appeared again in 1996, in con-
junction with a letter Newman wrote recalling a pivotal meeting between the two
artists in 1941. Newman, then twenty-four, had approached Mondrian asking to
photograph him for an experimental photography project. The painter not only
acquiesced but, as a gift of appreciation for Newman's portraits, made him two
drawings. It is generally accepted that one of these drawings became the predecessor
and catalyst for Mondrian's masterpiece *Broadway Boogie Woogie* (1942–43). —TA

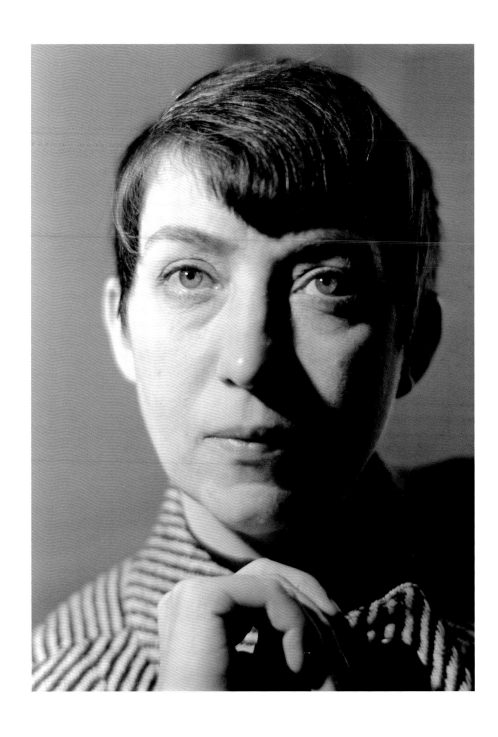

19

Lotte Jacobi (1896–1990)
Gelatin silver print, c. 1943
Published October 1980
The Art Gallery and the Lotte Jacobi Archives,
University of New Hampshire

Berenice Abbott (1898–1991)

The question was put to readers in the October 1980 issue of *ARTnews*: "Are Women Better Photographers than Men?" Decades earlier, Berenice Abbott had already answered the question, "I'm not a woman photographer; I'm a photographer." In Lotte Jacobi's portrait, we are confronted by Abbott, best known for her penetrating portraits of Parisian literati in the twenties and her documentation of New York City in the thirties. Abbott took seriously the potential of her medium to capture more than mere formal values. Proving herself by consistently rising to that challenge, she once remarked that if photography "is representational by nature of the realistic image formed by a lens . . . we should take hold of that very quality, make use of it, and explore it to its fullest." —KS

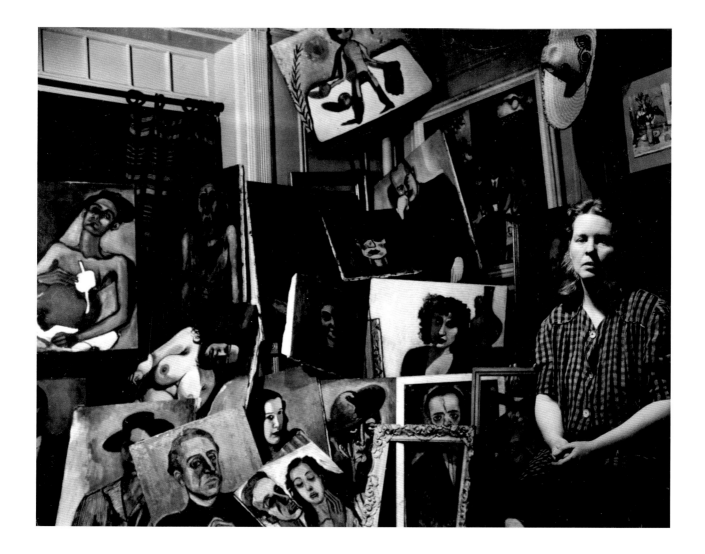

Sam Brody (1907–1985)
Gelatin silver print, 1944
Published October 1962
ARTnews Collection

Alice Neel (1900–1984)

ARTnews's article "Introducing the Portraits of Alice Neel" represented the first major feature written about the sixty-two-year-old artist. Best known for her paintings of the "human creature"—she disliked the term "portrait"—Neel had by 1962 spent thirty-five years working as an artist in New York City. In paintings such as *T.B. Harlem*, pictured on an easel to the left in this 1944 photograph by her partner, Sam Brody, Neel reveals her characteristically strong social conscience. Her depiction of this young Puerto Rican man recovering from surgery for tuberculosis conveys an empathy that was ever-present in her work. Although Neel lacked recognition during much of her early career, her expressionistic compositions were increasingly embraced beginning in the 1960s. —FG

21

Philippe Halsman (1906–1979)
Gelatin silver print, 1944
Published December 2000
Halsman Archive
© Halsman Estate

Salvador Dalí (1904–1989)

Philippe Halsman described his friendship with Spanish painter Salvador Dalí as a thirty-year collaboration. Halsman tried to elicit spontaneous behavior from all his models, but the Surrealist painter required no such prompting. From their first session in 1941, they discovered a shared interest in the unconscious mind and the potential of photography to reveal its depths. Over the next thirty years Dalí proved a willing accomplice for numerous suitably surreal photographs. —TM

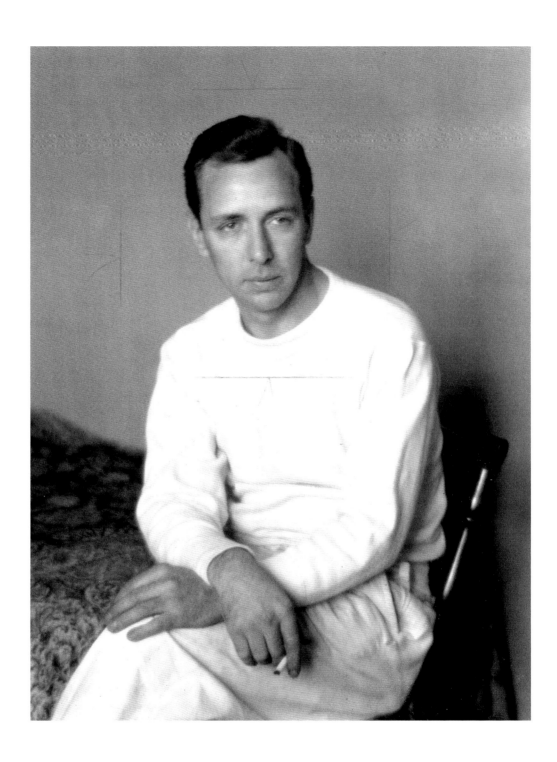

Peter A. Juley & Son (active 1896–1975)
Gelatin silver print, c. 1944
Published January 15, 1944
ARTnews Collection

Ralston Crawford (1906–1978)

From working as an illustrator in the studio of Walt Disney to sailing on freighters, Ralston Crawford followed many paths. World War II found him in the service of the U.S. Army Air Force, Weather Division, at the same time that he was enjoying success as a painter. In 1944 his charts of weather fronts hung side by side with his Precisionist and semiabstract work in a one-man show at New York's Downtown Gallery. —TM

23

Arnold Newman (born 1918)
Gelatin silver print, c. 1944
Published October 15, 1944
Arnold Newman
© Arnold Newman/Getty Images

Dikran Kelekian (1868–1951)

Considered the "dean of antiquities" among New York art dealers during his life-time, Dikran Kelekian was largely responsible for forming the Coptic, Early Christian, and Classical collections of Henry Walters (later founder of the Walters Art Museum in Baltimore) and the Gothic collection of financier and Metropolitan Museum of Art president George Blumenthal. This image represented one of twenty portraits of Kelekian that appeared in a 1944 Durand-Ruel Gallery exhibit honoring the dealer. Born in modern-day Turkey, Kelekian began his career in Constantinople, opened a gallery in Paris in 1891, and moved to New York shortly after the 1893 Chicago World's Fair. He was equally well known as an early champion of modern art—collecting and promoting such artists as Henri Matisse, André Derain, and Pablo Picasso by 1900. —TA

Collier & McCann (active 1946)
Gelatin silver print, 1946
Published January 1947
ARTnews Collection

John Marin (1870–1953)

Recognized as the greatest American watercolorist since Winslow Homer, John Marin enjoyed widespread acclaim at the close of his life. *ARTnews* published this portrait of the seventy-six-year-old artist to accompany a review of a 1947 retrospective at Boston's Institute of Modern Art. Pictured playing the piano at his seaside cottage in Cape Split, Maine, Marin projects a melancholy air. Despite the public recognition—one year after this exhibition a *Look* magazine survey named him the foremost American painter—Marin was saddened by a number of personal tragedies. Both his wife, Marie, and his longtime friend Alfred Stieglitz had died within a year of this portrait. In subsequent months, Marin and Georgia O'Keeffe worked to keep open Stieglitz's gallery, An American Place; however, this effort was ultimately aborted. —FG

Cecil Beaton (1904–1980)
Gelatin silver print, 1946
Published February 1951
Cecil Beaton Archives, Sotheby's, London
© Cecil Beaton Archives

Gertrude Stein (1874–1946)

In his *ARTnews* review of Yale's 1951 commemorative exhibition on writer Gertrude Stein and her celebrated collection, famed art critic Henry McBride praised the American expatriate as unique among collectors because she "collected geniuses rather than masterpieces." He continued, however, that her collection was "notable more for early discernment than for final achievement." In 1903, Stein joined her brother, Leo, in Paris, after abandoning a four-year study of brain anatomy at Johns Hopkins University Medical School. Collecting the works of Cézanne, Renoir, Rousseau, Gauguin, Matisse, and Picasso before they had gained international acceptance, the siblings soon found themselves at the center of one of the most important salons in Paris. Stein occasionally became the subject for artists, as seen in the painting by Francis Picabia that hangs above her head in this photograph by Cecil Beaton, which accompanied McBride's review. Stylistically dissimilar from his usual glamorous fashion photography, Beaton captured, with great sensitivity, a subdued and reflective Stein just months before her death in 1946. —TA

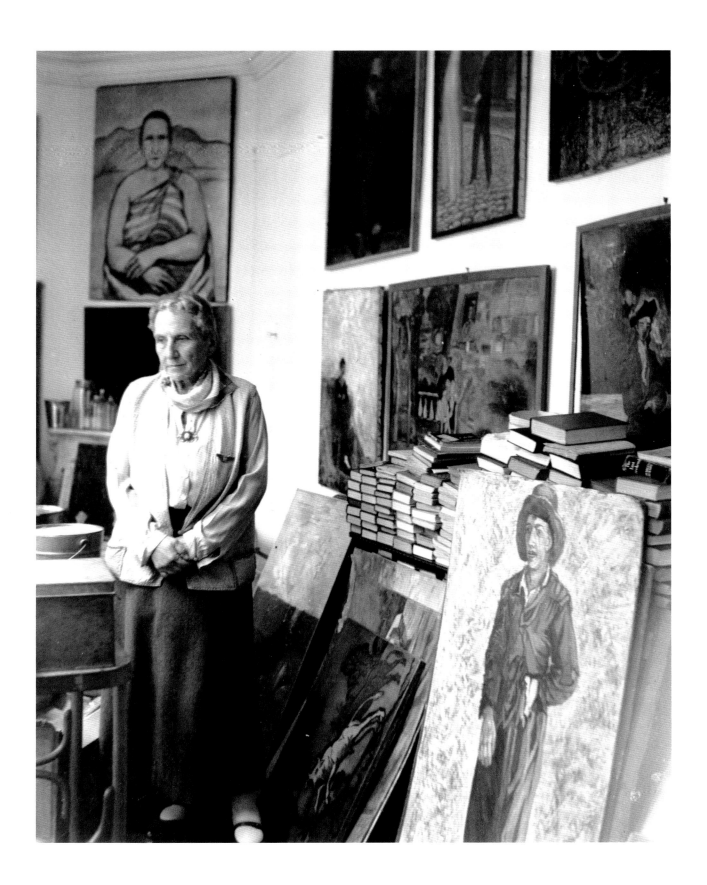

Wayne F. Miller (born 1918)
Gelatin silver print, 1946
Published October 1954
ARTnews Collection
© Wayne Miller/Magnum Photos

Constantin Brancusi (1876–1957)

When *ARTnews* took its readers inside Romanian-born sculptor Constantin Brancusi's Parisian home and studio in 1954, it was like entering an alternate dimension. Like his art, his home was clean, simple, and seemed to emanate light. Writer George Duthuit was enthralled by this artist who seemed without precedents, influenced more by philosophers like Lao-tzu and Confucius than by other sculptors. Duthuit was there for the unveiling of Brancusi's latest masterpiece, *The Bird*, a marble piece with clean lines that captures the energy of a bird in flight. Captivated by his surroundings and Brancusi's spiritual vision, Duthuit exclaimed, "We still belong, perhaps, to this world, but last minute neo-converts, we have the impression that we have left it." —SL

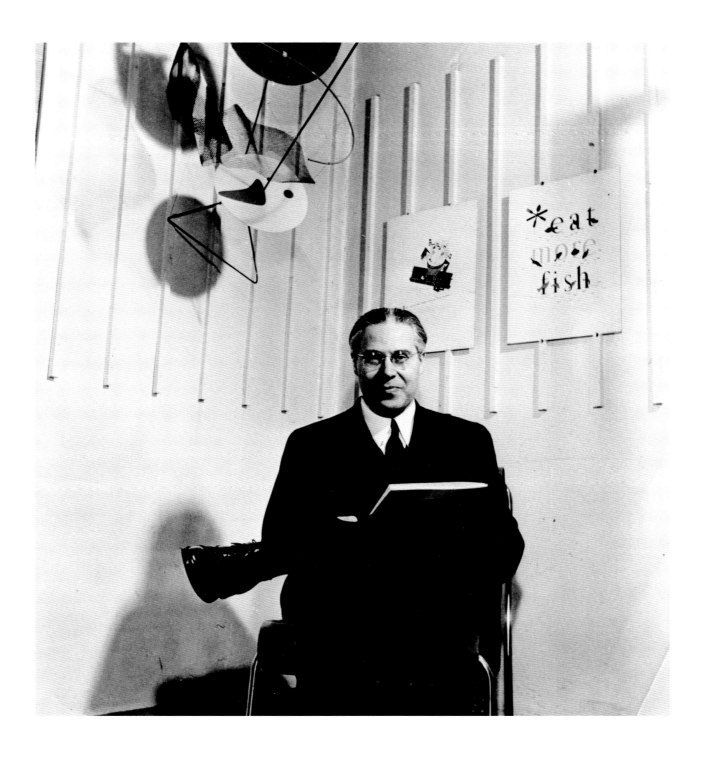

27

Unidentified photographer
Gelatin silver print, c. 1946
Published June 1947
ARTnews Collection

László Moholy-Nagy (1895–1946)

Though he studied law in his native Hungary, László Moholy-Nagy changed career paths following service in World War I. He came to prominence teaching the *vorkurs*, or introductory art-making and design course, at the Bauhaus in Dessau, Germany. A proponent of exploring new media and technology, Moholy-Nagy embraced photography and film and experimented with such materials as plastic, cardboard, glass, and steel. He remained active as an educator throughout his career; his dynamic personality earned him loyal adherents among his students, as well as some detractors. Following the rise of Hitler, Moholy-Nagy sought to continue Bauhaus teaching ideas in the United States, cofounding, with Walter and Elizabeth Paepcke, the Chicago School of Design, now the Institute of Design. This portrait of him seated before student projects was taken a year before his death. —TM

Irving Penn (born 1917)
Gelatin silver print, 1947
Published February 1984
Irving Penn; courtesy Pace/MacGill
Gallery, New York City
© 1948 (renewed 1976) by
Condé Nast Publications Inc.

Jacob and Gwen Lawrence, New York (Jacob Lawrence
[1917–2000] and Gwendolyn Knight Lawrence [born 1913])

Jacob Lawrence, the best known and most widely acclaimed African-American
artist of the twentieth century, is now recognized as a major figure in American
art. A talented painter who believed that the "Negro struggle is a symbol of the
struggle of all mankind," Lawrence often drew thematically on the African-Ameri-
can experience in his boldly colored, semiabstract images to invoke the human
experience, which transcends race and gender. Lawrence gained national recogni-
tion in 1941 when he became the first black artist to exhibit in a major New York
gallery and, consequently, was the first to receive national press coverage (includ-
ing a profile in *ARTnews* in 1944). Irving Penn, who was himself then gaining
acclaim as a photographer, made this portrait of Lawrence and his wife, Gwen
Knight (also a recognized artist), about the time of Lawrence's 1947 exhibition at
New York's influential Downtown Gallery. This was his first one-man show in New
York since returning to civilian life after wartime service in the Coast Guard.
Lawrence's pose seems awkward and uncomfortable in Penn's photograph, sug-
gesting the intense psychological pressure he experienced at that time for being
(as *ARTnews* described him in its review of the exhibition) "at thirty the best-
known Negro painter in America." —WS

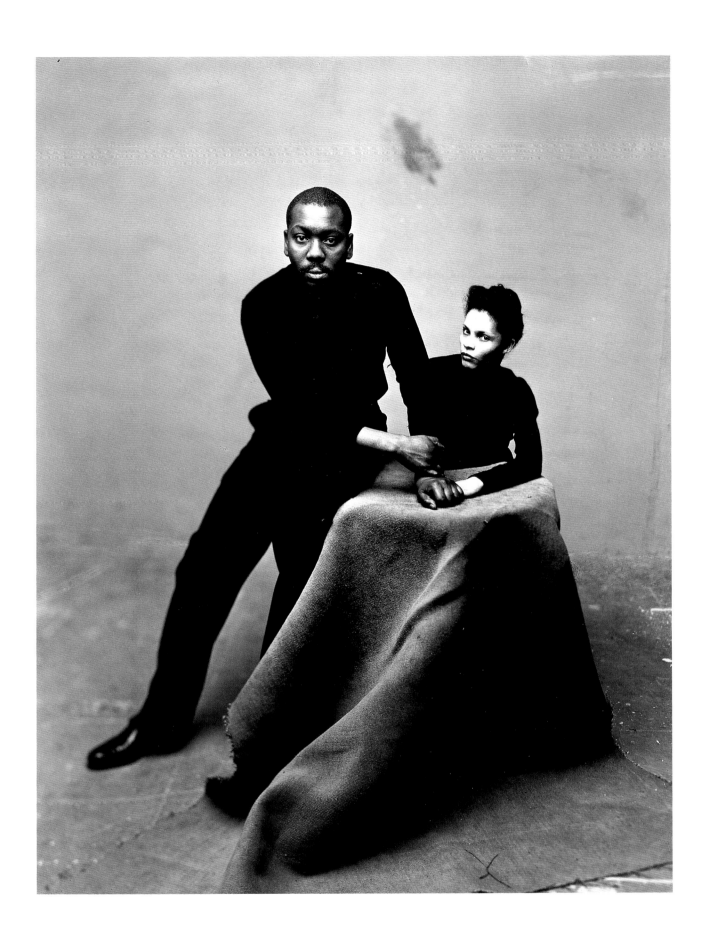

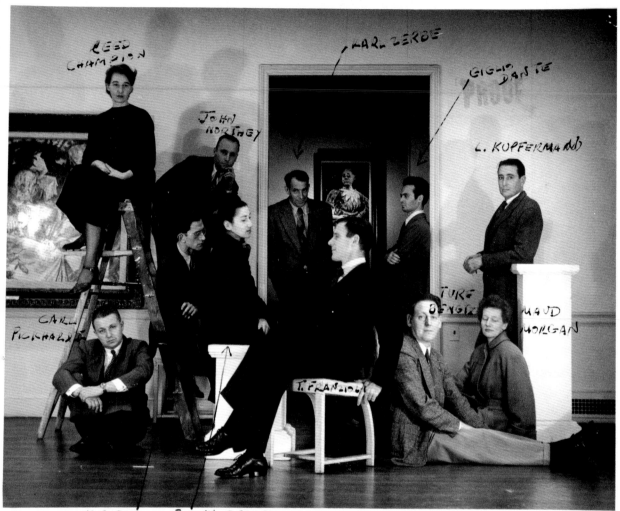

29

John Brook (born 1924)
Gelatin silver print, c. 1947
Variant published December 1947
ARTnews Collection

Massachusetts Painters:

Karl Zerbe, Carl Pickhardt, Reed Champion, Kahil Gibran, John Northey, Esther Geller, Thomas Fransioli, Ture Bengtz, Giglio Dante, Maud Morgan, Lawrence Kupferman

The galleries of Boston's Institute of Modern Art (now the Institute of Contemporary Art) provide the setting for this image of eleven artists featured in a 1947 group exhibition showcasing Massachusetts painters. Influenced by such artists as Karl Zerbe (in doorway on left), a teacher at the museum school, many of these painters worked in a style reminiscent of German Expressionism. A review of the show in ARTnews celebrated the exhibition as a sign of a brighter, more progressive cultural future for the city, though Boston would remain in the long shadow of the New York art scene. —TM

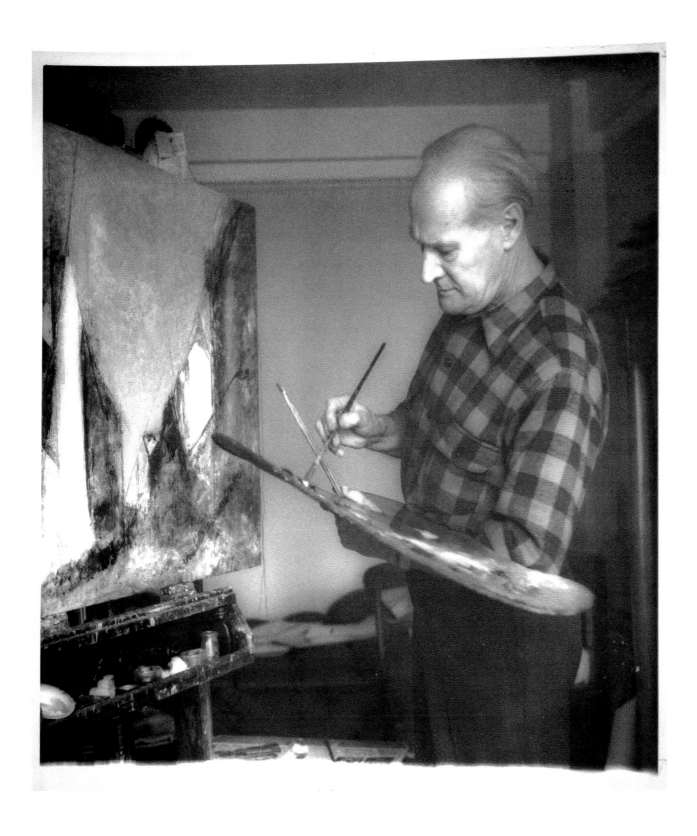

Josef Breitenbach (1896–1984)
Gelatin silver print, 1948
Published summer 1949
ARTnews Collection

Lyonel Feininger (1871–1956)

Nearly fifty years passed between Lyonel Feininger's departure from New York as a youth and his exile from Germany in 1937. Feininger began his career as a popular illustrator and went on to distinguish himself as a printmaker, painter, and teacher at the Bauhaus school of art and design in Weimar. Forced out of Germany by Hitler's campaign against the makers of so-called degenerate art, Feininger was fascinated by the New York City to which he returned. The soaring lines of its tall buildings became a regular subject of his work. —TM

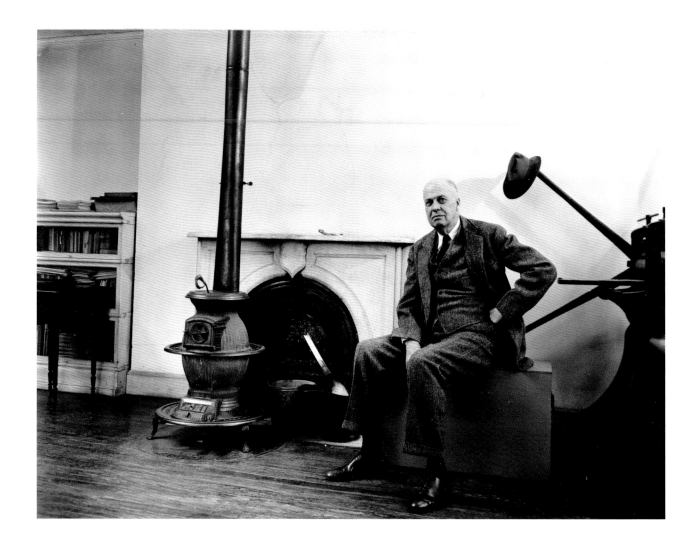

Berenice Abbott (1898–1991)
Gelatin silver print, 1948
Variant published March 1950
National Portrait Gallery,
Smithsonian Institution
© Berenice Abbott/
Commerce Graphics, Ltd., Inc.

Edward Hopper (1882–1967)

One of the most celebrated realist artists of the twentieth century, Edward Hopper is shown here in his Greenwich Village studio. This portrait by famed New York City photographer Berenice Abbott was published in *ARTnews* in March 1950 to commemorate the opening of a major Hopper retrospective at the Whitney Museum of American Art. Having worked in relative obscurity as a young artist—he sold only one painting during the first twenty years of his career—Hopper enjoyed great popular and critical success during the second half of his artistic life. Though many American painters were embracing the tenets of Abstract Expressionism during the 1940s and 1950s, Hopper remained dedicated to the realist aesthetic. —FG

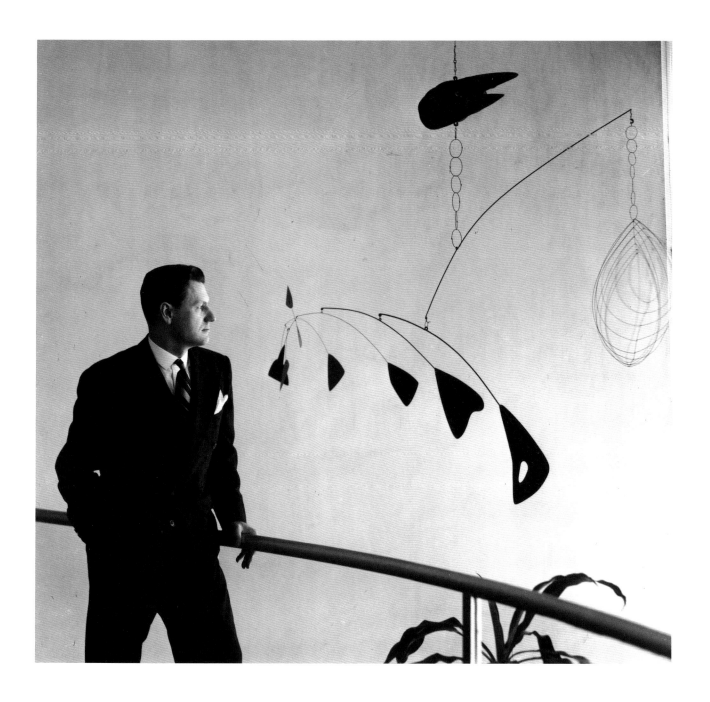

32

Arnold Newman (born 1918)
Gelatin silver print, 1948
Published March 1979
Arnold Newman
© Arnold Newman/Getty Images

Nelson Rockefeller (1908–1979)

Arnold Newman photographed Nelson Rockefeller looking very much in his element, admiring a mobile by Alexander Calder at the Museum of Modern Art in New York. President of the museum, of which his mother was a founder, Rockefeller was not content to rest on the accomplishments of his parents. As a patron of the arts Rockefeller made a point of supporting emerging artists and developed a reputation as a collector of works in the artistic vanguard. During his tenure as governor of New York, Rockefeller was an advocate for the arts and spearheaded numerous innovative building projects, including Albany's Empire State Plaza with its unusual egg-shaped performing arts center. —TM

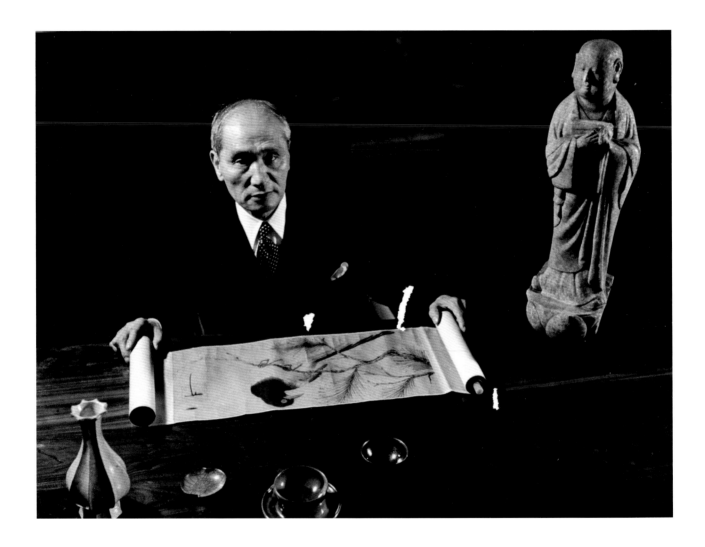

33

Rudolph Burckhardt (1914–1999)
Gelatin silver print, 1950
Published summer 1950
ARTnews Collection
Courtesy the Estate of Rudolph Burckhardt
and Tibor de Nagy Gallery, New York City

C. T. Loo (1880–1957)

Ching Tsai Loo was the preeminent dealer of Chinese art and artifacts for the first half of the twentieth century. Starting his business in Paris, Loo was almost single-handedly responsible for introducing early Chinese art—bronzes, jades, paintings—to Western Europe and North America. Because of his connections in Asia, he was able to obtain major pieces for such collectors as J. P. Morgan, Samuel Peters, Alfred Pillsbury, and Henry Clay Frick from eras never before represented in the West. This image of Loo, pictured among artifacts at the China Institute, was the first of many photographs to be published in *ARTnews* by photographer Rudolph Burckhardt. — TA

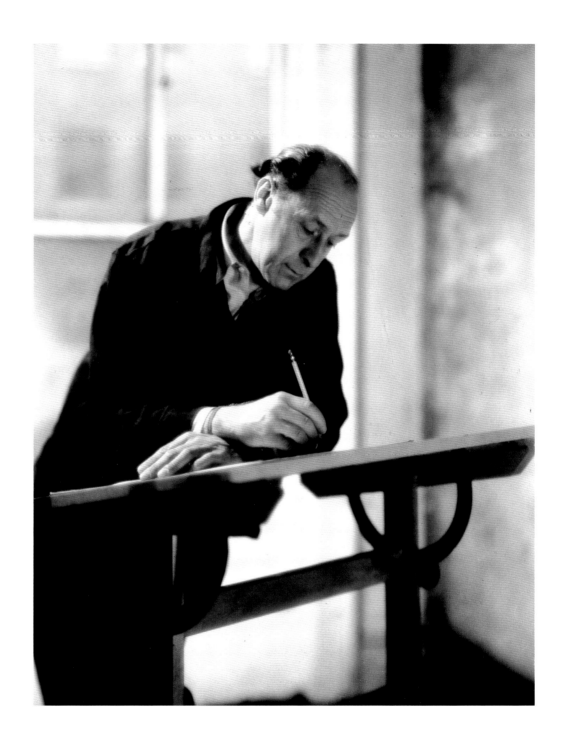

George Platt Lynes (1907–1955)
Gelatin silver print, 1950
Published January 1951
ARTnews Collection
© Estate of George Platt Lynes

Pavel Tchelitchew (1898–1957)

Noted as an artist of "transoceanic reputation," Russian-born Pavel Tchelitchew moved in 1934 from France to New York, where he was received with high expectations. In 1951 *ARTnews* suggested, with reserved praise, that his best work lay before him. Tchelitchew emerged from the company of the French Surrealists to produce a diverse body of work that ranged from neoromantic paintings and drawings of circus performers to a challenging "X-ray painting" series to innovative theater designs. George Platt Lynes, who first met Tchelitchew in Paris in the twenties, more than once photographed the artist at work in his New York studio. Shortly after he became an American citizen, Tchelitchew was prompted by poor health to leave New York for Italy in 1952. —TM

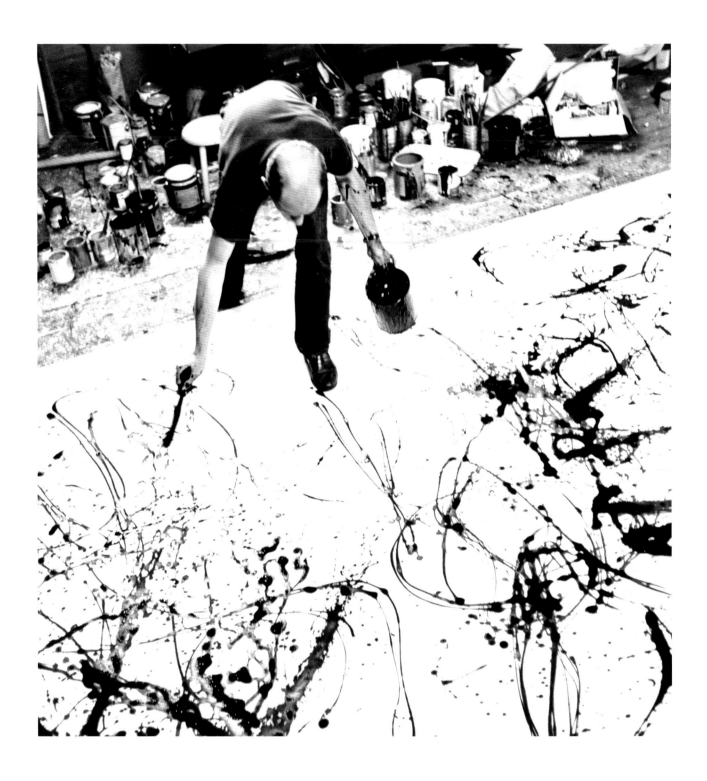

35a–d

Hans Namuth (1915–1990)
Gelatin silver prints, 1950
From a series published May 1951
National Portrait Gallery,
Smithsonian Institution;
gift of the Estate of Hans Namuth
© Estate of Hans Namuth

Jackson Pollock (1912–1956)

Though Hans Namuth was initially reluctant to photograph Jackson Pollock, an artist he considered overrated, he became fascinated by both the man and his art. Namuth followed this first session with more than five hundred photographs of Pollock at work, as well as a short black-and-white film and a color film in which he famously captured Pollock from below, painting on a sheet of glass. Influenced by Jungian psychology, theories of the unconscious, and the work of Surrealists like Joan Miró, Pollock abandoned figurative painting for pure abstraction. Pollock's unconventional methods—laying his canvas on the floor, walking on it, flinging and drizzling paint as he went—led some to accuse his work of arbitrariness. As spontaneous as his painting could be, however, Pollock remained attentive to design and profoundly concerned with rhythm and harmony, or as he emphatically stated, "No chaos damn it!" —TM

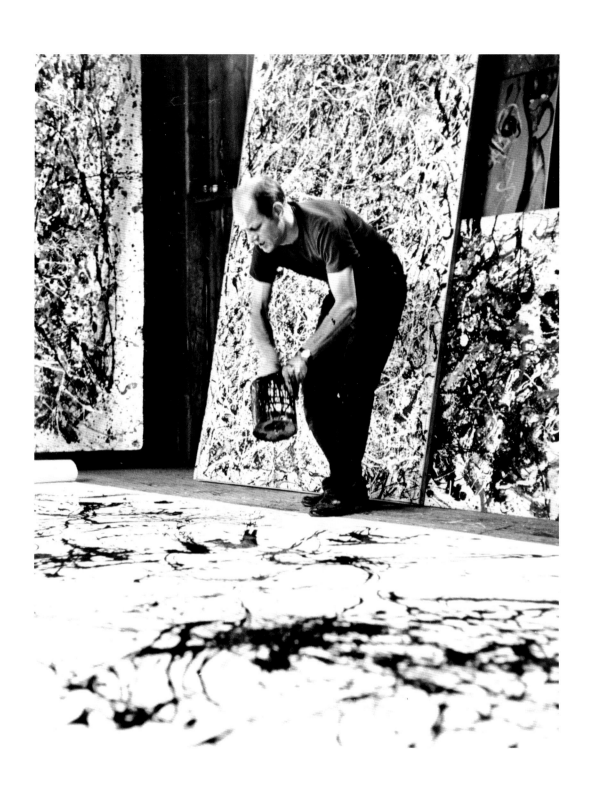

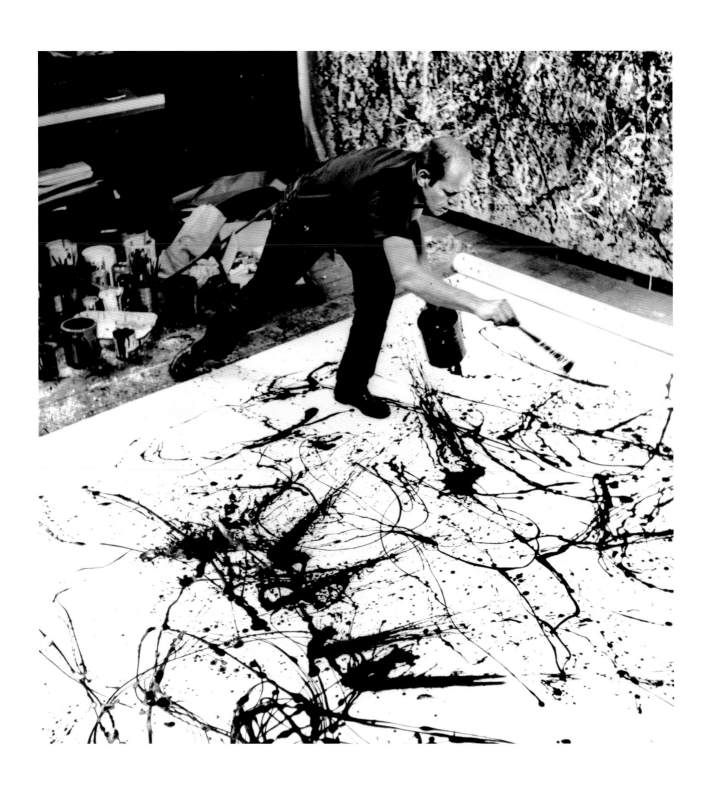

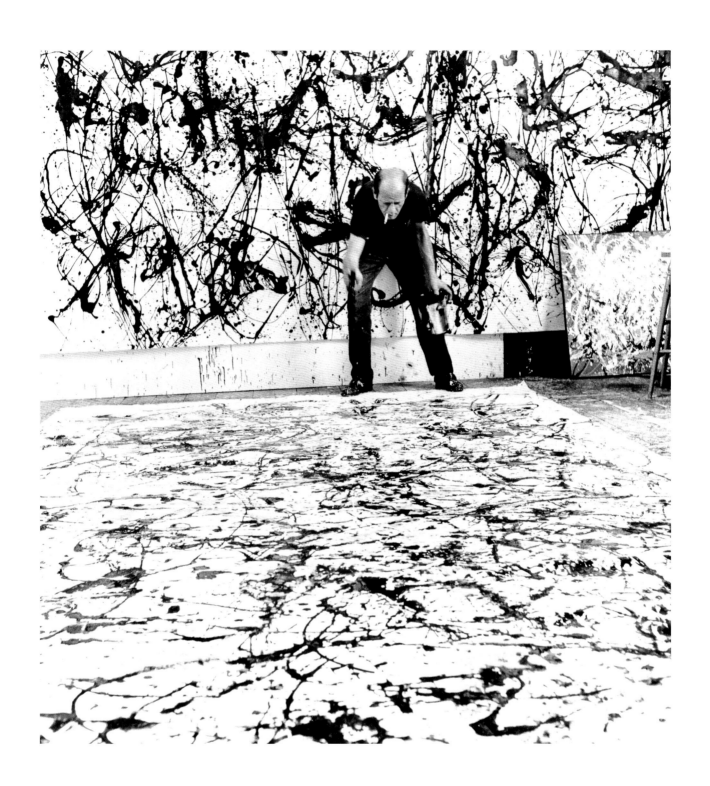

36

Nina Leen (1909–1995)
Gelatin silver print, 1950
Published January 1979
Photographs of the Artists Collection, Archives of
American Art, Smithsonian Institution
© Time Inc.

The Irascibles:
(bottom, left to right) Theodoros Stamos, Jimmy Ernst, Barnett Newman, James Brooks, Mark Rothko; (second row) Richard Pousette-Dart, William Baziotes, Jackson Pollock, Clyfford Still, Robert Motherwell, Bradley Walker Tomlin; (top row) Willem de Kooning, Adolph Gottlieb, Ad Reinhardt, Hedda Sterne

In 1950, twenty-eight of the most prominent artists in the United States signed an open letter to the president of the Metropolitan Museum of Art protesting a juried exhibition intended to increase the museum's collection of contemporary art. The letter accused director Francis Henry Taylor and curator Robert Beverly of loading the jury with critics hostile to "advanced art," particularly Abstract Expressionism. Nina Leen brought fourteen of the signatories together for a photograph that came to be dubbed "The Irascibles." Detractors considered the protest typical avant-garde posturing, but it proved to be only one of many quarrels the Metropolitan would face over the ensuing two decades about how to update its permanent collection. —TM

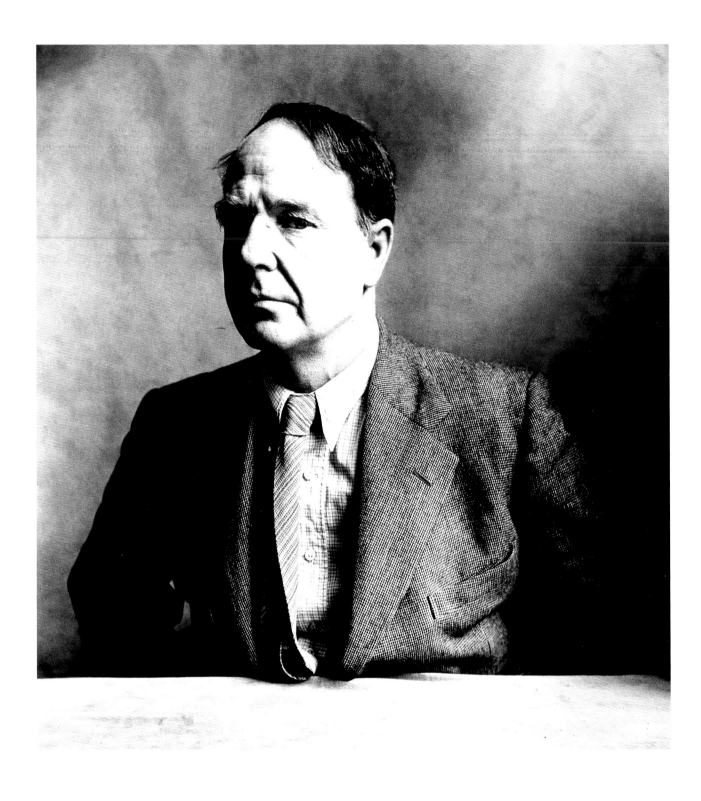

37

Irving Penn (born 1917)
Gelatin silver print, 1950
Published December 1984
Irving Penn; courtesy
Pace/MacGill Gallery, New York City
© 1951 by Condé Nast Publications Inc.

Henry Moore, London (Henry Moore [1896–1986])

Henry Moore is one of the greatest figures in British art and one of the major artists of the twentieth century. An innovative and influential sculptor, Moore is known primarily for his monumental works in stone and bronze of seated and reclining semiabstract figures—usually female—that are archetypal in form and powerful in effect. Moore created his works to be seen in outdoor settings: "I would rather have a piece of my sculpture put in a landscape, almost any landscape," he once said, "than in the most beautiful of buildings." Irving Penn made this dramatic likeness of Henry Moore in London as part of a series of portraits for *Vogue* of leading figures in British cultural life. For the assignment, Penn chose to photograph his subjects in an old-fashioned daylight studio, posing them in a featureless setting against a mottled canvas backdrop and relying on sunlight alone to illuminate and model their features. —WS

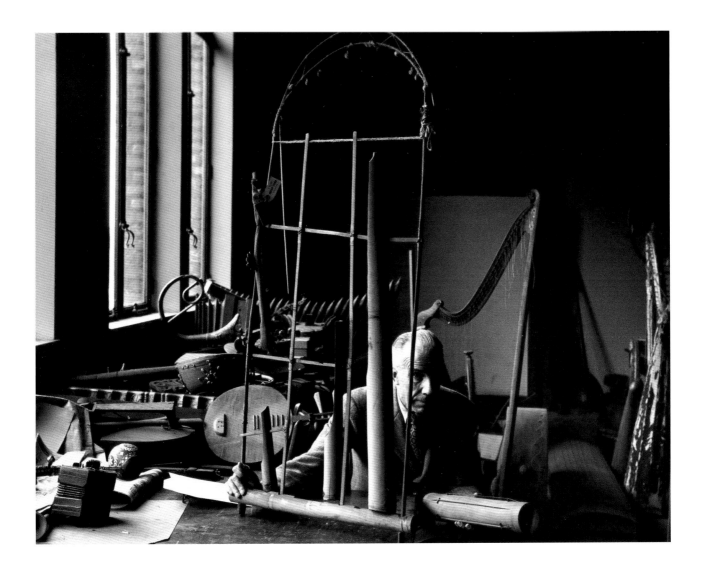

Reuben Goldberg (1883–1970)
Gelatin silver print, 1951
Published February 1952
ARTnews Collection

Franklin Watkins (1894–1972)

Photographer Reuben Goldberg captured Philadelphia realist and portrait painter Franklin Watkins among the collections of the University of Pennsylvania's museum. Watkins was there as one of seven men selected from the modern art world to be "let into the cellars and sub-cellars on a search for forgotten master-pieces" for the museum's innovative "Storeroom Show." As a way to "turn a new eye on the museum's collections," each man was allowed to choose objects he considered to have aesthetic interest. The exhibition's installation was as inventive as its selection process. Visitors were led down to the subterranean storage rooms, where spotlights picked out the chosen objects from the stored collections. —TA

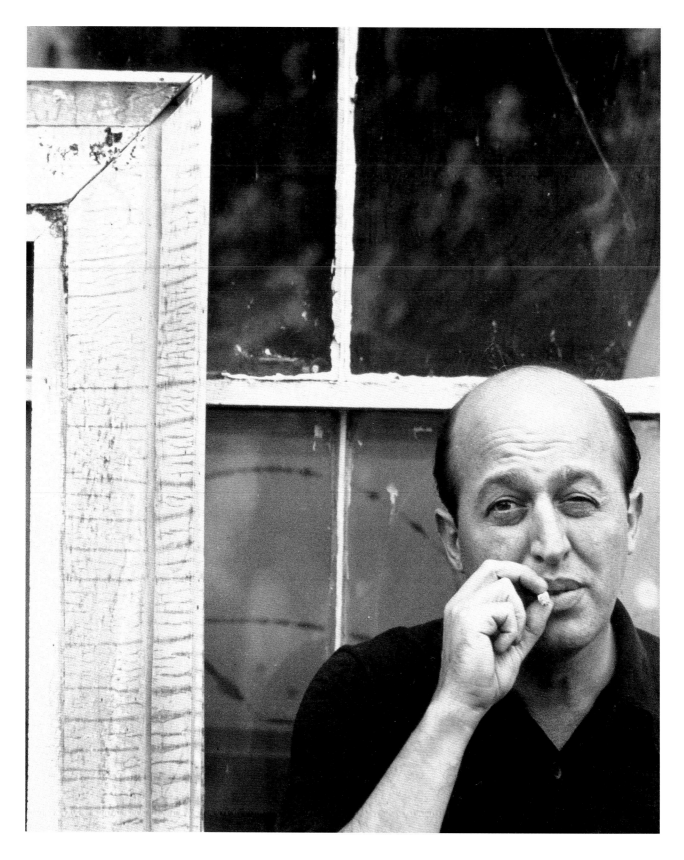

39

Hans Namuth (1915–1990)
Gelatin silver print, 1951
Published summer 1980
ARTnews Collection
© Estate of Hans Namuth

Clement Greenberg (1909–1994)

Clement Greenberg began his career in the 1930s by contributing essays on politics and art to *Partisan Review* and art criticism to *The Nation*. He emerged as one of the most prominent critics of American modern art in the postwar years and a champion of Abstract Expressionism. Greenberg was a regular presence in the studios of artists such as David Smith, Jackson Pollock, and Helen Frankenthaler, and his advice had a direct influence on the work of the artists he advocated. Though he became less active in the 1960s, his role in drawing international attention to American art and shaping the character of contemporary art theory ensured him a lasting place in the art world. —TM

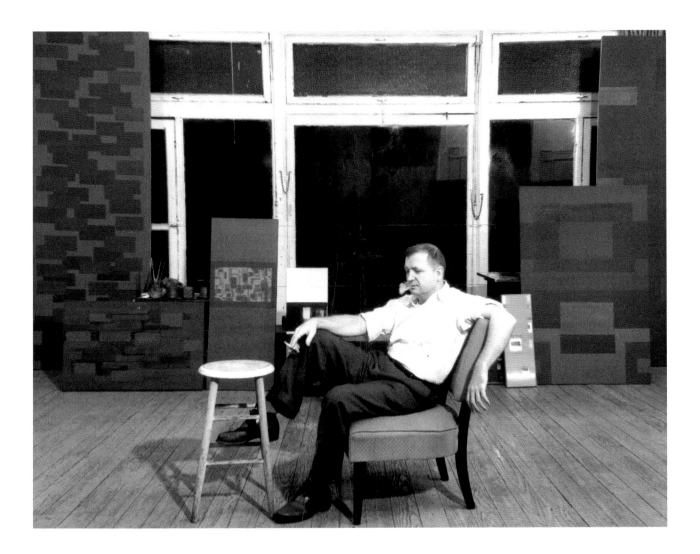

Walter Rosenblum (born 1919)
Gelatin silver print, 1953
Variant published December 1953
ARTnews Collection

Ad Reinhardt (1913–1967)

In reviewing Ad Reinhardt's 1953 exhibition *Recent Paintings* at New York's Betty
Parsons Gallery, *ARTnews* characterized the forty-year-old abstract painter as a
"well-entrenched veteran of the increasingly complicated Greenwich Village
painters' purgatory." Reinhardt was then associated with such well-known Abstract
Expressionist figures as Jackson Pollock and Clyfford Still, but he painted in a
distinctly different style. As the canvases in the background of this photograph by
Reinhardt's friend and Brooklyn College colleague Walter Rosenblum suggest, his
work employed monochromatic fields of color laid out in geometric patterns. In the
years following this exhibition, Reinhardt turned from a bright palette to one domi-
nated by darker hues. Because of these paintings and his deep interest in Eastern
philosophy, he became known toward the end of his life as the "black monk" of the
New York art world. —FG

Rudolph Burckhardt (1914–1999)
Gelatin silver print, 1953
Published April 1964
ARTnews Collection
Courtesy the Estate of Rudolph Burckhardt
and Tibor de Nagy Gallery, New York City

Jack Tworkov (1900–1982)

Jack Tworkov followed a traditional course of study at the Art Students League in
the 1920s and participated in the Works Progress Administration Federal Art Project
in the late 1930s. A decade later, however, influenced by his friend and neighbor
Willem de Kooning, Tworkov embraced Abstract Expressionism. He is considered
an important member of that movement, which owed its critical acceptance in
large part to *ARTnews*. This portrait of Jack Tworkov by Rudolph Burckhardt appeared
in a feature article published in conjunction with Tworkov's 1964 retrospective at
the Whitney Museum of Art, but it is an outtake from the group of photographs
Burckhardt made in 1953 to illustrate "Tworkov Paints a Picture," part of a regular
ARTnews series on artists at work. —WS

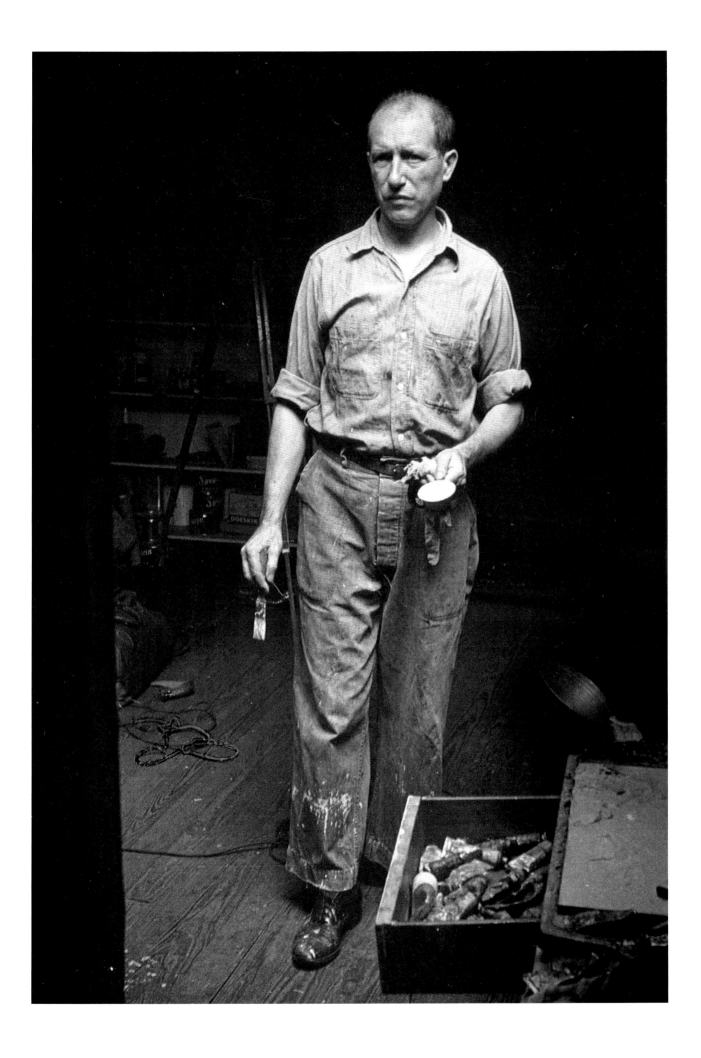

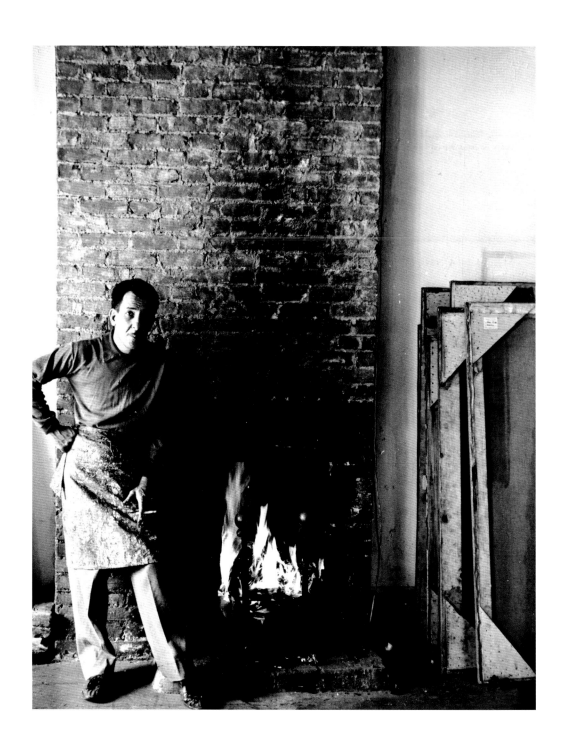

42

John Gordon Ross (born 1920)
Gelatin silver print, c. 1953
Published March 1967
ARTnews Collection

Franz Kline (1910–1962)

This photograph by John Gordon Ross captures the Abstract Expressionist artist Franz Kline in his New York City studio. Described by *ARTnews* as "one of the heroes of the New York School," Kline was renowned for abstract paintings that "explode before us at point-blank range." Often monochromatic, his canvases featured slashing strokes of paint that intersected to form complex shapes and rhythmic designs. Kline insisted that his works, despite their nonobjective appearance, were rooted in the world around him. Indeed, the titles of several paintings refer to places that he knew as a youth in eastern Pennsylvania. —FG

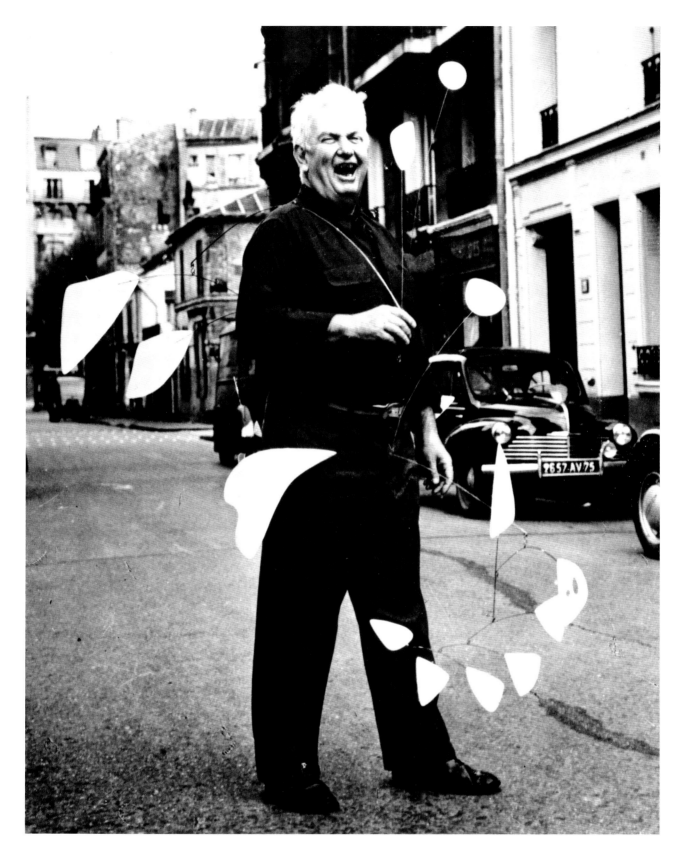

43

Agnes Varda (born 1928)
Gelatin silver print, 1955
Published November 1977
ARTnews Collection

Alexander Calder (1898–1976)

Trained as an engineer, American sculptor Alexander Calder won acclaim from
the art world for his mechanical sculptures and fanciful mobiles. In a piece
published in *ARTnews* in 1947, philosopher Jean-Paul Sartre recalled with admi-
ration and amusement how he had nearly been hit in the face by a lazily
turning mobile in Calder's Paris studio. Sartre argued that such unpredictability
of movement, dependent entirely upon wind power, embodied the essence
of natural movement. French filmmaker Agnes Varda, a friend of Calder's, snapped
this picture of the sculptor moving a mobile across a Paris street. —TM

44

Arthur Swoger (born 1912)
Gelatin silver print, 1957
Published December 1959
ARTnews Collection

Philip Guston (1913–1980)

Often described as an Abstract *Impressionist* because of the quasi-lyrical nature of his abstractions, Philip Guston worked in a series of ever-changing styles. Guston started as a figurative painter working on murals for the Works Progress Administration Queensbridge housing project in New York in the late 1930s. Several years later, he turned to easel painting, and progressively his work became less representational. By the 1950s he was working in a purely abstract style. For Guston, painting was always a means of self-discovery, the resulting picture a reflection of himself at some level. Late in his career, Guston returned to figurative painting. His critics were horrified by his primitive, almost cartoonlike style, calling it an affected and feeble move toward Pop Art and a mocking of Abstract Expressionism. In the October 1970 issue of *ARTnews*, however, Guston defended his change, saying, "I got sick and tired of all that Purity! [I] wanted to tell Stories." —TA

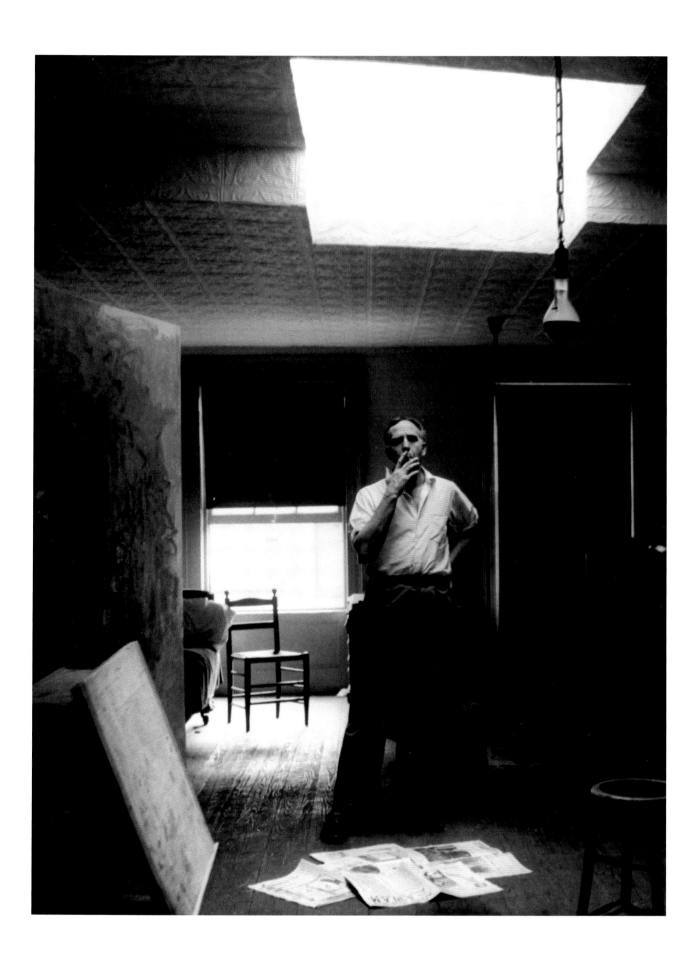

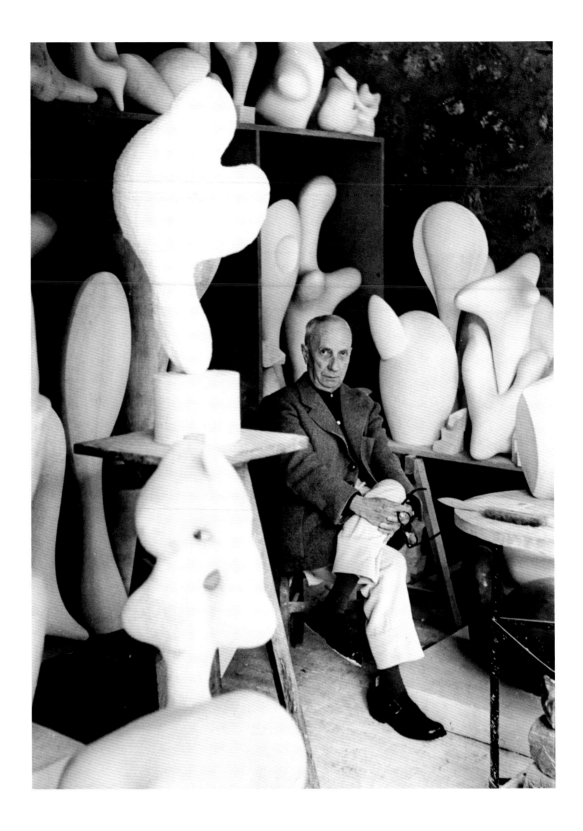

45

André Villers (born 1930)
Gelatin silver print, 1958
Published October 1958
ARTnews Collection

Jean Arp (1887–1966)

A member of the Dadaist movement from its earliest days in Zurich, French artist Jean Arp appreciated the element of chance in art as a liberating principle, applying his sometimes mystical ideas to painting, sculpture, and poetry. André Villers photographed Arp in his studio in the Paris suburb of Meudon, surrounded by the plaster models for his bronze sculptures. The amorphous shapes emulated the shapes and movements of the natural world and the sensuousness of the human form. —TM

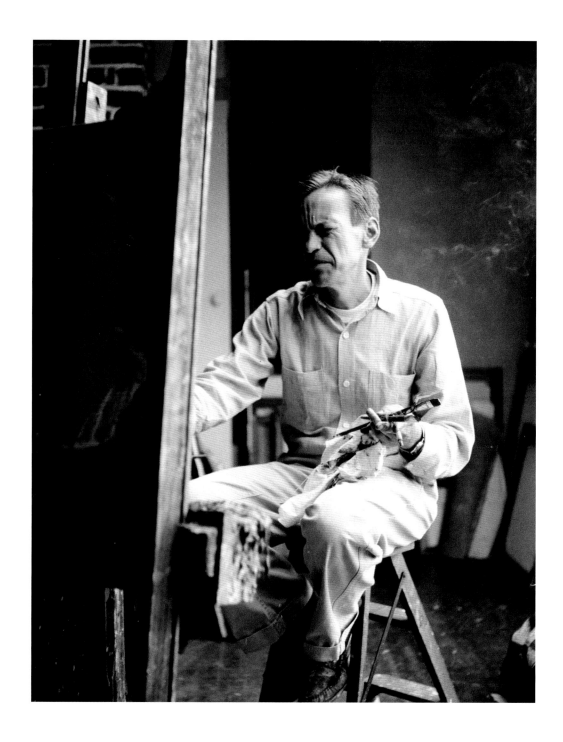

46

Imogen Cunningham (1883–1976)
Gelatin silver print, 1958
Published December 1989
Imogen Cunningham Trust
© 1978 The Imogen Cunningham Trust

David Park (1911–1960)

Imogen Cunningham often found portrait photography and sitters who would not let their guard down exasperating. She preferred to make uncommissioned photographs of her friends and fellow artists and photographers in the San Francisco area, like David Park. Park settled in California while working for the Works Progress Administration Federal Arts Project in the 1930s and, like Cunningham, taught at the California School of Fine Arts (now the San Francisco Art Institute). Along with Richard Diebenkorn, Park was a leading figure among the Bay Area Figurative painters. —TM

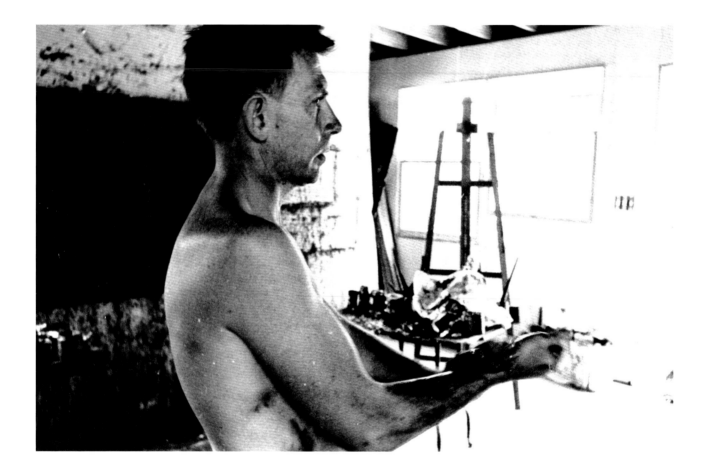

47

Robert Frank (born 1924)
Gelatin silver print, 1959
Published March 1961
ARTnews Collection
Robert Frank; courtesy
Pace/MacGill Gallery

Lester Johnson (born 1919)

Though Lester Johnson thrived on the creative energy of New York City in the early
1960s, he preferred to paint in the relative solitude of a tree-house studio on
Long Island. It was there that Robert Frank recorded Johnson's physically involving
and emotionally demanding style of working. Johnson built up paintings through
a process of brushing, flicking, scraping, layering, and even scrubbing paint onto
the canvas, sometimes with both hands, until the desired image emerged. Though
Johnson allowed himself to be photographed at work for an *ARTnews* article, "Lester
Johnson Paints a Picture," he would not finish the painting until Frank finally left,
and then he completely reworked the surface. —TM

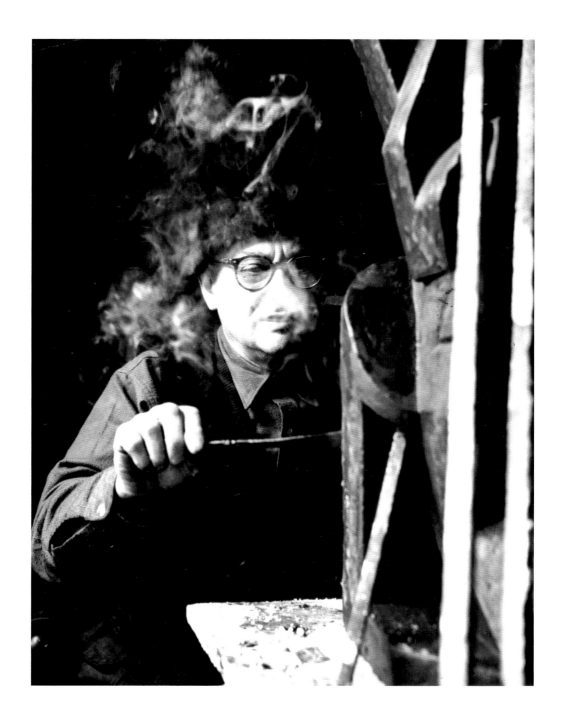

George Moffett (lifedates unknown)
Gelatin silver print, 1959
Published November 1961
ARTnews Collection

Jacques Lipchitz (1891–1973)

Sculptor Jacques Lipchitz described his arrival in the United States from France during World War II as an injection of youth at the beginning of his artistic maturity. Lipchitz began varying his "worked-over" Cubist sculpture with more "lyrical" and "spontaneous" pieces, often drawing on personal and spiritual themes. Looking back on the fifty-two years of his career at age seventy, the Lithuanian-born sculptor expressed enthusiasm for his continued artistic development, remarking, "I'd like to live a long time—as long as possible; I still have much to do. I might even become a good sculptor." —TM

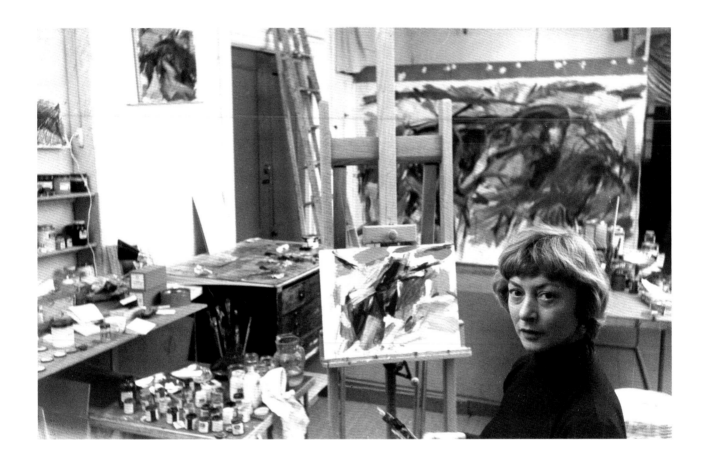

49

Rudolph Burckhardt (1914–1999)
Gelatin silver print, 1960
Published December 1960
Estate of Rudolph Burckhardt; courtesy
Tibor de Nagy Gallery, New York City

Elaine de Kooning (1918–1989)

After Elaine de Kooning returned to New York from teaching at the University of New Mexico, her studio burst with energetic paintings based on bullfights in Juarez, Mexico, and the expansive western landscape. De Kooning dryly observed, "Nowadays, when an artist discovers 'the sky,' it's like a bride who has never done any housework raving about her first vacuum cleaner. It's just not news." Yet she confessed that the experience prompted her to deviate from a more controlled linear style and work freely with lively, confrontational colors directly influenced by the Southwest. —TM

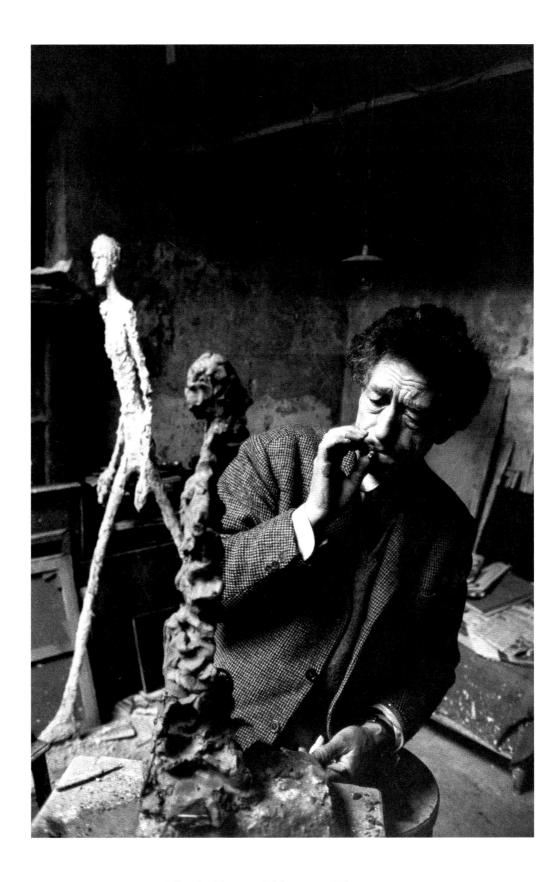

René Burri (born 1933)
Gelatin silver print, 1960
Published December 1995
Magnum Photos Inc.
© René Burri / Magnum Photos

Alberto Giacometti (1901–1966)

The elongated figures of Alberto Giacometti's sculpture have often been equated with the mood of post–World War II Europe. Giacometti himself cited more classical origins in Greek kouroi and Egyptian hieroglyphs. In 1995 *ARTnews* observed that the popularity of the Swiss artist's sculpture had been a mixed blessing. As with the cast metal works of Auguste Rodin and Edgar Degas, unauthorized posthumous reproductions of Giacometti's sculptures have created problems for scrupulous museums and unsuspecting collectors. —TM

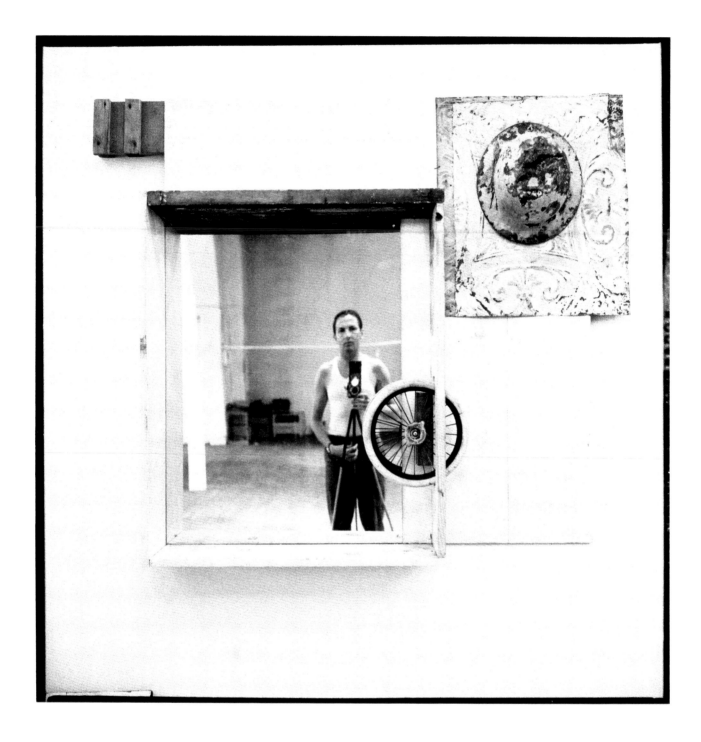

51

Self-portrait
Gelatin silver print, 1962
Variant published April 1963
Robert Rauschenberg
© Robert Rauschenberg/licensed
by VAGA, New York, NY

Robert Rauschenberg (born 1925)

For more than fifty years, American artist Robert Rauschenberg has created art using both traditional and nontraditional materials—often in combination. To understand how he worked, *ARTnews* sent a reporter in 1962 to meet Rauschenberg at his studio. There the thirty-seven-year-old artist was at the beginning of a "combine-painting" that he ultimately titled *Inside-Out*. Bringing together such items as a mirror, embossed tin, and a tricycle wheel and assembling them on a wood structure mounted on four casters, Rauschenberg created a freestanding sculpture from trash found in his lower Manhattan neighborhood. While working on *Inside-Out*, Rauschenberg took this photograph by aiming his camera at the mirror in the piece. Like so much of his work, *Inside-Out* creates a visual situation that implicates the viewer in the object itself. —FG

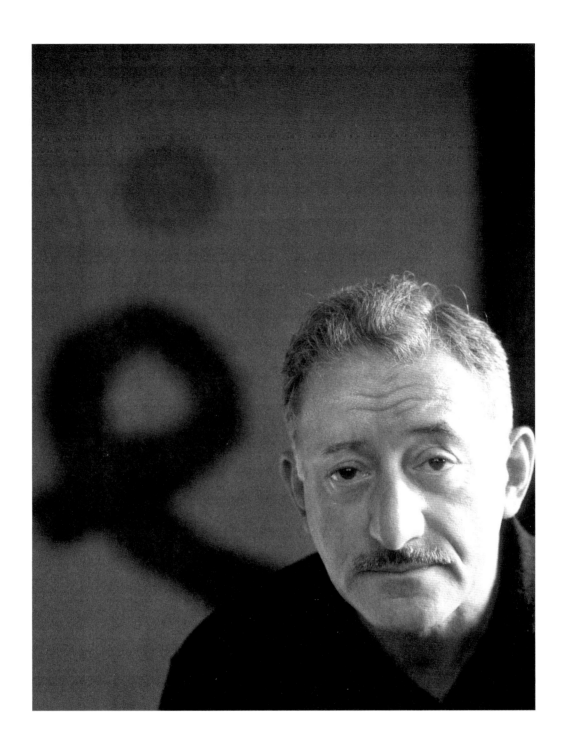

Hans Namuth (1915–1990)
Gelatin silver print, 1962
Published May 1963
ARTnews Collection
© Estate of Hans Namuth

Adolph Gottlieb (1903–1974)

In Hans Namuth's portrait, the head of American artist Adolph Gottlieb floats like
a punctuation mark in one of his own paintings. A leading figure among the Abstract
Expressionists, Gottlieb outspokenly rejected illusionism in art. Though he explored
the ideas of language and symbolism in paintings such as *Sign*, pictured behind
him, Gottlieb avoided using symbols or letters from any known language. Instead
he drew attention to the characteristics of the medium, the flatness of the canvas,
the relations between space and shapes, and the qualities of light and depth appar-
ent in pure color without reference to objects or subject matter. —TM

53

Ugo Mulas (1928–1973)
Gelatin silver print, 1962
Published in *ARTnews* Annual, 1964
Archivio Ugo Mulas, Milan
© Ugo Mulas Estate

David Smith (1906–1965)

This photograph captures the American artist David Smith at work in a recently aban-
doned factory in Voltri, Italy. Renowned for his abstract welded-metal sculptures,
Smith was there in May 1962 to complete a commission for the Festival of Two Worlds
in neighboring Spoleto. Though organizers asked him to submit three works to this
annual celebration of musical, dramatic, and visual arts, Smith was so energized by the
work space that was provided for him and the team of assistants who were assigned
to help him that he contributed twenty-six pieces to the festival. As *ARTnews* reported,
he was "the proverbial cat let loose in a creamery." Ugo Mulas, an Italian photogra-
pher experienced in interpreting artists' lives, spent long hours documenting Smith's
progress during his monthlong residence. In this photograph Smith stands before
his layout table inspecting the various tools that he found on the site. Several of these
wonderfully shaped instruments were ultimately incorporated into his sculptures. —FG

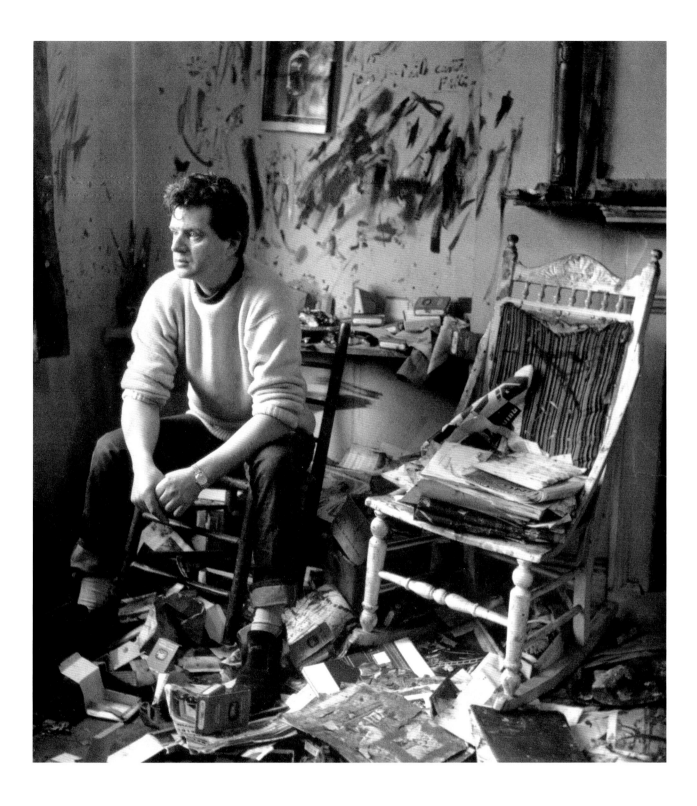

54

Douglas Glass (1901–1978)
Gelatin silver print, 1963
Published October 1963
ARTnews Collection
© J.C.C. Glass

Francis Bacon (1909–1992)

The year 1963 was a signal time for Francis Bacon, photographed here in his London studio. Bacon had earned a following among London's fashionable elite and youth subculture alike, as well as retrospective exhibitions at the Tate Gallery and New York's Guggenheim Museum. At a time when Clement Greenberg heralded the death of figurative art at the hands of pure formalism, Bacon remained defiantly concerned with figure and subject, often worked from photographs (never his own), and referred directly to the Old Masters. Paintings such as *Pope Shouting* and *Three Studies for a Crucifixion* revisited the canons of art with a fraught intensity and ferocity of style that *ARTnews* called "the paint of screams." —TM

55

Todd Webb (1905–2000)
Gelatin silver print, 1964
Published April 1987
Evans Gallery, Portland, Maine
© Todd Webb

O'Keeffe Walking in Twilight Canyon (Georgia O'Keeffe [1887–1986])

In paying tribute to the career of Georgia O'Keeffe, *ARTnews* observed that she "devoted her life to distilling in form and color the essence of the world she saw." After the death of her husband, Alfred Stieglitz, in 1946, that world was almost exclusively the American Southwest. Having first visited it in 1929, O'Keeffe developed over time a deep-felt connection to the region. From her ranch home in Abiquiu, New Mexico, she frequently traveled into this desert landscape looking for subjects to paint. In 1964, at age seventy-six, she and a party of friends floated the Colorado River. The group often left the rafts to explore the shoreline and surrounding landscape. Photographer Todd Webb, who had known O'Keeffe for nearly twenty years, created a series of portraits during these excursions. Here he pictured O'Keeffe walking through Twilight Canyon, a narrow and mysterious cavern that abutted the Colorado. —FG

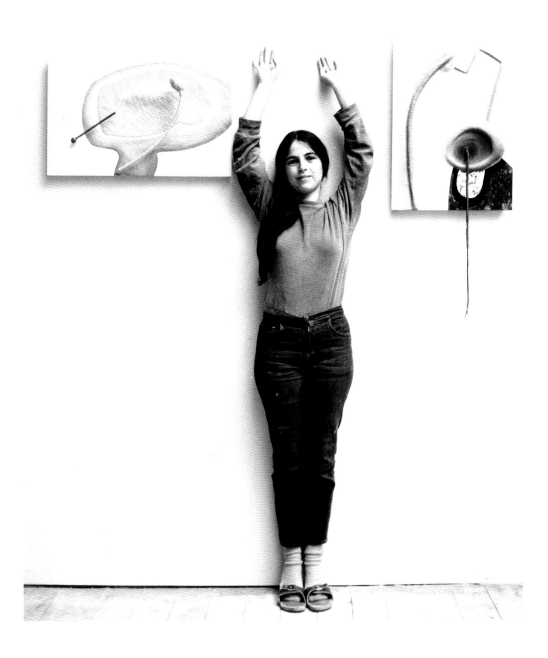

Manfred Tischer (birthdate unknown)
Gelatin silver print, 1965
Published November 1989
Manfred Tischer
© Manfred Tischer

Eva Hesse (1936–1970)

In the 1960s, installation artist Eva Hesse was part of a young generation of artists intent on undermining the austerity of Minimalism with a good dose of humor and absurdity. She fashioned her large-scale, mixed-media objects from latex-impregnated cheesecloth, fiberglass poles, drooping ropes, or tangled wires and played with concepts of order and chaos, male and female, natural and synthetic. Often her works were constructed to appear awkward, unstable, even irrational, and many contained references to the human body. Though Hesse's remarkable career was cut short by a brain tumor when she was just thirty-four, the vitality of her work earned her many followers. —TM

57

Rudolph Burckhardt (1914–1999)
Gelatin silver print, c. 1965
Published January 1966
ARTnews Collection
Courtesy the Estate of Rudolph Burckhardt
and Tibor de Nagy Gallery, New York City

Paul Georges (1923–2002)

A member of the second generation of the New York School, Paul Georges took elements from Abstract Expressionism—such as the physical immediacy of the paint—and applied them to the more traditional field of figurative painting. One of Georges's artistic quests has been to reach a style of figurative representation that is "completely natural yet also timeless." Pictured here with his model for *The Studio*—the subject for an article in the *ARTnews* ". . . Paints a Picture" series, Georges explained that he drew from Cubism to create the final figure—sketching and painting the figure from several positions and angles and then uniting them to form a final, more complete image. —TA

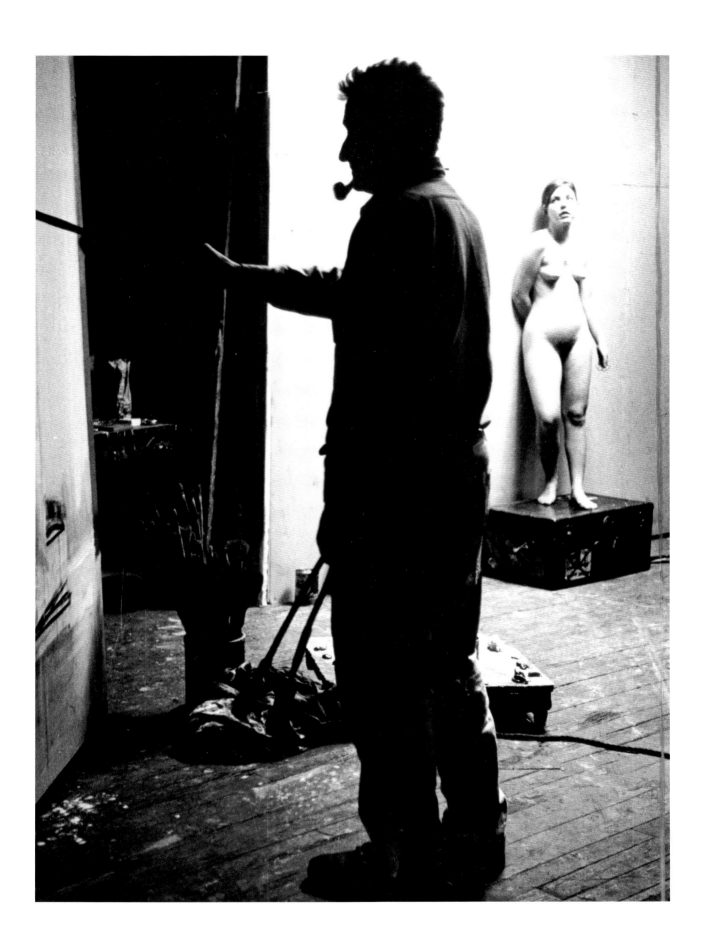

Hans Hammarskiöld (born 1925)
Gelatin silver print, 1966
Published May 1967
Collection of the artist
Hans Hammarskiöld
© Hans Hammarskiöld

Claes Oldenburg (born 1929)

Throughout his career Swedish-born sculptor Claes Oldenburg has transformed commonplace objects into uncommon art through his inventive manipulation of form and scale. In the mid-1960s, he undertook a series of drawings for fantastical civic monuments conceived as colossal in scope. An outgrowth of his heroically proportioned soft sculptures, the proposed monuments took the form of objects Oldenburg deemed uniquely emblematic of a particular city's mood or spirit. In 1966 his visit to London spawned several monument proposals. As Oldenburg told *ARTnews*, the British capital "inspired phallic imagery which went up and down like the tide—like miniskirts and knees and the part of the leg you see between the skirt and the boot." In this image, Oldenburg holds the ready-made mannequin knee that was the basis for the towering "Knees Monument" he envisioned for the Victoria Embankment. —AS

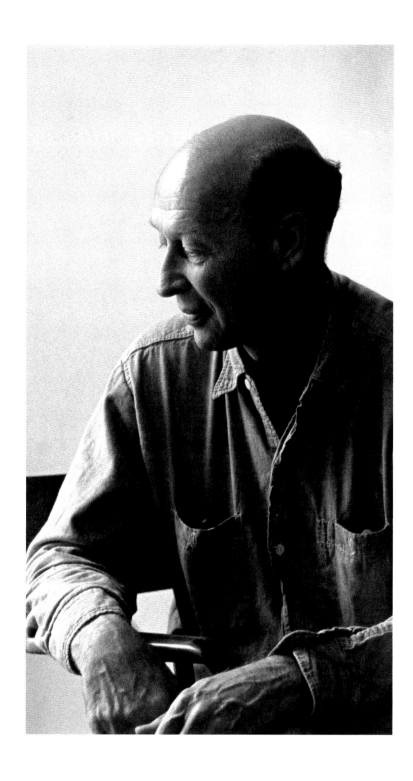

59

W. Krupsaw (born 1942)
Gelatin silver print, c. 1966–68
Published October 1983
Pace/MacGill Gallery, New York City
© W. Krupsaw

Harry Callahan (1912–1999)

"Who said capturing reality is the point of photography anyway?" exclaimed American photographer Harry Callahan in a 1983 profile in *ARTnews*. Though his sharply focused prints captured recognizable subjects, Callahan was often more interested in such formalist concerns as shape, pattern, space, and light. Born and raised in Detroit, Callahan took up photography at age twenty-six and spent the rest of his life using the camera to look anew at the world. He was also an influential teacher, first with László Moholy-Nagy at the Institute of Design in Chicago and then at the Rhode Island School of Design in Providence. Among his many accomplished students was W. Krupsaw, whose meditative portrait of Callahan is pictured here. —FG

60

Dan Budnik (born 1933)
Gelatin silver print, 1967
Published November 1967
ARTnews Collection

Willem de Kooning (1904–1997)

In conversation with critic Harold Rosenberg, Willem de Kooning explained that
he was an eclectic painter who enjoyed the history and tradition of painting with-
out feeling constrained by it. "I could be influenced by Rubens," he said, "but I
certainly would not paint like Rubens." Although de Kooning is most closely identified
with his controversial paintings of women from the 1950s, the explosive style that
characterized de Kooning's work in the 1950s and 1960s gave way to increasingly
elegant lines, fluid forms, and delicate coloring, reflecting his interest in the art of
Henri Matisse and Paul Cézanne. In 1972, at age sixty-eight, the Dutch-born artist
introduced another dimension to his work with his first exhibition of bronze
sculpture. —TM

61

Danny Lyon (born 1942)
Gelatin silver print, 1968
Published December 1970
Danny Lyon; courtesy Edwynn
Houk Gallery, New York City
© Danny Lyon/Magnum Photos, Inc.

Billy McCune (born 1928)

In 1968, while engaged in a project to document the grim reality of life within the Texas prison system, photographer Danny Lyon met Billy McCune, an inmate serving a life sentence. Through visits and exchanges of correspondence, Lyon and McCune forged a bond that led to a unique artistic collaboration. With Lyon's encouragement, McCune wrote movingly of his years of imprisonment and filled his letters with scores of colorful drawings. McCune's letters and images proved so affecting that Lyon incorporated them in *Conversations with the Dead*—the 1970 exhibition of his Texas prison photographs. As *ARTnews* noted in its review, "Lyon wanted McCune to share this occasion about prisons, to give utterance from behind bars that might articulate more than the lens could see." Lyon photographed McCune in his nine-by-five-foot cell in the Wynne Unit of the Texas Department of Corrections. —AS

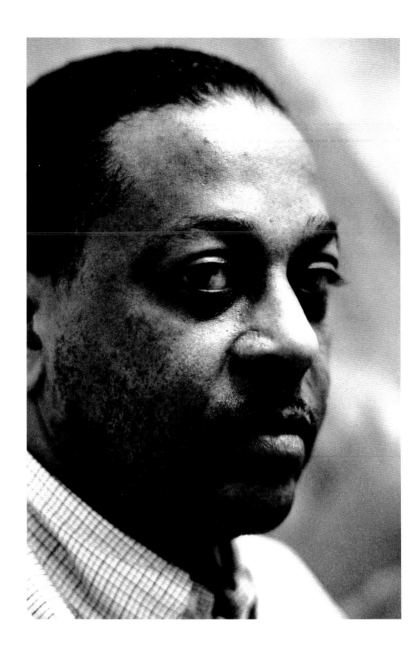

Rowland Scherman (born 1937)
Gelatin silver print, c. 1972
Published March 1972
ARTnews Collection
© Rowland Scherman

Thomas Sills (born 1914)

Thomas Sills came to art relatively late. Not until he was in his mid-thirties
and married to artist Jeanne Reynal did he begin to explore abstract expression.
Beginning with materials that Reynal used in her mosaics, Sills soon branched
out to oil on wood as well as canvas. Though he lacked formal training, his
sophisticated handling of color and innovative use of media caught the attention
of the New York avant-garde and led to his regular presence in galleries through
the early 1970s. —TM

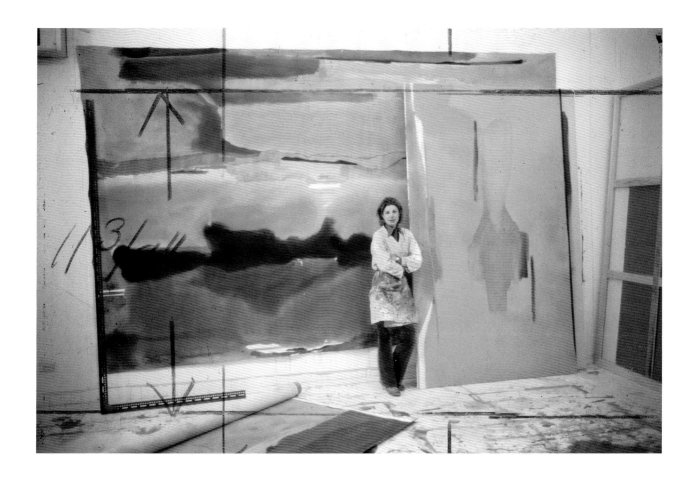

Alexander Liberman (1912–1999)
Color transparency, 1975
Published September 1975
ARTnews Collection

Helen Frankenthaler (born 1928)

A prolific painter and printmaker, Helen Frankenthaler is known for pioneering the "soak-stain" technique in painting. Drawing inspiration from the free-flowing paint of Jackson Pollock's 1951 black-and-white canvases, Frankenthaler began applying thinned color pigment directly onto unprimed canvases. Her resulting abstract paintings had a liquid appearance devoid of any tangible pigment, much like a watercolor, but more luminous and on a larger scale. In 1953, art critic Clement Greenberg introduced painters Morris Louis and Kenneth Noland to Frankenthaler's canvases. The two Washington, D.C.–based painters were so exhilarated by what they saw in her New York studio that they returned to Washington and immediately began to experiment with the soak-stain technique. —TA

Abe Frajndlich (born 1946)
Gelatin silver print, 1975
Published April 1991
National Portrait Gallery,
Smithsonian Institution;
gift of Paulette and Kurt Olden
in memory of Lily E. Kay
© Abe Frajndlich

Imogen Cunningham (1883–1976)

During a remarkable career that spanned seven decades, Imogen Cunningham produced a diverse body of work that mirrored the course of American photography through much of the twentieth century. She acquired her first camera in 1905, and her early portraits and figure studies were in the soft-focus, pictorial mode that defined art photography of the day. In the mid-1920s, her work took a new direction when she adopted a sharp-focus, modernist aesthetic to create boldly rendered images of plants, nudes, and industrial landscapes. Although formal portraiture became Cunningham's mainstay after 1930, she continued to explore other aspects of her medium, including still-life, documentary, and street photography. Wide public recognition eluded Cunningham for most of her career, but when it came late in life, she delighted in her newfound celebrity. Describing his encounter with Cunningham for *ARTnews*, Abe Frajndlich recalled, "She was in her garden, and she started holding her garden shears . . . as a play on the way I was holding my camera. That was Imogen—a woman totally alive and witty at 91." —AS

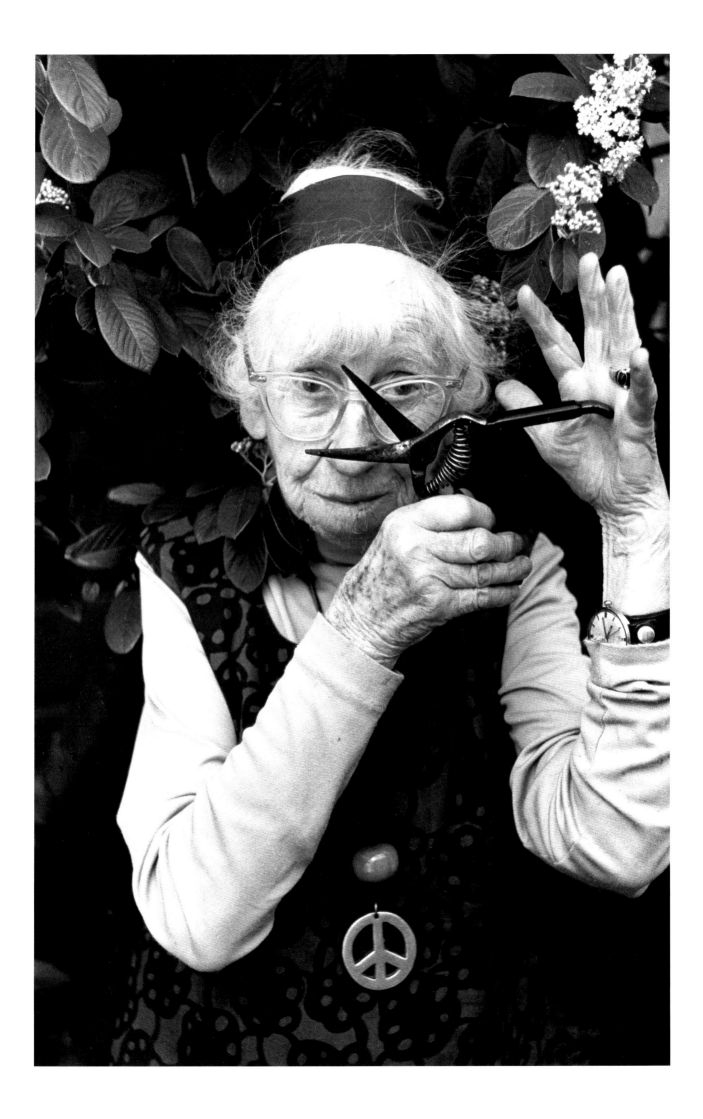

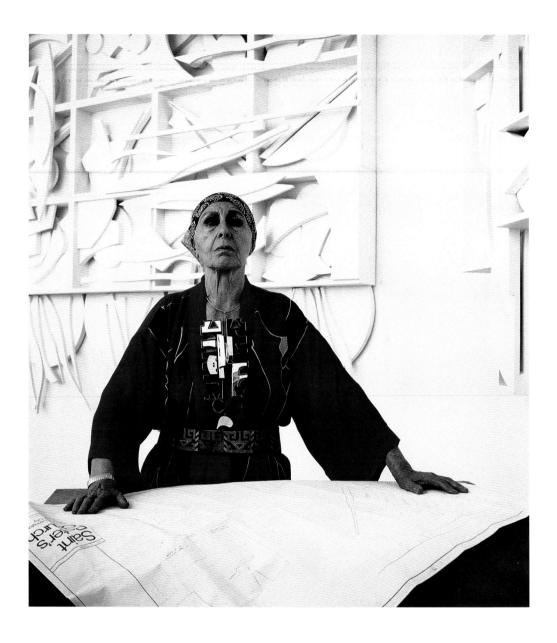

Hans Namuth (1915–1990)
Cibachrome print, 1977
Published May 1979
National Portrait Gallery,
Smithsonian Institution;
gift of the James Smithson Society
© Hans Namuth Ltd.

Louise Nevelson (1899–1988)

The May 1979 cover of *ARTnews* shows Louise Nevelson at age eighty. This uncropped version of the photograph reveals the location of the shoot—a wall of the Erol Beker Chapel, which Nevelson designed for St. Peter's Lutheran Church in Manhattan. Although her work did not gain widespread attention until the late 1950s, when *Sky Cathedral* was installed in the Museum of Modern Art, with her frenetic energy and creative spirit, Nevelson quickly established herself as a force to be reckoned with in the New York art world where she had worked unnoticed for decades. In this photo we see Nevelson in a dress, belt, and jewelry that echo forms in the wall sculpture behind her. In what seems a tribute to an artist who wanted above all to create environments that offer viewers the space to contemplate, Namuth has revealed a face and a posture that beg the viewer to take pause and reflect. —KS

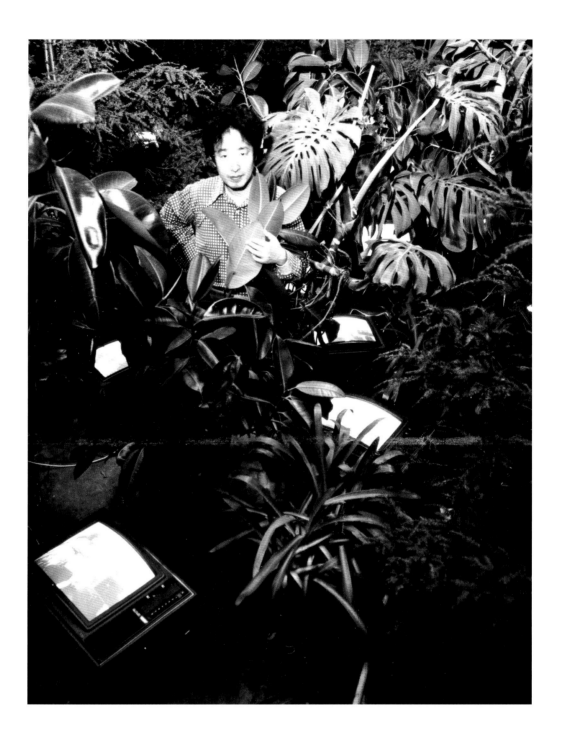

66

Friedrich Rosenstiel (lifedates unknown)
Gelatin silver print, c. 1977
Published September 1977
ARTnews Collection

Nam June Paik (born 1932)

Nam June Paik is regarded as the first artist to have comprehensively realized the potential of television and video as an artist's medium. Paik, best known for his video installations of televisions scattered through artificial landscapes, suspended from ceilings, and incorporated in anthropomorphic figures or in sculptural configurations, was the first artist to manipulate television circuitry and magnetic fields to create unique patterns and visual displays. When he moved to New York in 1964, the Korean-born artist was already established in Europe as an avant-garde composer—work he continued in the United States with cellist Charlotte Moorman. Paik also designed, with the help of Japanese engineer Shuya Abe, the first color video synthesizer, which allowed pictures to be mixed and distorted within the internal television system in an infinite variety of patterns. —TA

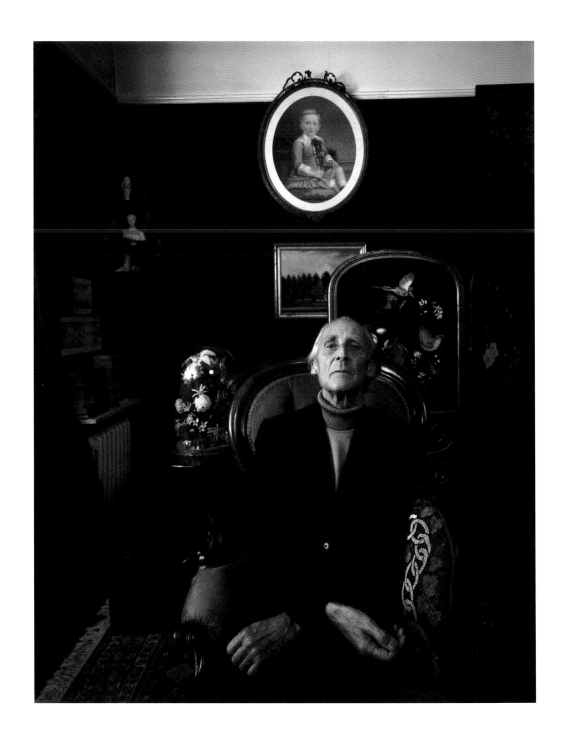

67

Arnold Newman (born 1918)
Polacolor print, 1978
Variant published March 1982
Arnold Newman
© Arnold Newman/Getty Images

Bill Brandt (1904–1983)

In characterizing the photography of British artist Bill Brandt in 1982, *ARTnews* exclaimed, "In Brandt's hands, the camera yields up a rich and strange world, a dreamlike space filled with mystery, eroticism, and menace." For more than fifty years Brandt used his camera to fulfill a variety of projects. At times his lens was a documentary tool, revealing the layers of social class in England or the impact of World War II on London and its citizens. At other times his camera gave him a way to explore abstract forms as expressed in both the landscape and the human body. Yet in all he photographed, he had a capacity, in his friend Arnold Newman's estimation, "to take everyday life and create moods and attitudes that were not seen before." Newman's portrait of Brandt at age seventy-four conveys some of the mystery that always surrounded the artist and his photography. —FG

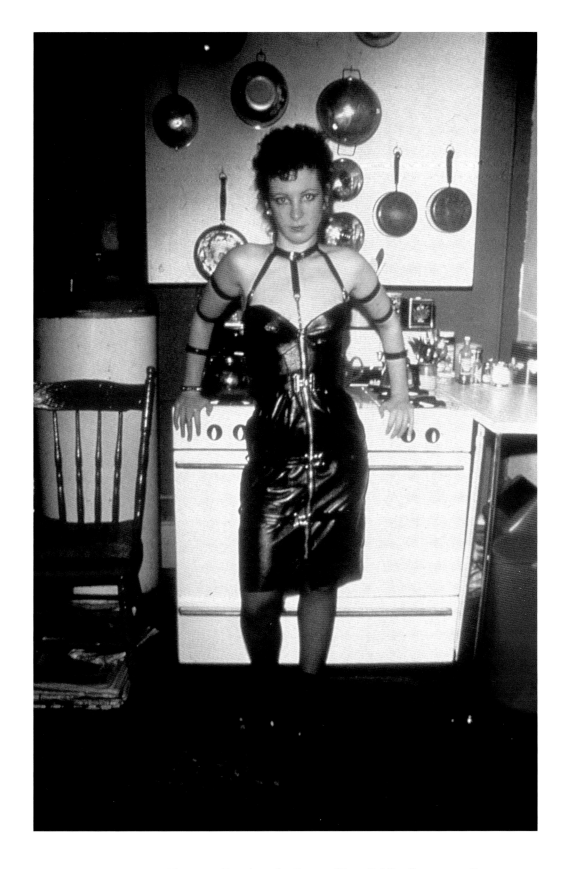

68

Self-portrait
Cibachrome print, 1978
Published December 1996
Matthew Marks Gallery
Courtesy of the artist and Nan Goldin;
courtesy Matthew Marks Gallery,
New York City

Nan as a Dominatrix, Boston (Nan Goldin [born 1953])

Nan as a Dominatrix, Boston, appeared on the cover of *ARTnews* in December 1996, while Goldin was enjoying a major retrospective of her work at the Whitney Museum of American Art entitled *I'll Be Your Mirror*. Her color photographs, which contemplate issues of gender, power, and dependency, were first shown, not in galleries, but as slide shows set to rock-and-roll soundtracks and played in clubs during the 1980s. In her work Goldin has chronicled drug rehabilitations, terminal illnesses, relationships, and abuse, as well as the quotidian affairs of life, exposing private, often intimate, frequently turbulent, and sometimes disturbing lifestyles. Over time she has assembled a visual biography of herself and the individuals who inhabit her life. —TA

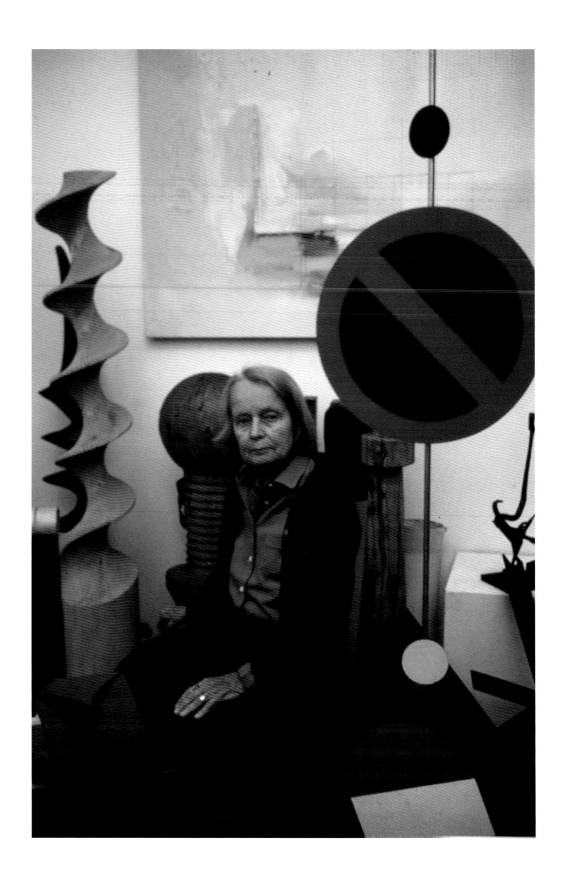

69

Lisl Steiner (born 1927)
Color photograph, 1979
Published March 1979
Lisl Steiner
© Lisl Steiner

Betty Parsons (1900–1982)

Described by *ARTnews* as the "den mother of Abstract Expressionism," Betty Parsons became famous for identifying, promoting, and nurturing a new generation of American artists in the years after World War II. From her gallery on Fifty-Seventh Street, she spent more than three decades championing the work of numerous young artists, including most notably the painters of the New York School—Jackson Pollock, Mark Rothko, Clyfford Still, Barnett Newman, Hans Hofmann, and Ad Reinhardt. An artist herself, she was as famous for encouraging young talent to grow and experiment as she was in recruiting them to her gallery. This portrait of Parsons at seventy-nine by Austrian-born photographer Lisl Steiner was featured on the cover of *ARTnews* with the simple yet fitting caption, "The Remarkable Betty Parsons." —FG

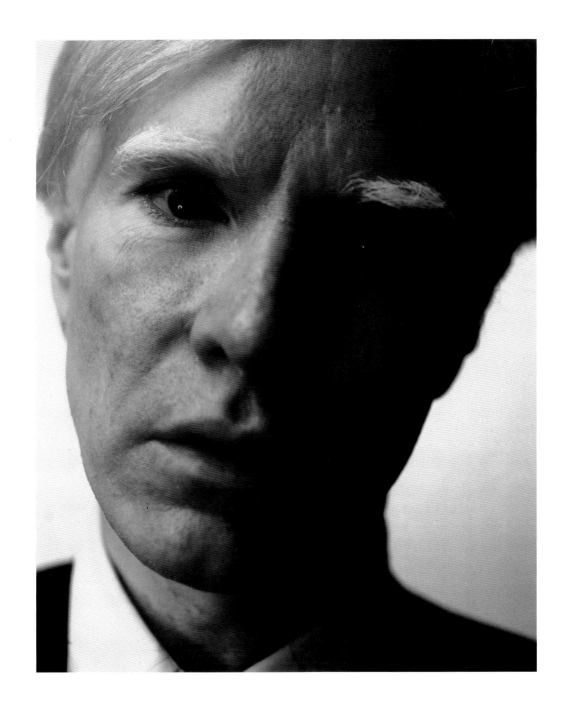

Andy Warhol (1928–1987)

Throughout his career, Andy Warhol was intrigued by the possibilities of using new
visual technologies to create art. Having moved to New York City in 1949, Warhol
was not attracted to Abstract Expressionism, the artistic movement then in vogue.
Instead, he gravitated toward an art that favored representational forms and mechan-
ical techniques. His appropriation of subjects from popular and consumer culture
and his pioneering work with photographic silk screens, filmmaking, and video
challenged traditional categories of art-making. Warhol was also interested in cul-
tivating and experimenting with his artistic persona. This Polaroid self-portrait
combines his fascination with new forms of image-making and his desire to explore
the subtle nuances of his identity. —FG

71

Neal Slavin (born 1941)
C-print, 1980
Published October 1980
Neal Slavin
© Neal Slavin

Twenty Women Artists

(bottom, left to right) Barbara Zucker, Faith Ringgold, Barbara Schwartz;
(second row) Rosemarie Castoro, Charmion von Wiegand, Louise Bourgeois, Miriam
Schapiro; (third row) May Stevens, Hannah Wilke, Joyce Kozloff, Nancy Holt,
Elaine de Kooning; (fourth row) Dorothea Rockburne, Isabel Bishop, Jackie Ferrara,
Nancy Graves; (top row) Colette, Audrey Flack, Rachel bas-Cohain, Laurie Anderson

The *ARTnews* of October 1980 was a special issue spotlighting the impact of
women on the art world, which—as the editor noted in his regular "Self Portrait"
column that month—had been "the message of the last ten years." For that
month's cover, *ARTnews* commissioned Neal Slavin, noted for his exceptional group
portraits, to photograph twenty representative women artists. Many of the women
who agreed to participate had never met, and after organizing the formal struc-
ture of the group, Slavin told his sitters to start talking to one another, hoping
to create "a common movement at some point, to have some fun, without losing
the good tension of the group." This photograph, the last of the session, accom-
plished exactly what the photographer wanted and was the unanimous choice for
the issue's cover image. —WS

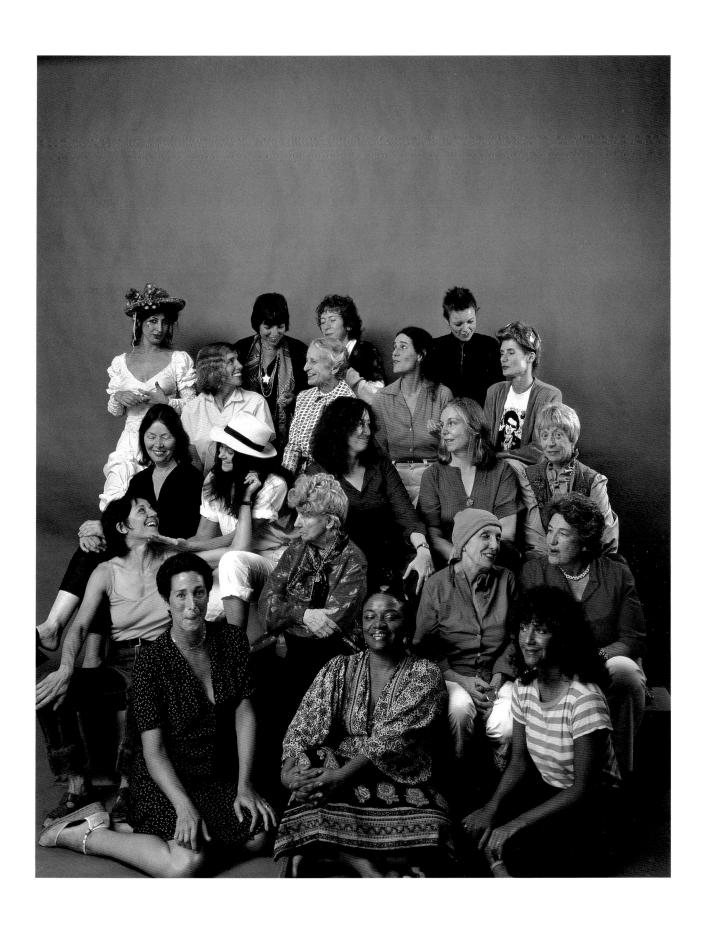

Hans Namuth (1915–1990)
Cibachrome print, 1980
Published December 1980
National Portrait Gallery,
Smithsonian Institution;
gift of the James Smithson Society
© Hans Namuth Ltd.

Romare Bearden (1912–1988)

Hans Namuth photographed Romare Bearden in 1980 in his Long Island City, New York, studio. Behind him hangs a picture of his grandparents on their front porch in North Carolina, one of the few decorations in the space. A specialist in collage, Bearden often looked to the past for inspiration. He once said, "I paint out of the tradition of the blues, of call and recall. You start a theme and you call and recall." This nod to the culture of the black South, where he spent his early childhood, was just a beginning for Bearden, who spent time studying such artists as Rembrandt and Henri Matisse as well as absorbing the influences of the Harlem Renaissance. —KS

Harvey Stein (born 1941)
Gelatin silver print, 1982
Published February 1984
Harvey Stein
© Harvey Stein, 1986

Susan Rothenberg (born 1945)

Susan Rothenberg moved her head during the exposure of Harvey Stein's photograph. The result is an eerie portrait of an artist whose emblematic paintings of horses and human figures diffused through feathery brushwork have been called lonely, mysterious, and intensely psychological. In the early 1980s Rothenberg was praised as one of the first painters to bring her medium convincingly past the conceptual art of the previous decade. —TM

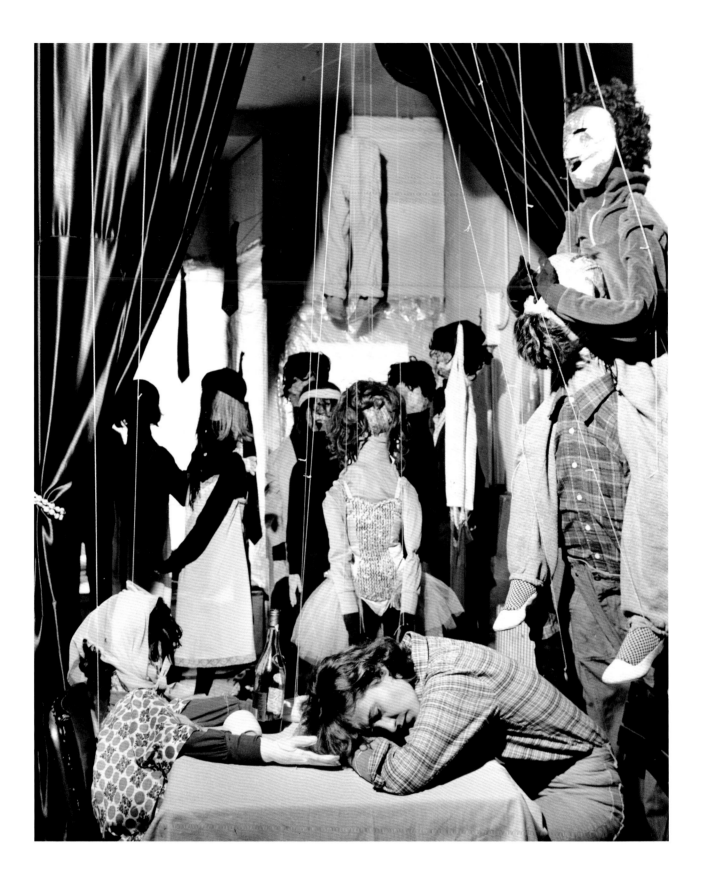

74

Peter Bellamy (born 1944)
Gelatin silver print, 1982
Published summer 1986
Peter Bellamy, from *The Artist Project* (1982)

Hanne Tierney (born 1940)

Using sophisticated marionette-like figures made of papier-mâché, clothing, material, air-conditioning ducts, metal coils, exhaust pipes, window blinds, and any other imaginable materials, Hanne Tierney animates dramatic stories and performances mostly of her own creation. She manipulates all the figures herself through a highly complex suspended grid system of pulleys and transparent fishing line, which she likens to "playing an instrument." Using a minimal verbal script, Tierney creates the story and characterizations through a range of highly emotive, subtle gestures. Born in Germany, Tierney was apprenticed as a worker in a spinning-wheel factory. At nineteen she moved to the United States to pursue a better life, writing children's stories before turning to designing, creating, and animating her complex sculptural puppets. —TA

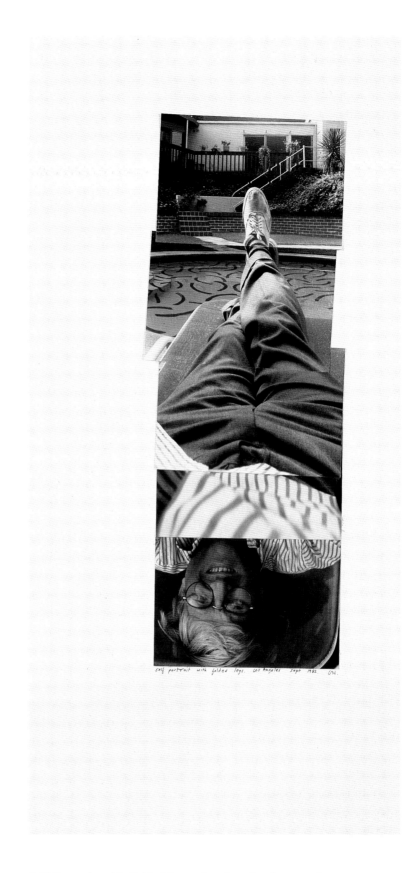

75

David Hockney (born 1937)
Photographic collage, 1982
Published October 1986
David Hockney
© David Hockney

Self-Portrait with Folded Legs. Los Angeles Sept. 1982

For this collage, British artist David Hockney turned his camera on himself, lying near the swimming pool of his Los Angeles home, a familiar subject from many of his paintings and prints. In the early eighties, Hockney began experimenting by applying to photography the multiple perspectives used by Cubist painters, combining Polaroid photographs of one subject taken over an extended time and from several angles. The resulting collages intentionally toy with the limitations of two-dimensional art, offering a journey through time and space over a flat surface. —TM

Leo Castelli (1907–1999)

One of the most influential art dealers of the twentieth century, Leo Castelli launched the careers of such Pop greats as Jasper Johns, Robert Rauschenberg, Andy Warhol, Roy Lichtenstein, and Frank Stella—convincing the world that American art of the 1960s was worthy of international recognition. Fleeing the war in Europe, Castelli and his wife, Ileana Sonnabend, came to New York from Paris in 1941. In 1943 he joined the U.S. Army and was assigned to military intelligence in Europe. For his military service he was granted American citizenship. Castelli introduced an innovative stipend system into the New York gallery world, putting the artists he represented on a payroll regardless of whether their work sold. Castelli was frequently pictured in the pages of *ARTnews*, and this image accompanied a brief article on his reception of France's prestigious Legion of Honor award for his contribution to the expansion of French culture. —TA

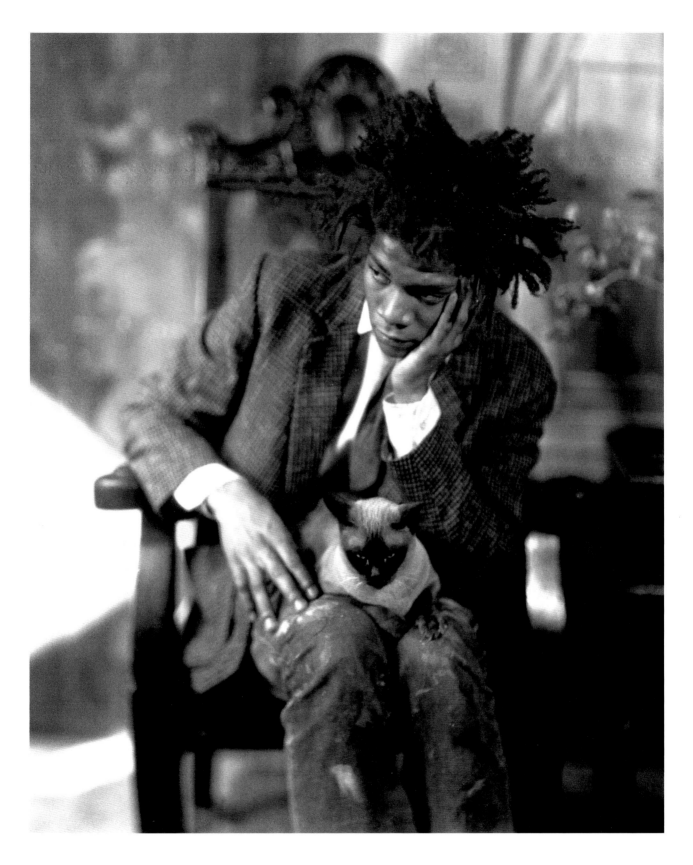

James VanDerZee (1886–1983)
Gelatin silver print, 1982
Published January 1989
Donna Mussenden VanDerZee
© Donna Mussenden VanDerZee

Jean-Michel Basquiat (1960–1988)

Jean-Michel Basquiat was a highly visible presence in the New York avant-garde art scene of the 1980s. Having made a name for himself as a graffiti artist using the tag SAMO—short for "same old shit"—Basquiat developed into an important Neo-Expressionist painter. His work often explored political themes such as racial conflict and economic oppression. Though critics frequently chafed at his "dramatic and bristly displays of superstardom," *ARTnews* wrote at the time of his death that "Basquiat's talent surpassed his notoriety as the rebellious young artist raging against the commercializing forces of society." In 1982 Basquiat sat for his portrait in the studio of famed Harlem photographer James VanDerZee, who was then ninety-six. After this sitting, Basquiat painted VanDerZee's portrait. —FG

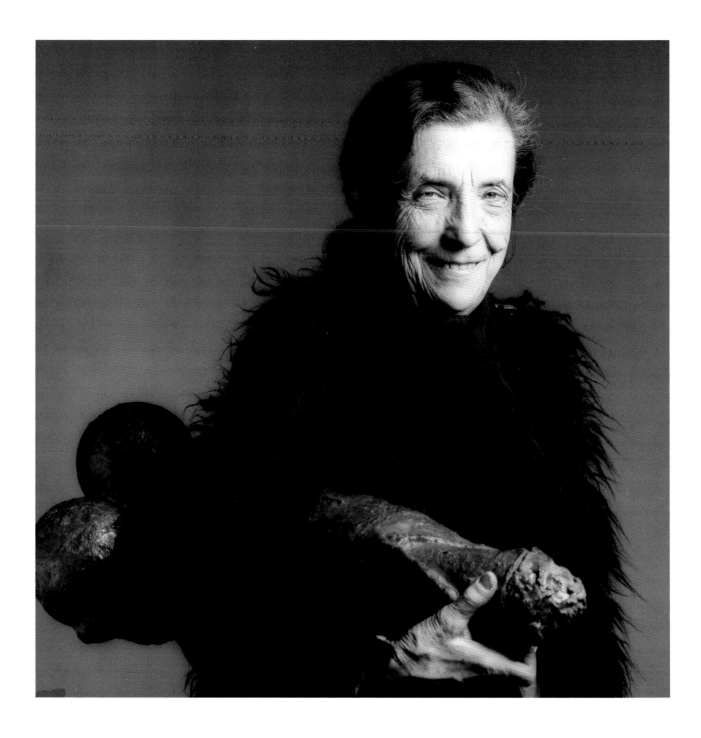

Robert Mapplethorpe (1946–1989)
Gelatin silver print, 1982
Published October 1989
The Estate of Robert Mapplethorpe
© 1982 The Estate of Robert Mapplethorpe.
Used with permission

Louise Bourgeois (born 1911)

In the midst of a nationally publicized scandal regarding the Corcoran Gallery of Art's decision to cancel a Robert Mapplethorpe retrospective, *ARTnews* published an article entitled "What Is Pornography?" that featured reactions to the controversy from twenty-two prominent artists, museum directors, and politicians. Sculptor Louise Bourgeois, whose work frequently engages questions of sexuality, was among the respondents. "Pornography serves the outrage of the special interests. This [argument over Mapplethorpe's work] is politics and has nothing to do with art," declared Bourgeois. Mapplethorpe's wry 1982 portrait of Bourgeois holding her latex sculpture *Fillette* accompanied the article. Bourgeois's mischievous smile and the manner in which she carries the aggressively phallic *Fillette*—a French term that refers to a young and inexperienced girl—conveys the ironic sense of humor that is often at the heart of Bourgeois's work. —FG

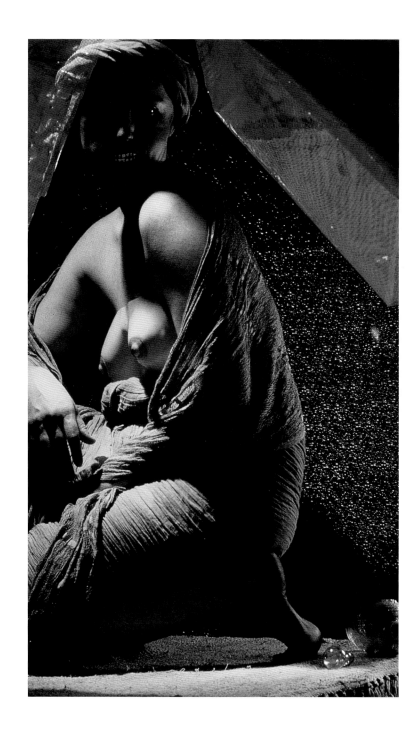

79

Self-portrait
C-print, 1985
Published March 1986
Linda and Harry Macklowe;
courtesy the artist and Metro Pictures

Untitled (#146) (Cindy Sherman [born 1954])

In the late 1970s, Cindy Sherman introduced herself to the art world through a series of critically acclaimed black-and-white photographs called *Untitled Film Stills*. Serving as her own model, Sherman uses wigs, makeup, costumes, lighting, and photographic effects to transform each would-be self-portrait into a startling character study. The references to film and television are apparent, but the ambiguous images are isolated from any narrative. These frozen moments contradict the familiar and jar the viewer into reevaluating how popular culture trains us to respond to images of the female body. This photograph from her follow-up series incorporates garish colors and prosthetic body parts to create a view into the female psyche. What lies beneath the surface is both horrific and grotesque. Sherman's unique ability to create striking, thought-provoking images while combining what *ARTnews* calls "camp *and* dead-earnestness" continues to assure her widespread popularity and critical success. —SL

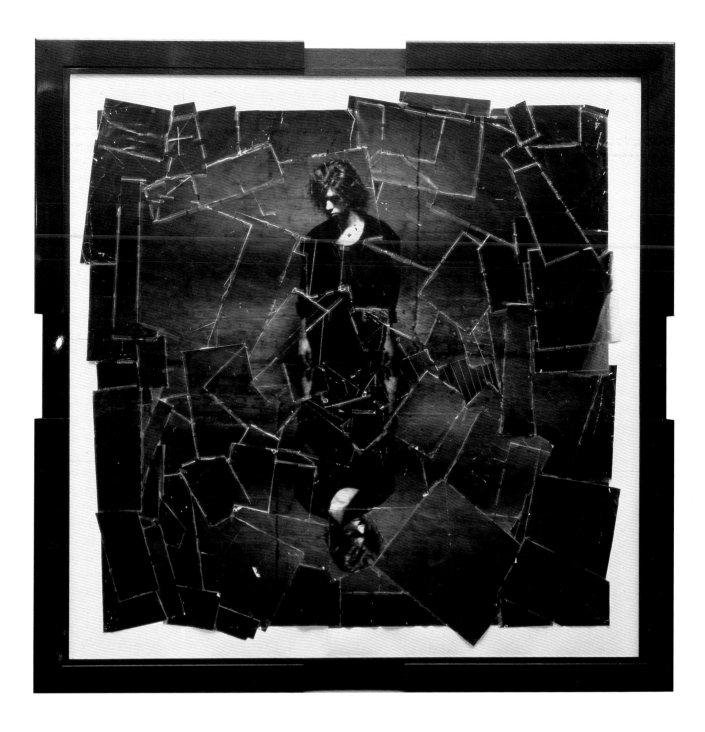

80

Self-portraits
Collage: toned gelatin silver prints
and tape, 1985–86
Published February 1988
Rondolfo Scott Rocha

Double Stark Portrait in Swirl (Mike Starn [born 1961] and Doug Starn [born 1961])

During an interview for a 1988 *ARTnews* article lauding the early success of photographic artists Doug and Mike Starn, the identical twins articulated the philosophy behind their torn and taped photo-collages: "We want to make the viewer feel the photography, as a painter makes you *feel* the paint, with drips and brushstrokes." The Starns endow their familiar subjects—stairs, horses, "masterpieces" of art, even themselves—with further meaning by combining various portions of an image to form a new piece. Their composite photographs integrate the aesthetics of nineteenth-century Romanticism into a contemporary awareness of the world. They take an art form where traditionally the materials of the work are inconsequential to the image and, much like Expressionism, make the physicality of the materials central to the work, bringing the human touch back to an increasingly mechanical and digital process. —TA

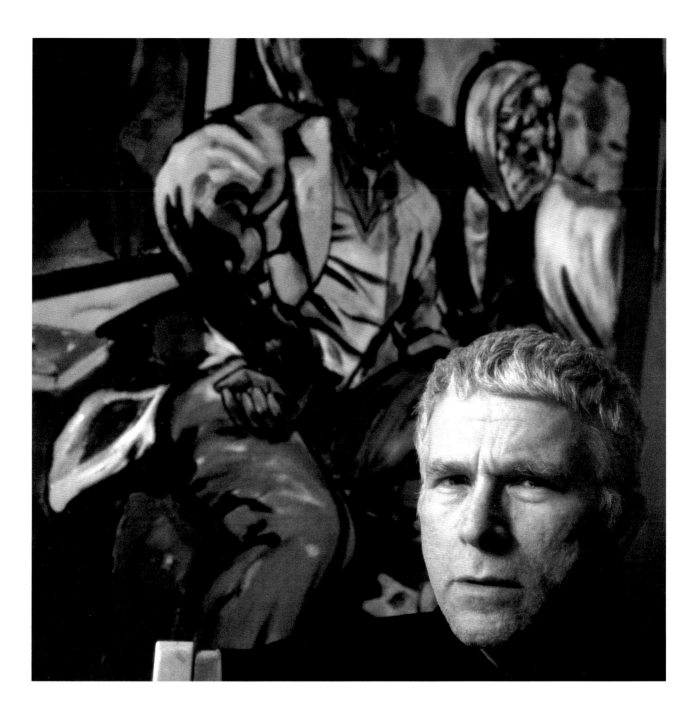

Prudence Cumming Associates
(active 1967–present)
Gelatin silver print, c. 1985–86
Published March 1986
ARTnews Collection

R. B. Kitaj (born 1932)

Although he was born in Cleveland, R. B. Kitaj has lived in England since the 1950s
and is considered a major figure in contemporary British art, a member of the
so-called London School. Kitaj describes himself as a depictive painter, and much
of his work deals with the most disturbing philosophical and moral issues of the
twentieth century—religious and racial intolerance, human suffering, and personal
isolation. This moody, somber portrait of R. B. Kitaj by Prudence Cumming Associ-
ates illustrated the feature story of this issue of ARTnews, while a less dramatic
photograph of the artist by Cumming graced its cover. —WS

Self-portrait
Gelatin silver print, 1986
Published summer 1990
Muna Tseng Dance Project, Inc.,
New York City

Lake Kamloops, British Columbia (Tseng Kwong Chi [1950–1990])

In 1979 Tseng Kwong Chi put on a thrift store Mao-era suit to enter a "coat-and-tie" restaurant in New York and was mistaken by the maître d' for a Chinese dignitary. The next year he successfully crashed the opening of the Ch'ing dynasty exhibition at the Metropolitan Museum of Art—posing with the rich and famous as a Chinese Communist official. Tseng realized then that he had tapped into a profound theme—one that would drive his artistic career for the next eleven years—"the pervasive ignorance of Westerners regarding Asia generally and China specifically." Posing at iconic tourist sites, Tseng displayed dramatic camera angles and spatial compressions in his early work. In the mid- to late 1980s, however, he abandoned the use of a cabled shutter release and worked with an assistant. By moving further from the camera and at times almost disappearing into the landscape, Tseng transformed his photographs into modern references to the grand tradition of nineteenth-century American landscape painting. Tseng, who died at forty of AIDS, is also well known for documenting the "street" work of graffiti artist Keith Haring. —TA

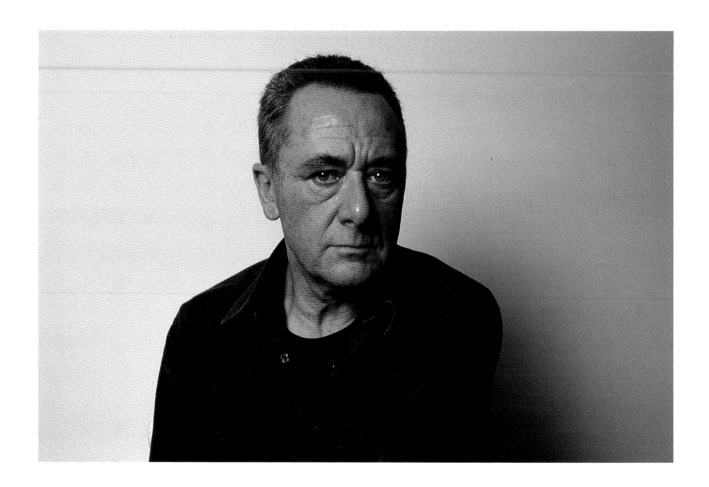

Gerhard Richter (born 1932)

German painter Gerhard Richter confronts Dirk Reinartz's camera with a disarm-
ingly frank stare. Richter's tendency to switch between colorful abstraction and
monochromatic photorealism has been attributed to a purposeful rejection of artificial
categories. The artist himself has cited his need for continual, intense self-exami-
nation. Considering the scope of his work in a 1989 interview, Richter insisted that
all his paintings, abstract or otherwise, depict "something very directly and very
naively, and are very dependent on how I am feeling." —TM

84

Abe Frajndlich (born 1946)
Dye transfer print, 1988
Published April 1991
National Portrait Gallery,
Smithsonian Institution
© Abe Frajndlich

Arnold Newman (born 1918)

Beneath this collage of portraits is photographer Arnold Newman. Since the 1940s
Newman has photographed many of the leading cultural and political figures in
the United States and abroad. He has published his work in such magazines as *Life*,
Fortune, and *Harper's Bazaar* as well as in more than a dozen individual mono-
graphs. Inspired by this record of accomplishment, New York photographer Abe
Frajndlich cut out some of Newman's most iconic images from a book and pieced
them together. He then photographed Newman, who wears this collage like a
mask. As Frajndlich explained in *ARTnews*, "It's very imposing and challenging to
make a portrait of a man who's defined so many faces for us." Taken on Newman's
seventieth birthday, this photograph not only celebrates a lifetime's work but
speaks to the important role that photographic portraiture played in shaping ideas
and perceptions in the twentieth century. —FG

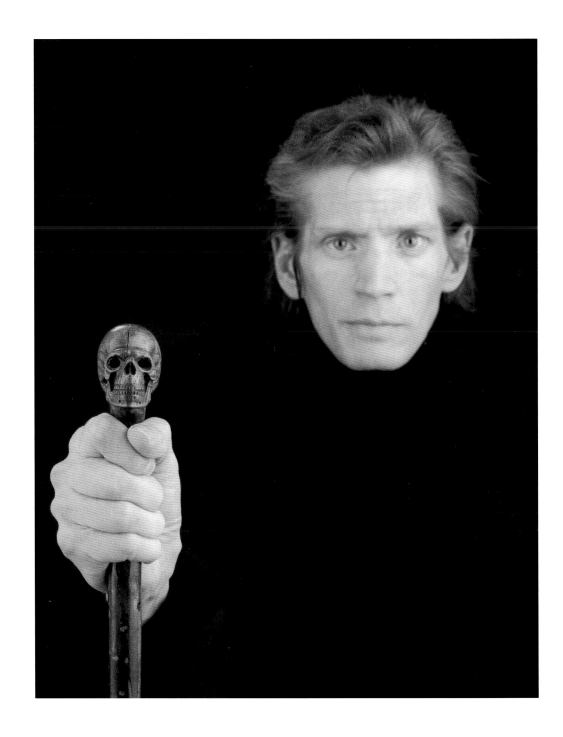

85

Self-portrait
Gelatin silver print, 1988
Published February 1994
The Estate of Robert Mapplethorpe
© The Estate of Robert Mapplethorpe.
Used with permission

Robert Mapplethorpe (1946–1989)

New York photographer Robert Mapplethorpe created this self-portrait in 1988 during a time of deep personal and professional anguish. Not only was a major retrospective of his work drawing heated criticism from conservative politicians and others who objected to the overt homosexual themes it contained, but Mapplethorpe was slowly dying of AIDS, a disease that was stripping his body of all strength and energy. Having lost his partner, Sam Wagstaff, to AIDS the preceding year, Mapplethorpe was now confined to a wheelchair. This photograph—published in *ARTnews* after his death—came to represent the crises that Mapplethorpe faced at the end of his life. It also made a poignant statement about America, a nation that at the time seemed incapable of confronting this public health emergency. —FG

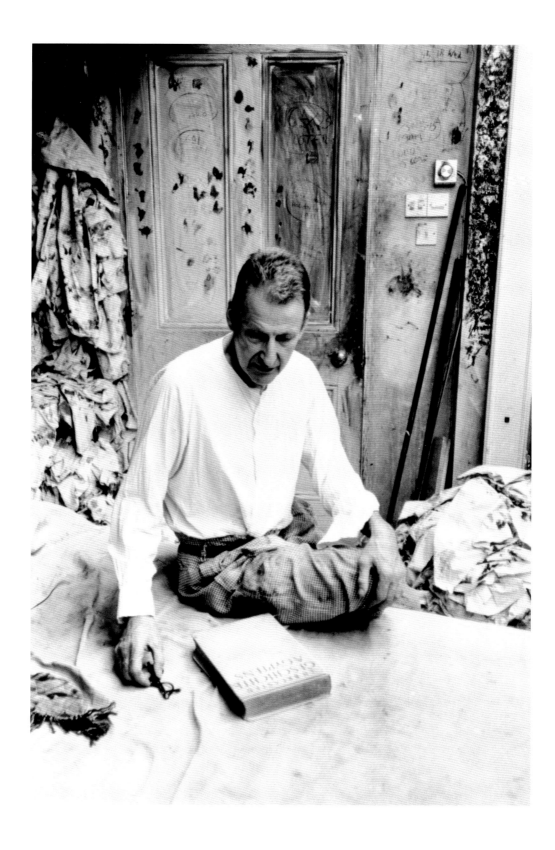

Julia Auerbach (born 1933)
Gelatin silver print, 1989
Published September 1993
Julia Auerbach
© Julia Auerbach

Lucian Freud (born 1922)

Julia Auerbach, a friend of Lucian Freud's, photographed the generally withdrawn artist in his London studio. In this image, Freud contemplates a copy of James Henry Breasted's *History of Egypt*, a subject of great interest to Freud's famous grandfather, who likened psychoanalysis to archaeological excavation. Probing, sometimes disturbingly frank portraits of friends and family members form the main focus of Freud's work, though his status as the preeminent portraitist in Britain led to a notable, and controversial, commission from Buckingham Palace for a portrait of Queen Elizabeth II, completed in 2001. —TM

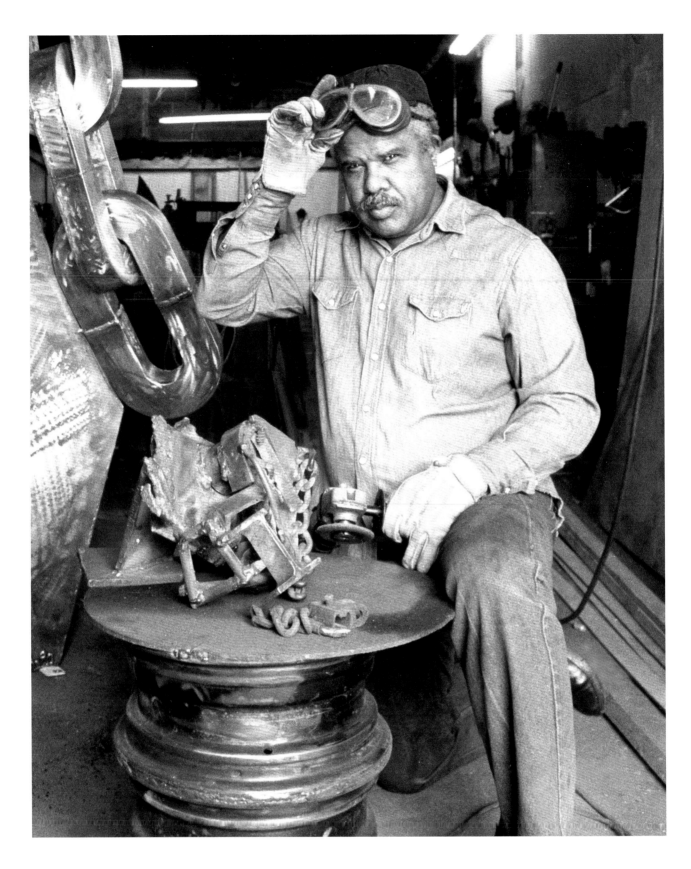

87

William E. Sauro (1923–2001)
Gelatin silver print, 1990
Published February 1995
Courtesy New York Times

Melvin Edwards (born 1937)

Melvin Edwards's popular work has ranged from large outdoor public sculptures to the challenging small pieces in his ongoing series *Lynch Fragments*. Started in 1963 in response to the turbulence of the civil rights era, the series tackles such social issues as slavery, racism, and the African-American experience. Edwards combines found steel objects—scrap metal, chains, spikes, hooks, handcuffs, and farming equipment—to create sculptures whose individual components and whole forms carry multiple meanings, from oppression and enslavement to the physicality and strength of human bonds. Edwards, whom *ARTnews* described as having the ability "to confront the good, bad, and the ugly of life, and to somehow construct a positive whole from the many pieces," is pictured here working on *Restless*, 1994— one of the more than two hundred pieces that make up *Lynch Fragments*. —TA

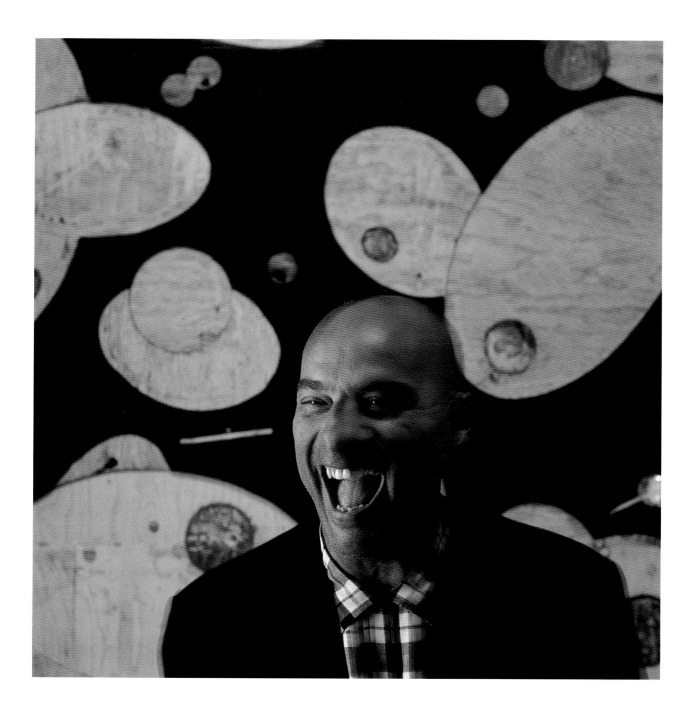

John Torreano (born 1941)

In 1991, *ARTnews* described John Torreano's career as "a single-minded investigation of the properties of real and fake gemstones." With an oeuvre that encompasses wall reliefs, paintings, custom-made furniture, and handblown glass vases, Torreano, who holds a black belt in judo and performs stand-up comedy, is as multifaceted as are his jeweled creations. He reflected in the 1991 article that "comedy, judo, and art have things in common: an incredible formal discipline, but also moments of complete spontaneity." Torreano gained his formal training at the Cranbrook Academy of Art outside Detroit, Michigan, and began his career as an abstract still-life painter. Gradually he moved toward further abstraction until the work transformed into his distinctive mixed-media creations composed of paint, fake gemstones, and other materials. —TA

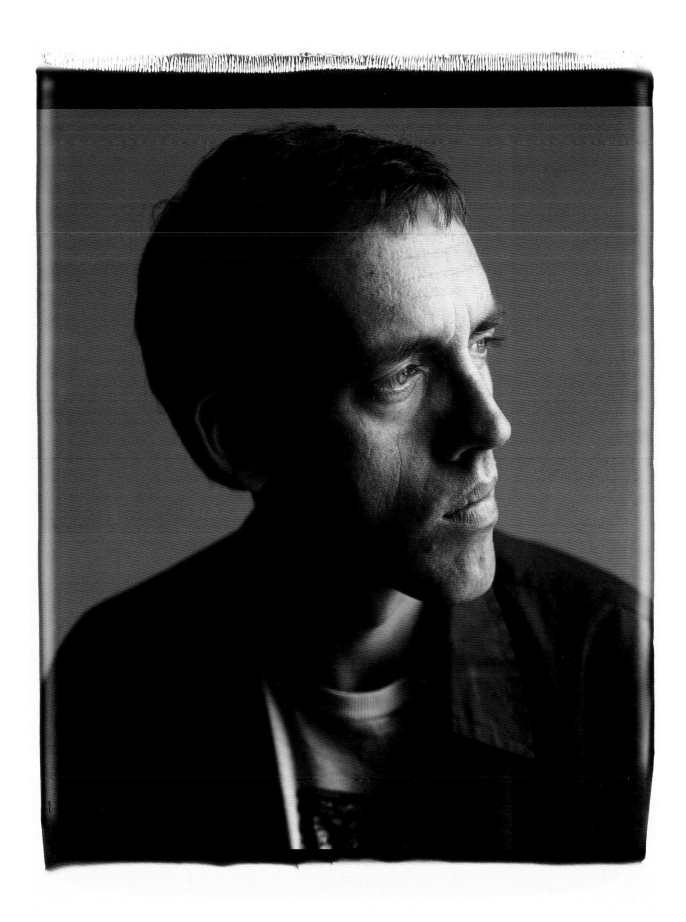

Timothy Greenfield-Sanders (born 1952)
Polaroid, 1991
Published October 1992
Timothy Greenfield-Sanders

David Wojnarowicz (1954–1992)

David Wojnarowicz was a painter, photographer, performance artist, and writer whose provocative works made him a well-known figure in the New York East Village art scene of the 1980s. Born in Red Bank, New Jersey, he endured a difficult childhood and struggled to make sense of his homosexuality—subjects that became a central theme in his art. During the height of a national controversy in 1989 concerning morality and censorship in the arts engendered by an exhibition of photographs by Robert Mapplethorpe, Wojnarowicz became embroiled in scandal himself. Following attacks from a host of politicians and religious leaders who called his work "pornographic" and "blasphemous," the National Endowment for the Arts revoked a ten-thousand-dollar grant for an AIDS-related exhibition in which Wojnarowicz was to participate. He challenged the NEA's ruling and, at the same time, brought a lawsuit against the conservative political action group the American Family Association for misrepresenting his art. He eventually won both campaigns. Wojnarowicz died of AIDS at age thirty-seven. —FG

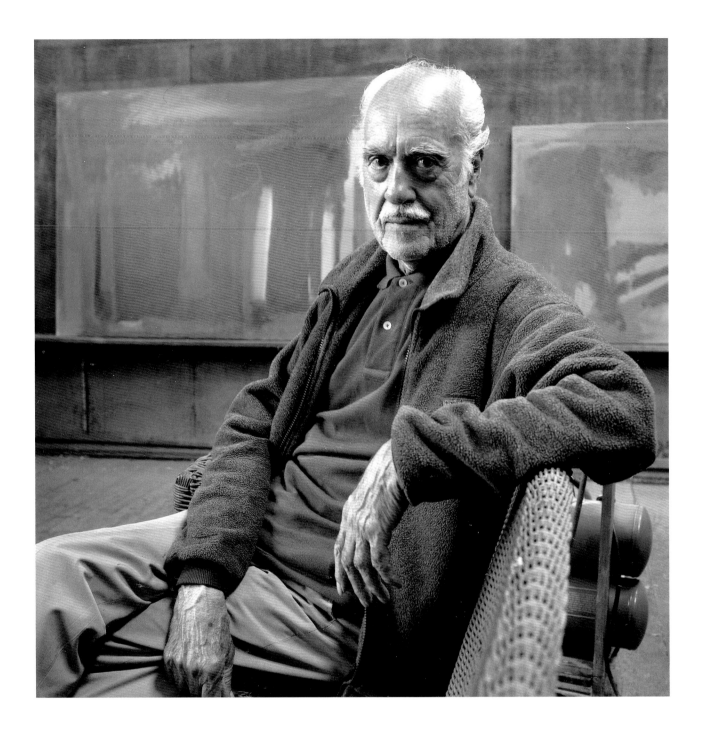

90

Laurie Lambrecht (born 1955)
C-print, 1992
Published February 1993
Laurie Lambrecht
© Laurie Lambrecht

Esteban Vicente (1903–2001)

Painter Esteban Vicente was the last of the European artists who came to the
United States during the early days of the New York School and the last of the first
generation of Abstract Expressionists. Born in Turégano, Spain, Vicente studied
art in Madrid with Salvador Dalí, lived in Paris, where he knew Pablo Picasso, and
had a successful painting career in Barcelona, where he befriended Joan Miró,
all before immigrating to New York with his American wife, Estelle Charney, in 1936.
A Spanish loyalist, he served as the vice-consul for the loyalist government in
Philadelphia during Spain's civil war. Vicente arrived at abstraction after a pro-
longed process of trial and error in the late 1940s but always retained within
his art a lyricism reflective of the Paris School and an extraordinary control of com-
position and harmony of color. —TA

91

Self-portrait
Gelatin silver print with overpainting, 1993
Published March 1993
Collection of the artist
William Klein; courtesy Howard Greenberg
Gallery, New York City
© William Klein

William Klein (born 1928)

The career of American expatriate artist William Klein defies easy categorization. For
more than fifty years, he has worked as a painter, photographer, and filmmaker
from his adopted hometown of Paris. Though he began his life as a painter creating
abstract canvases inspired by his mentor, Fernand Léger, Klein subsequently took
up the camera to document the world around him. He achieved early recognition as
a photographer after winning the prestigious Prix Nadar in 1956 for a book that
chronicled the city of his birth, New York, in gritty detail. His subjects since then have
varied widely. During the 1960s, for example, he split his attention between fashion
work for *Vogue* and a more politically engaged project recording antiwar and civil
rights demonstrations. As he later told *ARTnews* on the eve of a major retrospective
at New York's International Center of Photography, "I have always experimented
with new ways of doing things." —FG

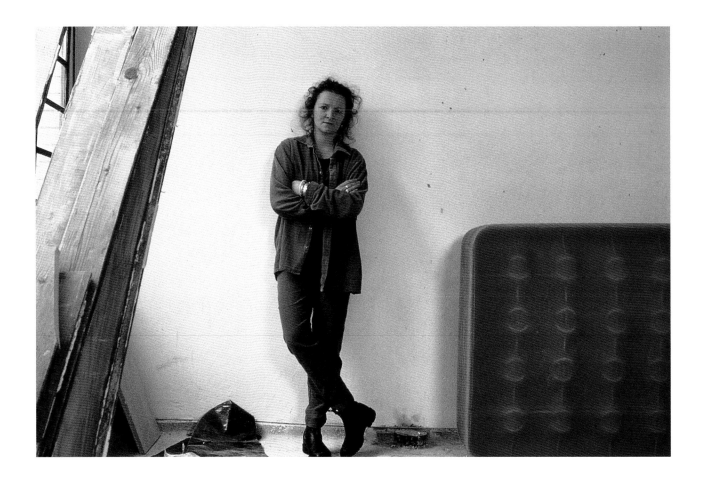

92

Dirk Reinartz (born 1947)
C-print, 1993
Published November 1993
Dirk Reinartz
© Dirk Reinartz

Rachel Whiteread (born 1963)

In just one of a number of events that led Rachel Whiteread to make headlines in 1993, she was awarded the Tate Gallery's prestigious Turner Prize for best British artist. At the same time, she was named worst British artist and awarded forty thousand pounds by a group of self-styled art-terrorists called the K Foundation. Known for casting everyday objects in beeswax, rubber, plastics, and plaster, Whiteread undertook one of her most ambitious projects in the fall of 1993, casting the interior of a Victorian house in concrete. Though *House* was a critical success, it was demolished after local residents protested that it was an eyesore. —TM

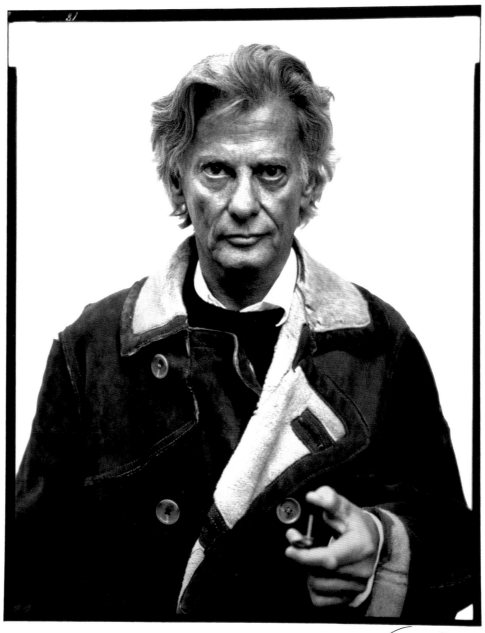

93

Self-portrait, New York, New York
Gelatin silver print, December 12, 1993
Published March 1994
ARTnews Collection
© 1993 Richard Avedon

Richard Avedon (born 1923)

Described by *ARTnews* in 1994 as "one of the most successful and widely imitated
photographers in the world," Richard Avedon has spent sixty years creating photo-
graphic portraits that have reshaped this tradition. The direct frontality and stark
white backgrounds of his large-format black-and-white portraits—exhibited here
in this self-portrait—are characteristic of Avedon's work in this genre. Having learned
photography while serving in the merchant marine during World War II, Avedon later
made a name for himself in the fashion and advertising industries. Yet his time doc-
umenting such difficult subjects as patients in a Louisiana mental hospital and
disenfranchised characters in the American West also points to a wider concern for
recording American life in its myriad guises. —FG

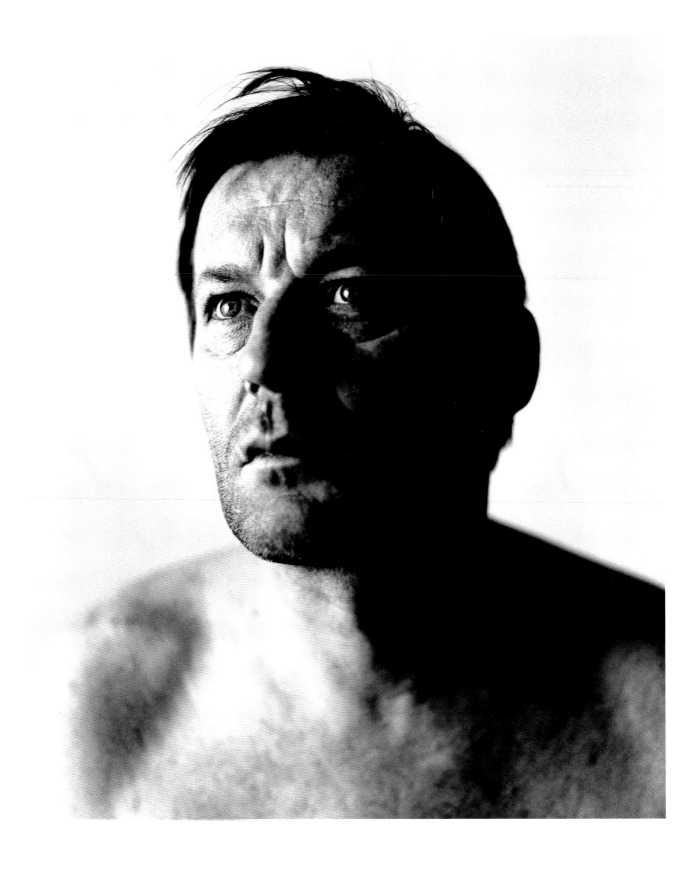

94

Elfie Semotan (born 1941)
Gelatin silver print, 1995–96
Published May 1997
Elfie Semotan; courtesy
Walter Schupfer Management
© Elfie Semotan

Martin Kippenberger (1953–1997)

Described by *ARTnews* on his death as a "flamboyant personality [whose artistic program] embraced painting, sculpture, photography, installation art, performance, and music," German artist Martin Kippenberger was an eccentric character in European avant-garde circles during the last quarter of the twentieth century. In addition to probing recent German history, his work frequently questioned the social function of art. In 1987, for example, he purchased a gray painting by his compatriot Gerhard Richter and installed it as the top of a coffee table. Though no one ever rested drinks or other objects on this table, the mere thought of that possibility provoked pointed responses in viewers. Elfie Semotan's portrait of a wild-eyed Kippenberger conveys something of his outrageous personality. —FG

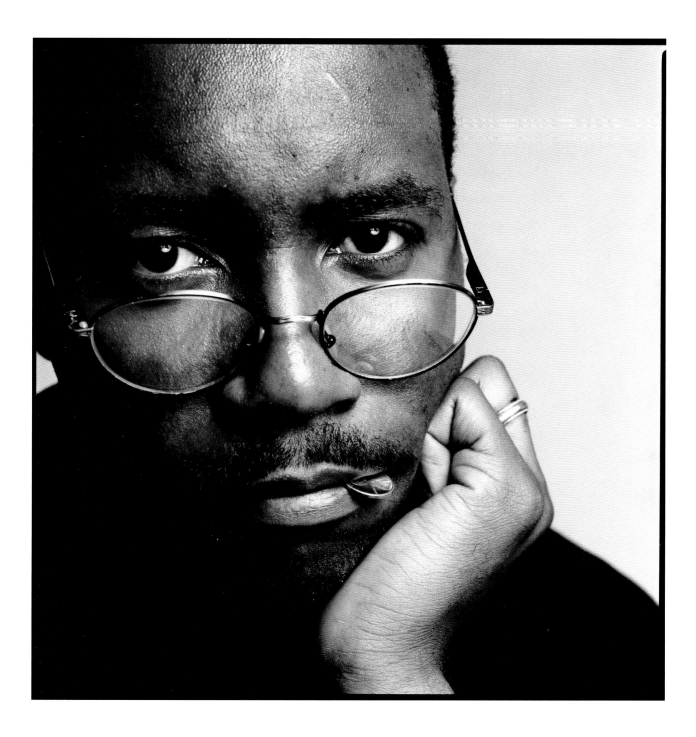

95

Patrick Demarchelier (born 1943)
Gelatin silver print, 1996
Published March 1999
Patrick Demarchelier; courtesy
Tony Shafrazi Gallery, New York City
© 1996 Patrick Demarchelier

Michael Ray Charles (born 1967)

The art of Michael Ray Charles has been concerned with exploring the legacy of historic stereotypes related to Americans of African descent. In his brightly colored paintings and prints, he employs such characters as Sambo, Aunt Jemima, and Uncle Tom to comment on contemporary racial attitudes. Given the potentially incendiary nature of these stereotypes, Charles has frequently been at the center of controversy. In a 1999 *ARTnews* article—which included this portrait by French photographer Patrick Demarchelier—Charles explained, "Every time I have a show there are some black folks complaining." Yet his success in eliciting strong reactions from his viewers seems to please Charles, who added that he finds this work "beautiful." Born in St. Martinville, Louisiana, Charles has taught at the University of Texas at Austin since 1993. —FG

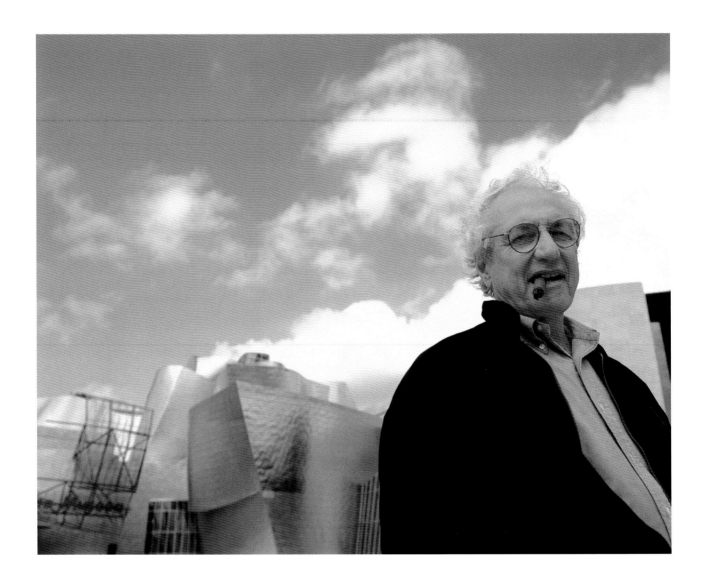

Todd Eberle (born 1963)
C-print, 1997
Published summer 1998
Todd Eberle
© 1997 Todd Eberle

Frank O. Gehry (born 1929)

Famed architect Philip Johnson called it "the greatest building of the century."
Frank Gehry was photographed in front of the Guggenheim Bilbao for a summer
1998 feature article in *ARTnews*. Gehry, a towering figure in the photograph as
well as a dominant force in the postmodern world of architectural design, creates
whimsical designs that incorporate such low-cost industrial materials as metal
panels, steel poles, and wire-mesh fencing. His commissions often resemble large-
scale assemblages or sculptures, and in fact, Gehry designs with the conviction
that "architecture is art." —KS

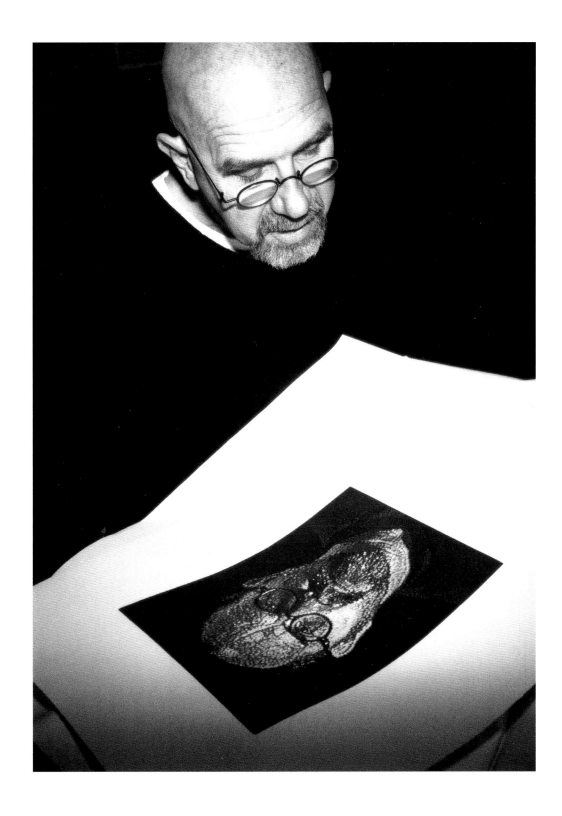

Chuck Close (born 1940)

New York artist Chuck Close has spent four decades representing the human face in a myriad of mediums. In depicting the countenances of family members and friends, though, he has been as interested in "notions of perception, scale, structure, realism, and abstraction"—to quote *ARTnews*—as he has been with more traditional portraiture concerns. In this photograph taken on the eve of his 1998 retrospective at New York's Museum of Modern Art, Close examines a self-portrait print. Despite suffering a collapsed spinal artery that partially paralyzed him in 1988, Close has continued to create likenesses that probe the very idea of representation. Given the media-saturated world in which we live, this work has proved especially provocative. —FG

Self-portrait
Gelatin silver print, 1998
Published March 2001
Meg and David Roth; courtesy
Bonni Benrubi Gallery, New York City
© Robert ParkeHarrison

DaVinci's Wings (Robert ParkeHarrison [born 1968])

Working in an artistic conceit that dates back into the early history of photography, Robert ParkeHarrison poses in his own photographs, not as a subject for self-portraiture, but as an anonymous Everyman figure struggling heroically but futilely with the forces of nature in a drear world. Incorporating aspects of theater, performance art, sculpture, and painting, ParkeHarrison's haunting, disturbing images transcend the familiar world of conventional photographic representation into surreality and resonate with the force of myth. —WS

Rankin (born 1966)
Gelatin silver print, c. 1998
Published November 1998
Rankin
© Rankin

Damien Hirst (born 1965)

Confronting the camera with the swagger of a rap star, Damien Hirst looks every bit the leader of a "New Guard" of young artists determined to put London on the map as the capital of contemporary art. In the late 1980s, Hirst made his mark in a series of group shows that he curated and presented in London warehouses. With the backing of private collector Charles Saatchi, Hirst quickly earned both fame and notoriety with works like *The Physical Impossibility of Death in the Mind of Someone Living*, which featured a fourteen-foot shark preserved in a tank of formaldehyde. Other projects, such as designing the interior of a London restaurant called Pharmacy and marketing paintings (often created by assistants) made by spinning a canvas under pouring paint, have furthered Hirst's reputation for brazen ambition and pushing boundaries. "So far I've found out there aren't any," Hirst explained in an *ARTnews* profile in 1998, "I wanted to be stopped, and no one will stop me." —TM

100

Jen Fong (born 1959)
C-print, 1999
Published January 2000
Jen Fong
© Jen Fong

Fred Wilson (born 1954)

Jen Fong photographed Fred Wilson among some of the objects he uses in his instal-
lations, which emphasize the need for more complete representation of diverse
communities in modern museums. Wilson's pathbreaking work—raising awareness
of those often excluded from traditional art and social history—won him a
MacArthur Foundation Award in 1999. Though Wilson is sometimes criticized for
being radically didactic, many museums have invited him to help reevaluate
their collections and exhibitions. —TM

Index